NOT WHITE ENOUGH

HOW VICTORIAN RACISM CONTRIBUTED TO THE DESTRUCTION OF A PHOTOGRAPHIC GENIUS

MURIEL MORRIS

◆ FriesenPress

One Printers Way
Altona, MB R0G 0B0
Canada

www.friesenpress.com

Copyright © 2023 by Muriel J Morris
First Edition — 2023

Photographer: Michael Spencer

All rights reserved.

No part of this publication may be reproduced in any form, or by any means, electronic or mechanical, including photocopying, recording, or any information browsing, storage, or retrieval system, without permission in writing from FriesenPress.

ISBN
978-1-03-915951-8 (Hardcover)
978-1-03-915950-1 (Paperback)
978-1-03-915952-5 (eBook)

1. BIOGRAPHY & AUTOBIOGRAPHY, PERSONAL MEMOIRS

Distributed to the trade by The Ingram Book Company

NOT WHITE ENOUGH

HOW RACISM CONTRIBUTED TO THE DESTRUCTION OF A PHOTOGRAPHIC GENIUS

BY MURIEL MORRIS

This book is dedicated to the Woodbury family, especially to the late Luanne Woodbury who was an inspiration. It is also dedicated to the late Alan Elliott for his generous support and genuine enthusiasm for Woodbury history. Both have proven dear friends on my journey of discovery. Finally, it is also dedicated to my cousin Marlene, who would have loved this book.

Walter Woodbury was a prolific experimenter, devising a multitude of photographic apparatus and techniques, but an inept businessman, losing the rights to his patents and all his money and businesses... He was famous among the photographic community in his own lifetime, but nearly forgotten after his death.

Most of all, Woodbury was an inventive genius who understood not only the mechanics of photography and its true potential, but the direction it would take in the future... He was the last in the line of inventors who worked in photography as a manual craft and the first to turn out mass production images. He occupies a unique place in photographic history, as do the processes he developed—the connecting link between the manual and the industrial. He died at fifty-one in 1885, and one wonders, if he had lived, where his keen mind and adventurous spirit might have taken him as the photographic world moved into the Twentieth Century.

—Barret Oliver, *A History of the Woodburytype*

TABLE OF CONTENTS

PREFACE .. 1

EARLY YEARS .. 5

AUSTRALIA .. 13
 A Rough Start .. 17
 A Big Break .. 22
 A Big Decision ... 28

JAVA ... 33
 Walter Strikes Gold of Another Kind 33
 Living the Life .. 43
 Walter Would Have Surprised His Mum 58

VICTORIAN ENGLAND .. 89
 Walter's Career Skyrockets and Crashes 90
 The Death of Walter .. 117
 Marie's Victorian Life .. 122

THE FAMILY DIASPORA: ABILITY, PASSION, AND INTELLIGENCE
FLEE ENGLAND .. 161
 Florence Who Wanted to be Normal 162
 Walter E., the Other Walter Woodbury 164
 Constance the Nurturer ... 176
 Indomitable Mayence ... 181
 Valence the Rebel .. 192

Scandalous Hermance .. *193*
Left-Behind Fayence .. *211*
Avence, The First to Die .. *218*

THREE HISTORIANS ... 219

APPENDIX 1: ELLEN WOODBURY FERGUSON: AN EMBITTERED WOMAN WHO WAS, PERHAPS, THE VOICE OF HER TIMES 221

APPENDIX 2: WALTER'S ECCENTRIC, INFLUENTIAL GRANDFATHER ... 227

APPENDIX 3: THOSE DOUGHTY WOODBURY WOMEN 247

APPENDIX 4: THE EARLY CLOSING MOVEMENT 251

APPENDIX 5: MY FAMILY ON THE CANADIAN PRAIRIES 253

APPENDIX 6: THE WEDDING IN SINGAPORE 261

APPENDIX 7: WALTER BENTLEY WOODBURY TIMELINE 265

APPENDIX 8: A SIMPLIFIED FAMILY TREE 271

APPENDIX 9: WALTER BENTLEY WOODBURY: PARTIAL LIST OF PATENTS .. 273

APPENDIX 10: THE WOODBURY GLACIER 277

AFTERWORD ... 279

LIST OF ILLUSTRATIONS ... 281

NOTES.. 291

BIBLIOGRAPHY ... 305

INDEX ... 311

ACKNOWLEDGEMENTS ... 321

ABOUT THE AUTHOR ... 323

PREFACE

Forget *Hamilton*. Forget *Bridgerton*. Even forget the Disney remake of *Lady and the Tramp*. A century (or two) ago, most inter-racial couples did not live in harmony, accepted by society, no matter what current media portrays, especially if they were middle-class couples. Walter Bentley Woodbury learned that to the sorrow of himself and his family.

In other societies, in other times, Woodbury would have been celebrated, even revered, as a man of genius. Epithets like "The Edison of Photography" or "The Caxton of Photography" have been used to describe him, yet he is not a "name" like Edison nor Caxton. He is the man who first patented a process by which thousands of photos could be mechanically printed from one negative, paving the way for books and magazines as we know them, yet he is commemorated by an obscure grave, a glacier in Antarctica that is melting, and a bistro in Amsterdam that closed during the Pandemic. That this is so is due, I think in part, to Victorian social attitudes toward a mixed-race couple. Woodbury's beloved wife, my great-great-grandmother, Marie Sophia Olmeijer, was the daughter of a Dutch sea captain and planter, Carel Olmeijer, himself half-Indonesian, and his Indonesian wife, known only as Sophie. Marie was visibly biracial.

I had no idea this story existed when I began researching my family tree. As it emerged, I was fascinated and appalled. Walter Bentley Woodbury is my great-great-grandfather. I didn't know that. I didn't know his story or the story of his family. I didn't know about the

family diaspora. We, ourselves, had obliterated this story. The story of Woodbury and his Eurasian bride and children is tragic in one sense but not another in that it shows us how far we have evolved concerning racial tolerance.

In the course of writing this book, though, I found that I could not attribute the "wreck" of Woodbury to the single factor of racial intolerance. Racist attitudes contributed but so did the character of Walter Bentley Woodbury himself. He was his own worst enemy. His impulsiveness was both a gift and a curse. It allowed him do brilliant and unconventional things, but it also prevented him from being steady when being steady was required. Racism was only a factor—a large factor—but not the whole cause of his rise and fall. It may have been a major factor in the family diaspora, as all but one of Woodbury's children and his wife left England within six years of his death. They fled to all corners of the Earth, becoming brilliant editors, hotel tycoons, teachers, scandals, and childbirth death statistics.

This book is a work of nonfiction, but you will find my voice in it. I cannot maintain a scholarly distance to this subject. I feel too strongly that Victorian England did the Woodbury family an injustice and wasted so much human potential. Social attitudes drove the Woodbury children out of England to scatter to the four winds, possibly because they were "not white enough."

Muriel Morris

Had he (Walter Bentley Woodbury) married an educated Englishwoman who could have saved him financial worries and gone with him into society—there is no telling what heights he <u>might</u> have climbed or what inventions might have been his. Marie did her best—poor little thing! She was clever with her needle, a good cook and tried hard, but, no one would associate with the children, or her—they had no play-fellows and as they grew older, no friends, always thrown in upon themselves! and the results were—very bad.

—Ellen Woodbury Ferguson (Walter Bentley Woodbury's niece) Handwritten family history 1935 in the collection of the heirs of Luanne Woodbury

EARLY YEARS

To understand this story, you need to know Walter Bentley Woodbury, the person.

To know a person, you need to understand some things about the most influential being and most influential period in his or her life. To Walter Bentley Woodbury, that being was his grandfather Walter Horton Bentley, and that period was his rapid coming of age during the Australian Gold Rush which began in 1851. These two influences shaped Walter Bentley Woodbury's personality and life in his trajectory from adventurous teen to celebrated inventor to a bankrupt man whose funeral was paid was for by friends and colleagues because there was no money otherwise. They also go far to explain why Walter didn't understand what the social cost of his "unsuitable" marriage to Marie Olmeijer would be.

Walter Bentley Woodbury was born on June 19, 1834 into a changing world and a forward-thinking family that was financially secure and embraced the technological and social changes of that world. In 1834, Robert Owen founded the National Consolidated Trades Union, while the Tolpuddle Martyrs, six Dorset labourers who tried to form a union by themselves, were transported to Australia; the navy launched its first steam-powered warship, the *Tartarus*, slavery was abolished in the Colonies but the *Poor Law* was amended so that the destitute could not get relief without entering a workhouse, and most of Parliament burned down. King William IV was on the throne and the ascension of Victoria was three years in the future.

Walter grew up in this world of contradictions, surrounded by people who were aware of both the benefits and costs of progress. The men of the family associated with intellectuals, gentleman scientists, artists and social reformers, and the biracial celebrity, John James Audubon, so Walter must have been blindsided by the shunning of his wife and children—sometimes even by members of his own family. In Walter Bentley Woodbury's world commerce was important but not as important as ideas, a lesson I think he learned at his grandfather's knee that stayed with him all his life. This and the lessons in self-reliance taught by his adventure to Australia made Woodbury the man he was.

Walter Bentley Woodbury was the son of John Taylor Woodbury and Ellen Bentley. Ellen was the second daughter of Walter Horton Bentley, who would play a seminal role in Walter Bentley's upbringing, a role made crucial by the death of his father when the boy was eight. Ellen had five children and, perforce, ran the shoemaking business so Walter was more or less raised and educated by his grandfather. So far this doesn't sound unusual, but it was.

Walter Horton Bentley, the grandfather, was an extraordinary man. Ostensibly, he was a shoe manufacturer. At least that is the business that kept the family well fed (and presumably well shod) and allowed Walter Horton Bentley significant time and funds to pursue his investigations and enthusiasms. He was that most Victorian of men, a true scientific amateur. He loved learning and he loved natural science, but he was also at home in the world of commerce and manufacturing and he was successful businessman (or at least somebody in his family was—his wife or his daughters actually did the day to day running of the shoe manufactory). That success allowed Bentley to spend significant time and money on his enthusiasms. For instance, to purchase an elephant skeleton, he spent a sum that would keep five tradesmen's families in comfort for a year.

Walter Horton Bentley was a naturalist. He wanted to educate the public about animals and he understood the power of seeing something for yourself. He bought the skeleton of Chunee, the elephant that had once been the darling of the Exeter Exchange Menagerie in London, before the animal was horrifically executed for bad behaviour,

probably caused by his close confinement. Chunee was 10 feet tall at the shoulder and kept in a small oak cage with a reinforced floor on the second floor of the Exeter Exchange building, where the menagerie was located. The ground floor of the building was a shopping mall.

Walter wanted the skeleton as part of an exhibit on comparative animal anatomies, so that the public could see and marvel at the similarities and differences in anatomy between the elephant, a mouse, a deer.[1] The exhibition was shown around the country and made no money. He eventually sold the skeleton at a loss. He was also associated with the Manchester Zoological Gardens, which displayed animals in relatively humane fashion, as compared to menageries like the Exeter Exchange and Tower of London. That too went broke, when the people of Manchester voted with their feet for a pleasure garden with some animals in it, down the road with one third of the price of entry.[2] The third of Walter Horton Bentley's great endeavours was his friendship and mentoring of John James Audubon, who had come to England with talent and a vision, looking for backing for his elephant folio of bird prints.[3] (See Appendix 2 for more on Walter Horton Bentley, a truly remarkable man.)

Walter's father, John Taylor Woodbury, was a member of the Early Closing Movement. (See Appendix 4.) Hours of work were not regulated, a condition that became more dire with the invention of gas lighting. With streets illuminated and much safer than they had been, people were out and about so shops stayed open longer, with some poor clerks not shutting up until 11 p.m. Factories increased their hours and boarded up the few windows they had so the millworkers would not notice the daylight passing. The Early Closing Movement advocated shorter hours (10 or 12 to a shift!) and Sundays off. Their naïve vision was that the workers would use the time for recreation and self-improvement. It was a lofty goal and not unlike the goals of Woodbury's grandfather. It's well to remember that the 1840s were known as "The Hungry Forties" with several years of failed crops hastening agricultural labourers into factories, and the Irish Famine of 1845–47 also provided a steady stream of desperate people ready to work in any conditions. Unfortunately, effective legislation on working

hours was not passed until 1912, but the Early Closing Movement fought the good fight.[4]

The young Walter Bentley Woodbury learned two key concepts from these men: the importance of having a passion that had little to do with business, from both his father and grandfather; and the power of the visual image from his grandfather.

The men of the family were allowed to follow their passions because the women of the family ran the businesses and financed their men. It was not only Ellen who was a successful businesswoman. Her sister, Elizabeth Bentley Whitworth, also ran a business: a grocery, which in Victorian times meant buying things by the gross and breaking up the large lots to small ones to sell at a storefront location. Elizabeth made enough as a grocer to support her three children when she was widowed by the untimely death of her husband and to support various family members who had nowhere else to go, such as Walter's little sister, Ellen, the widow and daughter of his brother, Henry James,, and Elizabeth's niece, Anne Green. The Bentley women were a force to be reckoned with.

Walter Horton Bentley died of apoplexy on October 5, 1848 at the age of 67.[5] "Apoplexy" is the Victorian term for a cerebral hemorrhage or a stroke. His death would have been sudden and devastating to young Walter Bentley Woodbury, who was fourteen at the time. His mother had remarried when Walter was 10, and had two babies, but second husband, James Lea, also only lived to 36 and died in 1850 before he even saw his second child, Emily. Walter was quickly put into an apprenticeship following his grandfather's death. But he was indulged by his mother, who was used to the men in the family being somewhat impractical.

Like his father and grandfather, Walter's young life was full of enthusiasms. Financial stability and love of learning show in Walter's delight in dazzling his young friends with his camera obscura, a device that projects an image on the other side of a wall or partition, upside down. Walter constructed this device himself when he was 12.[6] He later recalled that

> My greatest pride… was to take my boyish companions to the garret at the top of the house, here I had, by means of an old magnifying mirror, from which I had removed the mercury backing, and a sheet of looking glass, been able to throw a two-foot image on to a small table beneath. The foreground of the picture consisted mainly of chimney pots and roofs, but above these was a more extensive view, embracing the tower of the old Cathedral of Manchester, "Th'owd Church" as it was generally designated. To be able to show the time on the sheet of paper below without going on the roof where the best sight could not have distinguished the fingers of the clock, was my grand tour de force. The idea that such a picture could be fixed was too wild even to be dreamt of in my young philosophy.[7]

That he had the leisure to experiment with the camera obscura, and actually constructed it himself, indicated he was not required to work in the family shoe business. The family had means to afford the lenses and other components. He also had the expertise to remove the mercury backing from the mirror (I hope he wore protective clothing while he did so.)

There is no record of Walter being sent to the Manchester Grammar School, which provided a classical-based education. He may have been sent to the Manchester Technical School, now a part of the University of Manchester. Or he may have been tutored by Walter Horton Bentley, who is listed in the 1841 Directory as "schoolmaster." A Bentley uncle ran a school on the Isle of Man so Walter may have attended there for a while. There is no record of Walter B. working in the shoe factory, even in a clerical position.

Walter Bentley Woodbury began his apprenticeship with a civil engineering firm cum patent office in 1848 and found a new fascination. Frederick Scott Archer's book on the collodion process of photography was published and Walter was hooked. Walter B. was always more interested in engineering and photography rather than natural science—or running a shoe factory. Later, Walter notes:

> All the pocket money and tips that I could command were hardly enough to keep pace with the amount of pyro, silver etc. that I required, owing to the fascination that the novelty had for me. (He made a camera himself) out of stout millboard, bound together at the joints with strong black tape, the dark slide being composed of a similar material varnished. What the lens was like I scarcely remember. I must have taken a hundred little positives.

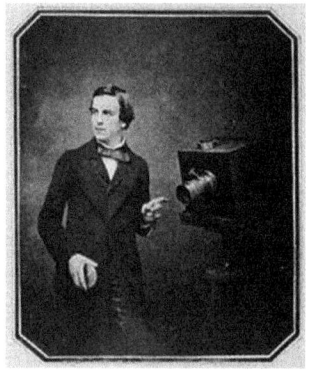

Walter, approximately 18 years old, circa 1852 (Courtesy Public domain, via Wikimedia Commons)

Again, this points to there being money in the family. That Walter had "pocket money and tips" indicates that his wages were not going into family funds, and someone (possibly Grandfather Walter's legacy) must have paid for Walter's apprenticeship.

In 1852, Walter was in his fourth year of five as an apprentice in the office of a civil engineer as a draughtsman, which would have been complementary to his photographic bent, had not another enthusiasm intervened. As Walter tells it:

> At this time a rival, a very powerful one, turned up in the form of gold fever, (Australian), which seduced, beside myself, so many thousands of people away from comfortable homes and situations. I had already served four out of five years of my apprenticeship to a civil engineer and had it (the gold fever) so bad that I begged off the remainder of the term. I should, I fear, have taken "French Leave" had my request not been granted. My old love, my idol (photography) was shattered and forgotten. Cradles, tents, picks, spades and revolvers put camera and collodion entirely on one side. I was off to Australia with all the requisites to make my fortune in a few months, and what is more, I truly believed I was going to do it.[8]

Walter convinced his mother Ellen to pay for his ticket and she did, allowing him (as his father and grandfather before him) to follow his enthusiasm while the family shoe business footed the costs. Perhaps this was the natural order of things in the Woodbury/Bentley enclave. It didn't seem to occur to Walter, as the eldest son, to stay home and help his twice-widowed mother who was raising seven fatherless children while running the family factory.

This was not because of family friction: Walter wrote letter after letter to his mum, signing them "your affectionate son" (letters that she kept and were transcribed by Australian Woodbury scholar Alan Elliott). The normal family procedure was that Bentley/Woodbury men went off and have adventures while the women kept the homes and businesses running and raised the next generation of dreamers.

In preparing for his enterprise, Walter entered into a syndicate with three drapers, Henry Lawton, thirty, James Taylor and David Barber, both twenty-two. (Walter's mum paid for his entry into the syndicate and gave him some money to get established, too.) They equipped themselves with spades and tents and took passage on the *Serampore*, bound for adventure and fortune. They hadn't got a clue about what awaited them.

The fourth of the syndicate was 18-year-old Walter, off to make his fortune in the goldfields, a product of a middle-class upbringing that had allowed him a respected mentor, a practical education, financial security, and loving relationships. He also had a second-class cabin because his mum bought him the ticket, while the others were in steerage. What happened in Australia would have been a bit of a shock. After all, Walter Bentley Woodbury was an indulged son of a prosperous middle-class Manchester family and had probably never done a day's physical work in his life.

To sum up: Walter grew up in a manufacturing family of some repute, which had a history of valuing ideas and actually being willing and able to spend money to follow their enthusiasms (or at least the men's). They were financially stable enough to spend substantial sums on their passions.

The women in the family seemed to have more business acumen than the men—and more physical staying power. The women's industry provided the money that allowed their menfolk to pursue whatever was their intellectual enthusiasm of the moment. Walter was a true child of his family: he followed his enthusiasm to Australia, funded by his mother. Like his grandfather, and perhaps his father whom we know little about, who tried to change the way people thought about nature or working conditions, Walter was off to make his mark on the world. He did, but not in the way he intended when he was 18.

AUSTRALIA

Like most people who rush for gold, Walter Bentley Woodbury found the experience to be both a sharp learning curve and a serious disappointment. In virtually every gold rush, the claims were almost all staked and being worked long before the "rushers" arrived in California or British Columbia's Cariboo, slogged over the Chilkoot Pass to the Yukon's Klondike, or docked in Australia. Walter's experience was no different. He spent three months aboard the *Sermapore* getting to Australia, only to find that all those picks and spades and pans he brought with him were worse than useless.

The gold rush seems to have been a 19th-century phenomenon because there were rushes for the entire century to places like California, Australia, South Africa, and the Klondike in Northern Canada. I am trying to understand the psychology of the rush—or maybe it's the rush of the rush because, like Walter, I'm sure that most rushers were fuelled by optimism rather than desperation, although desperation would have been a component for many. The average working-class person faced a life of drudgery: long hours, low pay, few prospects to improve his/her lot or the lot of his/her children.

This is also the century of emigration from the settled countries of Europe. That leap of faith was what brought my Morgan ancestors from the comfortable village of Thornbury in Gloucestershire to the bleak and forbidding Prairies of Saskatchewan in 1881. There, they lived in a sod house until they could break their land and grow a crop

to qualify to own the land. Unlike the majority of gold rushers, they prospered and thrived, despite heat, drought and minus 30°C winters, the four Morgan sons each claiming and farming a section of land (one square mile), building a life for themselves, and eventually marrying two of Hermance Woodbury's daughters, Walter's granddaughters. But that was, in effect, a land rush, not a gold rush.

Let me give you some background on the Australian Gold Rush, because before I began this research, I wasn't even aware that Australia had had a gold rush. I live in British Columbia, Canada, and this province's history was shaped by the Fraser River Gold Rush and later Cariboo Gold Rush. British Columbia abruptly became a Crown Colony because of the fear of an influx of American "rushers" in the Fraser River Gold Rush of 1858.

The population of the colony of Vancouver Island, particularly Fort Victoria, went from 500 (mostly employees of the Hudson's Bay Company and their families) to 20,000 in a year, many of them Americans coming from the California gold fields as the Rush of 1849 petered out. Fort Victoria quickly ceased to become a trading post exporting fur and barrels of salted salmon, and became a tent city, just like Melbourne four years earlier. As with the Australian Gold Rush, there was lawlessness, problems with the Indigenous people and the "fast-forward" creation of cities, infrastructure, governmental structure, and trade.

Australia's history was shaped by its gold rush too. Australia began as British colony/penal colony soon after its discovery in 1788. By the 1840s, the population was significantly made up of transported convicts. Gold was discovered in trace amounts, but Governor Gripp supressed the findings, saying "They'll (the convicts, I presume) cut our throats." So, there was officially "no gold" in Australia.[9] Then the 1848 California Gold Rush began and so many free men left Australia that there was a significant shortage of labour. The government did a 180-degree turn on its previous position and offered a prize for anyone who could find gold in quantities worthy of mining.

In 1851, the $10,000 prize went to Edward Hargreaves, whom Robert Hughes, author of *The Fatal Shore*, describes as "a corpulent bull calf of a man"[10] who had failed as a Forty-Niner in the California rush

but learned and brought back the techniques the American miners used, such as panning and sluicing. The word was out and the gold rush began.

In 1851, Victoria had just become a state, separated from New South Wales. It had formerly been called Port Phillip, and its main product was wool. Melbourne was a smallish town and there were only 77,000 people in the entire state. The gold rush changed all that. At first, gold had been discovered in New South Wales and men flooded out of Victoria. The Victorian Government retaliated by offering a £200 prize for gold discovered within 200 miles of Melbourne. Their strategy worked, as gold was discovered in Clunes, then Castlemaine, Ballarat, and Bendigo. The New South Wales sites petered out and the men returned to Victoria. And others followed. Within 10 years, the population doubled, and in 20 years, between 1851 and 1871, the Australian population quadrupled, from 430,000 to 1.7 million as gold seekers flooded in from Britain, China, North America, and Europe.

Newspapers circulated stories of the fabulous wealth to be had: miners filling horse troughs with champagne, lighting pipes with £5 notes, and generally disturbing the established society of landowners and convicts.[11] News of the squalid conditions created by the huge influx of men, did not. Hughes again:

> By then (1852) Melbourne was both a ghost-port and a continuous saturnalia. Port Phillip had become a Sargasso Sea of dead ships, rocking gently at anchor through a hundred tides and then a hundred more, bilges unpumped, their masts a bare forest… In the grog shops and hotels that lined the filthy, traffic jammed streets of the young city, where a man could sink up to his knees in mud and ordure merely by stepping off the curb, a round-the-clock orgy was conducted by… the diggers and their hangers on… drinking the gold away.[12]

I'm not sure Walter's mum would have bought him a ticket to that had she known.

Australia did not give up its gold easily. Although there were fabulous finds like the Kerr Nugget, which was said to weigh a 100 pounds,

the surface gold was quickly exhausted. Soon gold mining involved "deep-lead" mines, which could not be operated by one man. These mines took months, sometimes, to produce gold and went deep into the ground. This was not mining by panning with minimal equipment; it took partnership and sometimes syndication to produce gold.

Some historians speculate that the Australian concept of "mateship" began with the diggers in these difficult conditions. Still, there were enough great finds to keep people coming, and in the decade of the gold rush, Australia produced one-third of the world's gold. Of the 30 largest gold nuggets ever found, 23 came from Australia, the largest yeilding 290 kilogram of gold.

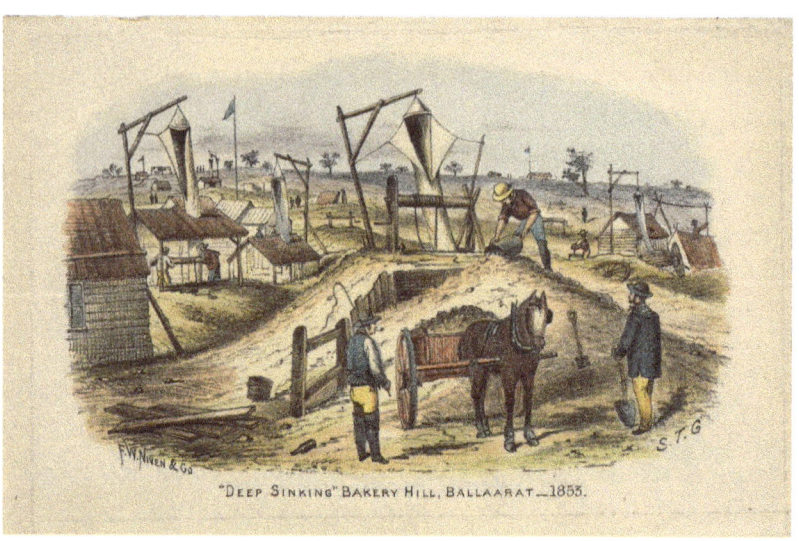

"Deep Sinking" Bakery Hill, Ballaarat 1853, by S.T. Gill
(Courtesy National Museum of Australia)

Of course, 99.999 per cent of the miners never found anything like the Kerr Nugget. Living conditions were rough, whether you were at the diggings or in Melbourne, a city not equipped to handle the huge influx of diggers and would-be diggers from all corners of the globe.

Walter arrived in this fetid, overcrowded colony. What did a nicely brought up middle-class English lad do when thrown into the rough and tumble of colonial Australian life? This lad lost his middle-class

sensibilities about hard physical labour and he coped without losing his moral values or his sense of humour—or his love of photography.

Walter shipped out of England on the *Serampore*, under the command of Captain Hope Smith. The 87- ton vessel carried 182 adults, 19 children, and five infants as passengers and made the voyage in a brisk 96 days, leaving Liverpool on July 5, 1852, and arriving in Melbourne on October 13 of the same year. Walter's mother had booked him into a second- or intermediate-class cabin so his accommodation was not too dire. The rest of his syndicate of friends were in third class, which was much less comfortable, but middle-class Walter got the middle-class cabin, even though it took him a bit of time to realize that he was favoured as he tells us in a letter to brother Henry James.

> "I did not much like the look of it at first, as the room (if I may so call it) in which we were to sleep was only about 8 feet square and 6 of us to sleep there. The bunks as the beds are called took up nearly all the room so that when we went to bed we had to go in the one at once, but luckily for us there was one of the bunks unoccupied, so we had a place to put our things which was very convenient." Walter notes the food is not too bad either: "junk (beef) rice and plum dough and twice a week, Pork, biscuit and Pea soup, 3 times and preserved meat, potatoes and plum dough on the other days."[13]

"Plum dough" had nothing to do with fruit; the word "plum" meant "risen" or "plumped." It was a vast improvement on hardtack biscuits and its relative is the plum duff Christmas pudding, as the Victorians pronounced this "dough" to rhyme with "rough," "tough," or "cough."

Eventually the *Serampore* entered Melbourne harbour. And that's when Walter was in for a reality check. A big reality check…

A ROUGH START

There were no hotel rooms available when Walter and his shipmates got to Melbourne. The city had had two years since the first onslaught

of gold seekers and had learned to cope, but not enough to accommodate the continuing influx of optimists. Walter and the syndicate camped in Canvas Town and paid dearly for the privilege. Well, 33,000 gold-seekers arrived in 1852, and Walter was only one among them. He found himself in a boomtown with horrendous inflation, offering little or no chance of digging up a fortune.

Disheartened, the syndicate quickly disbanded. Australian Woodbury historian Alan Elliott tells us: "Goldfield life was masculine, rough tough and unhealthy with 'colonial fever' and accidents common. For many, luck was the master of success and hard work and weather tested the new diggers; alcohol brought its own problems. Many like Woodbury's shipmate Royle, unsuccessful at prospecting, returned to depression-laden Melbourne and took on the most menial positions for survival. Woodbury's original partners broke their agreement and returned to their old trade as drapers."[14] Walter did not have a trade to return to: he broke his apprenticeship articles. He did have a family, though.

Canvas Town South Melbourne 1854, by S.T. Gill
(Courtesy National Museum of Australia)

Walter wrote faithfully to his mother, Ellen, although his letters to his brother, Henry, were a little less carefully worded. To both, he confessed that he didn't even bother to go up to the diggings as "not one in a hundred being able to make as much as would pay for their food" and that he was "obliged to pick up whatever (he) could get." To his mother, he wrote:

> I engaged with a man to drive a team of horses to the diggings with 3 pounds a week and my food. As you may guess I found this rather hard work I had to sleep under a cart at night on the hard ground with a sack of oats for a pillow and to walk about 20 or so miles a day. We made 2 trips to the diggings in the time I was with him which was three weeks so I earned 9 pounds in a short time. Then I took a cook's place at an inn.[15]

That's the sanitized-for-mum version. Here's what he wrote in the usual letter cross-written to maximize space, to his brother Henry in a letter dated October 6, 1853:

> [A] carrier of goods to the diggings… engaged me to drive his 5 horses at the rate of 3 pounds a week and rations; of course, I made but a sorry driver to begin with, as I knew about as much how to harness a horse as a camel, but however I soon got the way of it. Every morning I had to be up by sunrise and go sometimes two or three miles to find the horses and harness them after which I had to make a fire and put on the water for breakfast, then when it boiled put in a handful of coffee and sugar and fry some beefsteaks or mutton chops. Then we would set to with a piece of steak on top of damper [Australian soda bread] and cut it with a sheath knife which I carried in my belt sailor fashion. After breakfast, we would get the horses to and at dark, after going 10 or 12 miles we would camp and get dinner and after feeding the horses we would make another start, go about the same distance and camp for the night, after spreading the tarpaulin over the dray to sleep under. This was the worst part of it, this sleeping under the dray as the tarpaulin only covered the sides and the wind and rain used to come through the ends so that all the while I was on the roads I do not think I got above 2 or 3 hours every night. I found this rather hard though I determined to stick to it and so I should have done if (on the second trip to the diggings) I had not been laid up with boils on my feet so that I could not walk, however he (the carter) did not seem disposed to stay behind and let me recover a little or let me get on the dray so that walk I must whether I could or not, but as last I got so bad that I could not go on and lay down on the grass to rest, he however took no notice of me but went on with the dray and I tried to follow but was not able. So I managed after resting some time, to get to a public house (Here was I 30 miles from Melbourne with 4s in my pocket, just enough to pay for a night's lodging.) I

> then went to the master of the place and asked him if he could give me anything to do, he said that his cook had left him but he had written to Melbourne for one who would not be up for a week but if I liked he would engage me for a week at 30s till the other cook came up. I made bread in the camp oven, baked and boiled meat, washed up and swept the kitchen with all the other work as a servant. Of course, this took down my pride a little as I often thought what would all you think if you had seen me with my sleeves tucked up washing a pile of plates and dishes.[16]

So, here was our indulgently reared boy from Manchester coping with the realities of fending for himself in a much rougher world than he was used to. And there was no way out: Walter had convinced his mum to buy him a one-way ticket, perhaps purchased with the bravado of youth or the naïve assumption that he'd be able to buy a first-class passage back in no time, once he's dug up all that gold.

He was halfway around the world and his social class, education, and skills were irrelevant. I think that it's remarkable that an 18-year-old could view the carter's unkind treatment of his willing but inept assistant without rancour. It was just something that happened. There's a nice trace of self-deprecating humour in Walter's picture of himself as laughable as chief cook and bottle washer at the inn. In one of his letters to Ellen dated November 21, 1852, he concluded (although he hadn't been in the colony long) that "No one must come out here without being able to work, they must work or they will never get on. Many of our passengers are working on the roads and getting 10s a day. A man need never be ashamed of his work here as one man is as good as another."[17]

Cross Written Letter Number Seven
(Courtesy the National Library of Australia)

The rough-hewn egalitarianism of Australia had brushed off on Walter, but, lest I paint Walter as some kind of enlightened modern in Victorian clothing, here's his description of Australian Aborigines. He was not above being a judgmental Victorian. In a letter from Buninyong dated June 20, 1853, he wrote:

> We have had a tribe of the native Blacks camped near us for the last week so that we have an excellent opportunity of seeing how they live. They are a very lazy set of people and you cannot possibly get then to do any work for you even if you offer them money; they are too lazy to build a hut to live in but construct what they call miamias, consisting of two forked sticks placed in the ground with one stick running across the top of them, they then rest large pieces of bark or branches of trees on these which gives them a shelter from the wind. They lie all around their fires at night and all the covering they wear is a possum rug or a blanket thrown around them. Their principal food is the opossum which they find out by knocking on the trees and where they find a hollow sound they cut open the tree and so catch the opossum. They also kill turkeys, pigeons and parrots with the boomerang which they are very expert at throwing. When they are very hungry and can get nothing else they will pick up the spiders, beetles, cockroaches and ants and eat them. The men are called coolies and the women lubras, a wife or mother they call a gin and a child picaninny.[18]

Ouch! "Lazy," "coolie," "picaninny." Although much of this account was dispassionate scientific description, words indicating a thoughtlessly racist attitude crept in. "Lubra" is a derogatory term for an Aboriginal woman and "gin" implies sexual exploitation.[19] Probably I missed the reference because I associate gin with hot summer days and chilled tonic water, rather than with the oppression and suffering this meaning entailed.

Walter was a product of his own time, albeit a fairly open-minded product. But those words reflected the attitudes ingrained by society. That entrenched attitude later prompted Ellen Woodbury Ferguson's

assessment of Walter's family. She too was a product of her own time. Alan Elliott, who had written much about Walter's time in Australia and was Australian himself, pointed out that the Australian Aborigines were not "lazy." Their culture did not include such Western entities as day labour, money, and road building.

Back to Walter's story: Walter, undeterred by his rough treatment by the carter, returned to Melbourne with not much money in his pockets. But he noted the following:

> Not being encouraged to try my fortune at the diggings..., and after some months trying to get some congenial position, I found my little means almost exhausted, being reduced to about 6 pounds, besides being thousands of miles from home. But just at that time, of all extraordinary things, what should I see in an old store shop but a camera and lens for sale. My old love returned at the sight of it; it had evidently never left me, and I recklessly, never thinking of the question, 'What will he do with it?' went in and spent two-thirds of my last remaining worldly wealth on its purchase.[20]

A BIG BREAK

That purchase was fateful. It was also emblematic of Walter's life. He had little money, he was 17,000 km from home, and he spent two-thirds of his capital on an unusable camera—because of the idea of it. Although Walter did not use the camera immediately (it required chemical supplies he could not afford) its possession became his fall-back position.

First, however, he would have two significant periods of decent employment. After the debacle with the carter, Walter was employed by William Tenant Dawson as a member of a survey team, albeit a rather lowly member. He was one of two chains-men, which meant he carried the chain and pegs, cleared the bush away and did the physical work of laying out the town's boundaries or road's path.

Of his work with the drayman, Walter said that he would have stuck to the job and only his blistered feet prevented that. He stuck to his surveying job. He described Mr. Dawson as "gentlemanly" and while the crew were encamped near Melbourne, Walter used his wages to pay for chemicals to play with the camera. In doing so, he took some of the first collodion pictures ever taken in Australia." I can at last manage to take a good likeness… Now I never have a failure," he writes happily to his mother in the letter of January 1853.[21] Walter even instructed his boss in taking photographs.

This photograph, most likely taken by Walter, shows Dawson and his crew. So, not only was Walter the photogapher of the first panorama taken in Australia, he also took the first shot of a surveyors' camp. The photograph was sent to me by Australian historian and expert on Woodbury's Australian life, Alan Elliott, ARPS.

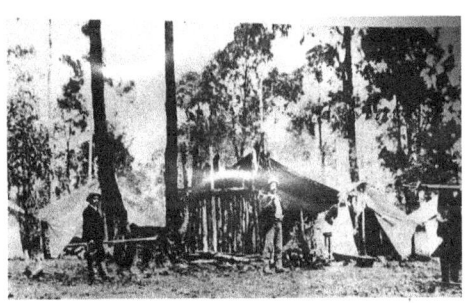

Surveyors' camp, Buninyong, 1853. The gentleman in the white hat in the centre is Dawson. (Courtesy the collection of Alan Elliott)

The surveying job was rough work compared with the brain work Walter was used to. He really was "working dirty" as opposed to "working clean." Walter gave us an account of his daily work:

> The flagman is first sent out in a straight line as far as we can see him and when Mr. Dawson has set him in line, we have to chain up to him, my partner putting an arrow (a piece of iron rod turned to a ring at one end and pointed at the other) into the ground at every chain (22 yds.) which I come up to and after setting him in a straight line again take the arrow and go on again until we come to the flag when we have a fresh sight. We are running a line of 2 or 3 miles in length, whatever happens to be in the way we have to go through it up to the knees in water very often.[22]

The work could be dangerous. At one point near Buninyong, Walter was washed off his feet by the current of a river, rescued by his co-workers, and Mr. Dawson made him drink a brandy in the local pub for medicinal purposes, despite Walter's protests that he was teetotal.

Walter dressed like a colonial—"moleskin trousers, red woolen Frock, leather belt with a sheath knife and broad green straw hat with a green veil tied round it to prevent the dust getting into the eyes."[23] And dust was not the only problem.

> I dread the thought of hot winds, musquitos, and flies and other annoyances of the Summer season. As we were out the other day marking trees we came across a large black snake that had come out of his hole to bask... One of us had nearly trod on him but just happened to catch a glimpse of him before he took a step which would have proved fatal to him. The snakes are not the only venomous things that we have to fear but also Scorpions, Centipedes and the Tarantula, a spider about as large as a pigeon's egg in the body with legs in proportion. [Not all dangers were creepy-crawlies...] I mentioned in a former letter that drink was the ruling vice of this colony, as a good example we have already 5 public houses in Buninyong although taking the whole township together there are not above 20 houses in it.[24]

Walter stayed with the surveying work until the job finished and he found himself again looking for employment, although this time he had some money in his pockets. He had also become a valued member of a team, as well as physically tough, self-reliant, and resilient.

Walter was once again at loose ends, but he was not the disillusioned, naïve, lonely and desperate young man of a year ago. He still missed his family, and asked for letters which he said were like "angels' visits." He calculated the dates the ships from England arrived and hoped for mail, at one point getting so anxious that he advertised to see if any has gone missing. As he became more settled and successful, he asked repeatedly for his younger brother, Henry James, to come out and join him, although this did not happen until Walter was settled successfully in Java.

His mother may have been more adept at reading between the lines of his letters than Walter suspected and she did not allow Henry James, who was two years younger, to travel out, especially as Walter appealed for Henry James' presence in a letter in which he noted people were dying of starvation in Melbourne, he'd met a shipmate reduced to homelessness and he has taken photographs of the notorious Lola Montez. Walter sent photos (not of Lola!) to his mother, his sister Lucy, and his little sister, Emily, and signed his letters to his mother, Ellen, with "Your affectionate son." He sent money so that Ellen could get pictures of the family taken and send them to him.

Walter also noted that "during all the vicissitude, even in the bullock cart, which for me was my only home, my old love, my camera, accompanied me; and I often regretted when surveying some of the untrodden wild spots which we had to go through, that I had not the chemicals and necessaries."[25]

Now Walter had a second bit of luck. When the surveying work with Dawson lost its romance, Walter got a job with the Sewer and Water Commission in Melbourne—no more beds made out of flour sacks and sticks for him.[26] The interviewer asked if he could see some of Walter's drawings, so Walter went back to Dawson and returned with a glowing reference then created drawings that impressed the Commission. The job was his and with it, the stability and stimulation of living in an urban environment. He was respected by colleagues and employer, getting a living wage and doing the job he was trained for. The Commission's project was the construction of the Yarra Reservoir.

The work was not taxing, and soon Walter took up photography again: "in my new position, I was able to obtain (chemicals etc.) and what was better, had plenty of spare time—all the day outside 10 am. and 4 pm. so that I had plenty of time to devote to my old pastime; in fact, longed for the hour of four to strike so that I could resume my morning's work."[27] That work was the taking of an eight-part panorama of the young city. It's the first panorama taken in Australia and survives in the National Museum. This is one-quarter of it, of Astley's Amphitheatre. Walter was also recording the stages of construction of a large building opposite his lodgings, which was intended to house

the 1854 Exhibition. The Exhibition Committee was so impressed by Walter's work that they had him take a photograph of the completed building and sent it to London to be the template of the design for the commemorative medal—and Walter won one of those medals. He entered nine views of Melbourne in the collodion process on glass. (Collodion was the wet-plate process by which an image was recorded on a glass plate coated with gun cotton dissolved in ether or alcohol, then sensitized in a bath of silver nitrate before exposure. The wet negative needed to be washed clean—and all of this done in the dark in approximately 15 minutes.)

Two of the eight photographs of *Panorama of Melbourne*
(Courtesy Royal Photographic Society, Victoria)

This medal was the first public approbation of Walter's work as a photographer; he cherished the medal.

> From that day, I ceased to be an Amateur Photographer! I have while I write (having just referred to it for the date) the relief view of the Exhibition in the form of the medal awarded to me for a series of collodion views (taken of the principal buildings of Melbourne) in the year 1854, while I was still an amateur, and this I shall always value more than all others I have since attained, even the Grand Gold Medal of Moscow.[28]

Unfortunately, the work at the Water Commission ran out. The planning stages of the reservoir were finished and Walter was again out of work, this time in a recession. No, it was more like a depression as he told his mum that "thousands were out of work and many dying of starvation."²⁹ Rather than starve looking for a nonexistent job, Walter decided to create his own by setting up as a photographer. He had the camera, the chemicals, and the medal to prove his credentials.

1854 Exhibition Medal designed by Walter and won by Walter (Courtesy Royal Photographic Society, Victoria)

Ever the optimist, Walter and a fellow Mancunian named Spencer, who needed a bit of teaching in the subject, took a horse and dray and set out for the diggings. They thought there were too many photographers in Melbourne, but their opportunity did not come in the town of Kyneton. Even though Walter had his medal displayed in a showcase to woo prospective customers, the £100 a month he had anticipated did not materialize. When the investment money was gone, Walter and Spencer parted ways and Walter returned, somewhat chastened, to Melbourne.

I write "somewhat chastened," because Walter hadn't given up on being a photographer. He borrowed money from a bank, set up photographic rooms in North Melbourne and had 100 advertising leaflets printed. He celebrated his 21st birthday alone because he could not afford to pay for the celebration. And the situation did not improve. The rooms he had rented were too far from the center of the city and eventually, once he had photographed all the sitters in the neighbourhood, he had to accept a job offer.

Perez Mann Batchelder, an established photographer who had learned his trade in the American gold fields, then moved to Australia, offered Walter £4 a week because, as Walter wrote to his mother that Batchelder "had come to the conclusion that I was the best glass artist in Melbourne."³⁰ Walter even managed to photograph Lola Montez,

although Walter did not tell his mother that Lola was as famous for her many lovers (Franz Liszt, Alexander Dumas, King Ludwig of Bavaria and others) as she was for her theatrical career and scandalous "spider dance."[31] Walter kept a picture of Lola for himself.

Walter tried to keep the studio running in North Melbourne with his income from working for Batchelder but admitted that business flagged and that the studio was too out of the way to attract non-local customers. After two months of not meeting expenses, Walter made a decision to give up the studio and move on his own into Melbourne proper. He knew his own worth: "My likenesses are considered to be much superior to most… I shall soon get the best trade."[32] By August of that year in Letter 14, Walter admits, "If I had had capital, I might have gotten on well as I think that my productions, at the present time, are equal to any in the Colony."[33] For a time, Walter worked with Batchelder, but in 1854, Batchelder's brothers Freeman, Benjamin, and Nathaniel joined him, and Walter was probably not needed in the studio. So, his next move was out of Melbourne to the Ovens Goldfields.

The famous/notorious Lola Montez (Courtesy Wikipedia, Original in the Metropolitan Museum of Art, NY)

A BIG DECISION

Walter and Davies, his assistant from the small studio in the suburbs, walked 200 miles to the Ovens Goldfields. It took them 14 days. Three days later, they were in business in a hotel that boasted a skylight. Two days after that, a new photographer arrived in town. Walter took it hard:

> We had not been up 2 days before another party in the same business arrived and started in the same place, but whenever one person goes another is sure to come. Business there might

be enough for one person but not for two, which is rather annoying to come 200 miles for. I also find that the Winter which was just coming on was the very worse time of the year, another thing I found out was that if I had been up 6 months previously, I might have made a pile as the Woolshed, 6 miles from Beechworth where I write this was in its height as it has been one of the richest Gold fields in the Colony, but I think I was born to be unlucky.[34]

Here's the nub of it: Walter knew he had a superior talent, but he was baffled by the business side of things. He tried to be businesslike, asking his mother to buy supplies for him in England because things cost three times as much in Australia, but the list for London merchants never materialized. He mentioned it, but supplies neither the particulars of the order, the financing, nor the means of sending the goods to Australia.

By now, he had asked three times for his younger brother, Henry James, to come out, but Ellen, wisely, still didn't send him. (Notice, though, that however desperately poor Walter was, he never asked his mother for money for a passage home.) His own enterprises failed repeatedly from wrong placement or competition or the wrong partner. Perhaps this was the first bat-squeak of the future where Walter, "The Edison of Photography," died so impoverished that a collection had to be taken for his funeral.

But Walter was seldom depressed for long. He was proud of his Woolshed house he had built himself "without the aid of a single person, it contains three rooms. A nice little sitting room at the front, the operating room in the middle and a bedroom with a fireplace at the back, it is really speaking a tent, but all the walls are lined with thick carpet and a flat ceiling so that it is as comfortable as a house. In the sitting room the walls are covered with Damask which looks very nice it also contains a sofa a mahogany table and 4 chairs with a round table with the portraits and cases on, also a large looking glass."[35] He speculated that he could sell it for £60. So here was Walter, turning his hand this time to carpentry and invention/improvement of existing structures, something he did all his life long.

And sell his little tent-house he did, for in the same letter, he confessed that he was going to leave Australia altogether. He hadn't found Gold (he usually capitalized it in his writing) but he was unwilling to come home with £100 to his name, which was what he worked out his assets to be. He and a friend who had £200 in capital would "make a complete tour of all the principal South Sea islands, which will perhaps occupy us for 2 or 3 years, then we intend to sail for Valparaiso in Chili [sic], South America where we shall probably settle down to make our homes."[36]

Woodbury's portrait rooms, fitted-out tent, Ovens Gold Fields (Courtesy Wikipedia Free Commons and National Media Museum)

Of course, things didn't go according to this plan.

So, to sum up Walter in Australia: he landed, a naïve, rather indulged 18-year-old who had never done a day's physical labour, who was ill-prepared for the rough-and-tumble of life in the Colony. After a few false starts and one truly impulsive purchase, never losing his optimism or sense of humour, he got two good jobs. Surveying on Dawson's gang taught him about teamwork, self reliance, and hard physical labour. The Water Commission work taught him about using his education and allowed him the time and resources to pursue—and be recognized for—his photography.

The Exhibition Medal changed his mindset from amateur to professional photographer. But when he tried to set up as a photographer on his own, he failed. Competition, poor decisions, and lack of capital doomed his efforts. Yet apart from a few moments of despair, Walter came up with still another plan for a bright future. He was not afraid of physical work and took pride in his accomplishments whether they were excellent portraits or a comfortably fitted tent. But his plans were

impractical. About all he knew about Valparaiso was that it was in an earthquake zone. He didn't even speak Spanish.

He was still a naïve dreamer.

JAVA

WALTER STRIKES GOLD OF ANOTHER KIND

Walter's plan to sail the South Seas and make a home in Valparaiso never worked out; somewhere it morphed into another plan to visit Java, the Philippines, China, and India. Perhaps these sites were chosen by his new partner, James Page, who seemed to have brought most of the capital while Walter brought expertise to the partnership. This plan didn't work out either… But Walter did leave Australia, setting sail for Java, armed with photographic supplies and a more compatible partner with whom he would work for years. Perhaps less impetuous than the decisions to go to Australia and to purchase the camera, nevertheless, this too was a life-changing move.

For the next six years, James Page featured largely in Walter's life, but who was he? Arthur Rowbottom, who was introduced to Walter by a mutual business acquaintance and became both his friend and financial advisor for a time, wrote about the relationship in his book *Travels in Search of New Trade Products* published in 1893, eight years after Walter's death. He claimed Walter and Page knew each other on the *Serampore* and that they chummed around in Australia.

> At first Mr. Page, who had taken with him his photographic apparatus, was intent on exercising the photographic profession as a means of livelihood on his arrival in the colony, but both

> he and Woodbury were seized by the gold-fever that prevailed, and before they landed, they had resolved upon going together to the goldfields to try their luck. They were not very successful miners, however, little or no gold coming in their way, and it was not long before they came to the conclusion that it was possible to find a more profitable employment for their abilities, so they left the gold mining to take care of itself and started a store in the neighbourhood of the mines. But even this venture was not attended by success, and they ultimately decided to sell out their stock, and return to Melbourne. What they would do on reaching Melbourne was hardly known to themselves. They were sorely disappointed with their experience up to that point, and Australia did not seem to them the El Dorado that they had imagined.[37]

From Walter's own letters home, preserved by the Royal Photographic Society and now in the Victoria & Albert Museum, we know this was not the case. The partner in the Ovens Goldfield adventure was Davies, and before that, Spencer. Walter never did go to the gold diggings as a miner or open a store. Of course, Rowbottom was writing from memory some 40 years after the events and, as with all of us, sometimes memory may play tricks. We know the memory of family history writer, Ellen Woodbury Ferguson, did too, as she listed Page as a dentist and had them in the California gold fields. Where Rowbottom *was* reliable was in his account of the business dealings with the pair. But more of that later.

We do know that Walter and James Page shipped on the *Young America*, considered to be one of the most beautiful clippers of her day, which would have appealed to Walter's artistic side. The ship had carried Chinese miners to Melbourne and was virtually empty going back north. (By 1860, one adult male in five in Victoria was Chinese. This played out in the Lambing Flats Riots in 1860 in which Caucasian miners attacked the Chinese miners repeatedly over a period of 10 months. People died although the Government used troops to keep the peace; it eventually responded by restricting the immigration of

non-whites, a foreshadowing of the "White Australia" policy. (This seems a strangely 19th-century solution, as the Chinese miners seem to be the ones being attacked.) [38]

The *Young America* in full sail (Courtesy Royal Photographic Society, Victoria)

Walter and James Page were the only two passengers on the voyage north. They were pampered with fresh bread and eggs in first class and got to know the captain David S. Babcock and his family well. Rowbottom notes that Walter and Page were given passage at very little cost, being written into the ships books as crew members. Perhaps as a quid pro quo for this favour, Walter gave the captain's young daughter, Nelly, 11 photographs of Australia and the diggings for her album.

The *Nellie Babcock Album* is still in existence, sold by antiques dealer James Carbonell of San Francisco to the National Library of Australia in 2010.[39] It contains photographs of early life in the frontier towns and mining camps, including pictures of rather nattily dressed miners in ties, tams, and top hats, observed by two cynical and more appropriately dressed men. (Could they be Australians observing the English miners?) At any rate, Nellie's album is full of landscapes, images of rivers, landscapes, towns with enormously broad streets, and gold-seekers. It's a treasure in itself.

Nellie's father's ship sailed north and the landscape became more tropical. Walter was enchanted. This was a far cry from the flat and dusty landscape of Melbourne or the winding, dingy streets of Manchester. The plan was to go to Batavia, modern-day Jakarta, Indonesia, then Manila in the Philippines, and finally somewhere in China and India. They never got past Batavia. Here's Walter's first impression of Batavia:

Five Unidentified Men Working a Gold Mine Near Beechworth, Victoria 1856 (Courtesy National Library of Australia)

> …delight at the avenues of beautiful trees, the colourful flowers and the 'hundred of natives dressed in all colours parading in the streets', so different from drab and dingy Australia. (Perhaps more than this, he was astonished at the lifestyle of the Europeans.) I was also surprised to see at every door 2 or 3 carriages with all the horses not higher than three feet (beautiful little things) the reason of so many is this, if a European here if he wants to go next door must have a carriage.[40]

The clipper anchored off Batavia Haven and Walter and James and their belongings were rowed up the Harbour Canal to the small customs house where they had to pay duty of the equivalent of 25 shillings. They did not have a visa or a work permit, but that didn't deter them, although this detail did pose a problem later on.

View of Ford Street, Beechworth, Victoria 1856 (Courtesy National Library of Australia)

They took a carriage inland to the European residential area and found rooms with a Scottish landlady, Mrs. Bain. Her house was on the edge of the Konningsplein (King's Plain) and Walter considered it to be the "Hyde Park of Batavia."

Not only was the area beautiful, it provided and excellent opportunity to set up a photography business. The language barrier was overcome by James Page, who was fluent in French, the language many colonials liked to use. There was an encouraging notice about the studio in the local newspaper *Java-Bode* on May 23, 1857, before the pair had even actually set up. Fortuitously, the partners made the acquaintance of a Dutchman who spoke French, English, and Malay, in addition to Dutch. (Walter himself would later learn Malay.) They were visited by the American Consul, who assured them they would make their fortunes. And they did.

After first dismissing Batavia as "a lazy place" compared to Australia, Walter and James settled in to the luxurious life of a colonial European:

> We rise at 6 am and take a walk for half an hour then come back to breakfast at 7—after breakfast from about half past 7 to 10 or 11 are our principal business hours as it is then pretty cool, at 12 we have what is called tiffin, a sort of luncheon. After tiffin we take a siesta for an hour and on waking have a cup of tea brought in to us, the rest of the afternoon we pass away by finishing the morning's portraits, reading, drawing or anything else until 5 o'clock when we bathe and dress for dinner which we have at half past 6, after dinner we take a drive for about an hour or two, come home, have a cup of tea and go to bed at about half past 9,--such is our daily life, one day exactly like another.[41]

This, I think, was more like what Walter had in mind when he went to seek his fortune and he got it all for £2 a week rent and 3 shillings a day for the carriage. It was surely an improvement on his situation in Australia, following a dray down a dusty road when he had blistered feet, or sleeping on a bed made of flour sacks and swatting "musquitos"!

Within a few years, Walter and James moved out of the boarding house and acquired their very own studio. Ironically, until as late as 1858 Walter intended to move on from Java and continue photographing the exotic in China. His letters to his mother twice mentioned that Henry should sail to Singapore to meet Walter before he went into China. I suspect that Page's marrying "a Malay lady" as Rowbottom noted, scuttled the plans, hence the substantial home and studio.

Here's an early picture of the atelier (you can tell that because there is no Dutch Royal Crest indicating patronage of the government over the door of the studio), complete with those pesty carriages. It's on the corner of Gang Secretarie, next to the Hotel de Netherlander and backing on to the Governor General's Palace—a far cry from living above a shoe factory at St. Mary's Gate in Manchester or in a glorified tent in Australia!

Woodbury Atelier on Gang Secretarie
(Courtesy the Rijksmuseum)

The building was built of white coral blocks, with 20-foot-high ceilings, large windows, marble floors, a large porch and awnings, and beds that were eight feet across and shrouded in mosquito netting to deal with the hot, humid climate. The temperature in Batavia (Jakarta) is an unvarying, humid 25°C all year round.

And here is a shot of the lush back garden of the atelier. It too was a world away from living on the smoggy inner-city streets of Manchester. The plants grow in prolific heaps, and the walker in the garden has on a casual and cool white cotton outfit. The object at the far left is a birdcage. They seem to have been fashionable and I've seen them in other photos that Woodbury and Page had taken of substantial houses around Batavia. The firm moved into this new building on March 18, 1861.

Now, there is an irony to this situation: Walter had found the style of life to which he would have liked to become accustomed, but it was in some ways a sham. *Pointy Shoes and Pith Helmets* is about life and culture in the Ambonese Islands in the Molucca Straits but close enough to Batavia socially, geographically, historically, and politically (both areas had been controlled and shaped by the VOC, the Dutch East India Company) to be relevant to Walter's lifestyle in Java. The author, Marianne Hulsbosch, observes "those Europeans who lived in the Ambonese islands did not really belong to the European upper social strata, but by mirroring their rituals they could, at least for the duration of their stay in Ambon, fulfill their pretence of belonging to this higher social elite."[42]

The back garden of the Woodbury Atelier
(Courtesy the Rijksmuseum)

When Walter's family in Manchester lived over the shoe business, they kept two live-in servants, according to the census records of 1841 and 1851. By the 1851 Census, Ellen had eight children but no governess or nursery maid. The women of the household were not ladies of leisure: Ellen ran the shoe business and her sister, Elizabeth, worked with her; then as a widow Elizabeth supported her own extended family by working as a grocer (1861 Census).

Walter's establishment in Batavia was much more elaborate and luxurious than the living accommodations in Manchester. When Walter took pictures of the household/atelier staff, there were three stable boys, two coachmen, multiple house servants, a housekeeper, and a whole crew of men who proudly posed with the photographic equipment they carried around for Walter and James Page. In fact, Walter commented that there

was no point in experimenting with the simpler dry-plate photographic equipment because there was no shortage of porters for his wet plate clobber. And considering that slavery was only abolished in Indonesia in 1860, there were probably a lot of people glad for the paid work. The group below was the photographic crew of 12 assistants and porters.

There were almost as many people employed in the house itself.

The world Walter had found himself in was like no other he had experienced. It was not just the fruit and scent and lushness,: it was the social order:

Woodbury's photographic assistants and porters (Courtesy KITLV)

> The Dutch East Indies were not the typical settler colony (founded on) massive immigration from the mother countries (such as the United States or Australia [or Canada]) and hardly involved displacement of the indigenous islanders. Neither was it a plantation colony, built on the importation of slaves (such as Haiti or Jamaica), apart from some nutmeg plantations in the island of Banda during the VOC (Dutch East India Company) era, or a pure trading post colony (such as Singapore or Macau). It was more of an expansion of the existing chain of VOC trading posts.[43]

Since the Netherlands was one of the smallest nations in Europe, it could hardly muster the number of emigrants necessary for a settler colony, so it came up with a much more ingenious solution as described by Alfred Russel Wallace in 1869 in his book *The Malay Archipelago*:

> The mode of government now adopted in Java is to retain the whole series of native rulers, from the village chief up to princes, who, under the name of Regents, are the heads of districts

> about the size of a small English county. With each Regent is placed a Dutch Resident, or Assistant Resident, who is considered to be his "elder brother," and whose "orders" take the form of "recommendations," which are, however, implicitly obeyed. Along with each Assistant Resident is a Controller, a kind of inspector of all the lower native rulers, who periodically visits every village in the district, examines the proceedings of the native courts, hears complaints against the head-men or other native chiefs, and superintends the Government plantations.[44]

This contemporary account is rather politically naïve, I suspect, as Albert Woodbury found himself taking pictures of the Aceh Uprising and subsequent executions in the 1870s.

Nevertheless, Walter and James found themselves in a society that had multiple tiers of wealthy and elite citizens. There was the established Indonesian society, with its princes, sultans, and artists. Woodbury and Page Photographers took portraits of the Sultan of Solo and his extensive family and palaces, other royalty, and pictures of the acclaimed Romantic painter, Raden Saleh, and his wonderful, palatial wedding-cake of a house. They took portraits of the Dutch Residents (a "Resident" was an official government advisor) like Van Spaal and other ordinary colonial residents and their environs like the Harmonie Club. They took portraits of wealthy Chinese merchants. They took portraits of the socially upwardly mobile Eurasians. They took photos of clubs, of landscapes, and of "Java types" (the average Javanese at his/her occupation). In the words of my grandmother, "they've landed in a pot of jam" and it's a sweet, not a sticky, situation.

Raden Saleh, Romantic painter
(Courtesy Rijksmuseum

Raden Saleh's house (Courtesy Rijksmuseum)

Landscape, with Tigers Listening to the Sound of a Travelling Group, Raden Salah
(Courtesy Wikiart public domain)

Woodbury was astonished at the amount of money he could charge for his work and the popularity of it. There had been and were other photographers on Java: Adolph Schaefer had been commissioned to take daguerreotypes of archaeological treasures such as the sculptures at Borobudur, Anton Lecouteux had a studio but shut it in 1856, and Isidore van Kinsbergen's studio rivalled Woodbury and Page.[45] But the skill and artistry that won a medal in Australia were recognized and patronized in Java.

Woodbury and Page, the firm, charged twenty guilders or rupees for a portrait upwards. Walter wrote to mother Ellen, "We get very good prices for our portraits—from 20 rupees (£ 1 14 s) to 120 (£10). Those we charge £10 for are done on paper and afterward coloured

by an Artist here to whom we pay one half the amount for colouring them."[46]

Within a year, Walter and James were making between £700 and 800 annually. According to *Measuring Worth*,[47] the straight conversion value of £700 would be £60,220 but the economic power of the sum, which means measured as a percentage of the GDP of Britain, would be an astonishing £1,754,000! No wonder Walter was chuffed. He was a long way from Australia, but it seems he had finally struck "Gold."

LIVING THE LIFE

Walter and his partner found themselves successful and sought after, but that very success brought problems, the principal one being the cost and difficulty of obtaining supplies; the secondary one being that, although the partners worked together, they didn't seem to have the same goals and aspirations. Walter was very much the photographer while Page seemed to want to travel and see more of the islands—at least until he met the lovely Malay lady. The young men came to Java flush with supplies; they didn't anticipate either their welcome or the length of their stay. They put plans for travel to further destinations on hold. Soon, they needed to rectify the little omission of having neither passports or travel permits when they had arrived, so they applied for them, discovering that "the government here is very strict, and all persons who stay here for a short time must have two securities, each £200 for our good behaviour. We got a Dutch gentleman (the Government Secretary) and the British Consul for the other."[48]

Two hundred pounds was worth between seventeen thousand and one hundred thirty-six thousand pounds depending if you're measuring by straight monetary calculation or the calculation of incomes of the time. Obviously, they had been successful to be able to provide useful contacts who could provide the massive surety. The security that Walter was so blithe about was more than the amount of their working capital when they embarked on their journey. The Dutch authorities required the monetary guarantee to keep layabouts out of the country, but Walter and James Page were not layabouts. When portrait taking

palled and supplies started to run low, the partners had two solutions, a "photographic ramble" through Java to take landscape shots to sell to the European public and a journey to England to procure further supplies. The pair had purchased supplies from Australia and Ceylon, but the supply chain was expensive, erratic and irregular-- even when they were able to buy materials, so a better source of supply had to be established. And they had collateral—approximately 700 photographs and photographic negatives of Java, its landscape, its plants and its inhabitants. Walter was certain that the Dutch Government, if nobody else, would be interested.

It was the superb quality of the landscape photographs that ensured the place of Woodbury and Page in the history of photography—of Java and of everywhere else--that established the reputation of their atelier. In this later photograph of the atelier, the Dutch Royal Crest over the studio door meant this photo was taken in the late 1860s after the firm had received prestigious Royal Patronage. The gentleman at the entrance looks like Walter's brother, Albert. Both brothers eventually joined Walter in Batavia and became partners. Albert, who was always a bit of a handful, after arriving, leaving, and returning to Batavia, eventually ended up owning the entire Woodbury and Page firm by the 1870s when Walter and Marie had gone to England to patent the Woodburytype and Henry James and Sarah had taken their child home to the medically safer environment of England.

Later photograph of Woodbury Atelier with the Dutch Royal crest over the workshop
(Courtesy KITLV)

Walter was doing so well that Mother Ellen (as opposed to Sister Ellen and later, Niece Ellen, the family historian) had finally relented in 1858 and Henry James, leaving behind Sarah Jane Aldersey, a lady with whom he has had an "understanding," for years, finally came to Java with Walter's financial assistance. According

to Ellen, Henry James did not have the financial stability to marry, so perhaps the shoe business was not doing as well as it formerly had been.

Ellen might not even have been running it any more because she had married Edward Lloyd, a successful businessman from Stafford. Walter congratulated her on being able to "retire" in one of the last letters (Letter 13, February 26, 1856) he wrote from Australia. However, in Ellen's will there was no mention of the shoe business at all, so perhaps it had been her marriage portion to Mr. Lloyd who was himself a shoe manufacturer and had subsumed it into his own business interests. Not one of the three brothers was associated with the shoe factory when they returned.

Henry James had learned how to colour photographs and so he brought a valuable skill to the atelier, saving half the cost of the coloured portrait. Walter also discovered that Henry James was very good with children and could coax them into freezing for the relatively long minutes it took to make an exposure. Henry James' presence also allowed Walter to leave the business to make the long trip to England for photographic supplies. And he had collateral: Walter and James may have been running out of supplies, particularly nitrate of silver, but he had pictures and negatives on glass. Walter and James had taken a trip to Buitenzorg (now Bogar), their first "photographic ramble" in September 1857.

Portrait Henry James Woodbury from the *Whitworth Album* (Courtesy Janet Nelson)

That's where the botanical gardens and the Palace of the Governor were.

I had no idea that the Buitenzorg Botanic Gardens (now called The Bogor Botanic Gardens) was as large, if not larger than Kew Garden in London; it was started for the very same reason—to cultivate useful plants for the region and the Empire. In Kew's case, think breadfruit and rubber trees. Buitenzorg was instrumental in the introduction the South American cinchona tree (the source of quinine from its bark) to Indonesia. Like Kew, although its initial commercial function

has become obsolete, the garden is still giving pleasure and supporting research.

Walter took photographs of the gardens, the palace and the grounds, and environs of the upscale Hotel Bellevue. He knew that views of exotic places were hot commodities in Europe, and his landscapes, beautifully composed, were certainly marketable. This is a view of the Buitenzorg Botanic Gardens from my own collection.

Fountain in Buitenzorg Botanic Gardens (Collection of the Author)

As Walter wrote:

> During our travels through Java, we have taken a great number of stereoscopic and large negative views… these are very valuable, especially views of India (i.e. the East Indies) and will fetch as much as 10 pounds each in England or in Holland, we also have a lot of large views of the ruined temples of this place which the Government of Holland are very anxious to obtain, altogether we expect to get as much as 400 pounds for the collection. As we know nobody in England in that line of

> business who could negotiate the sale of them, we have come to the conclusion that it will be best to go home and dispose of them ourselves.[49]

Walter travelled to Southampton via Singapore and the overland route across the Isthmus of Suez (the canal being nearly ten years in the future) to the Nile River, up the river to the Mediterranean and went straight to Stafford to see his mum, Ellen. After all, he had not seen her in seven years, and their relationship was a close one. He should have noticed a real change in his little sister, Emily, because when he left, she was five and she was now 12! However, Emily was living with Aunt Lawton, being "not wanted on the voyage" of Ellen's new marriage, so Walter must have had to visit his Aunt Elizabeth to see his sister Ellen as well. But Walter's visit, although personally rewarding, was not financially successful, at least initially.

Arthur Rowbottom may have been hazy on many details of Woodbury and Page's early lives, but he seemed to remember financial matters with clarity. According to Rowbottom:

> [Walter] was quite unable to induce his friends to advance him any money and he could not get goods on credit to go out to such a little-known part of the globe as Java; he therefore applied to some of his old friends for assistance in carrying out his project. Mr. Walter Short, of Birmingham, a large timber merchant, informed him that I was receiving large supplies of dammar (a resin used in ink and varnish) from Java, and in that connection might be able to render him assistance.
>
> I was at the time partner in the Coal Union in North Wales and had frequent occasion to pass through Stafford, so I took the opportunity of calling upon Mr. Woodbury there, when he explained the exact position of affairs to me, and I undertook to help him out of his difficulty. I not only found him a few hundred pounds to buy material with, but went up to London with him to help him in making his purchases for cash. We

bought a considerable supply of nitrate of silver, and a stock of the latest and best cameras, and when we had seen to the shipment of the supplies, Mr. Woodbury accompanied me to Birmingham and stayed with me at my residence at Gloucester Terrace for some time. While in Birmingham we invested largely in cartes-de-visite.[50]

Stereoscope viewer (Courtesy Wikipedia given to public domain by David Paoe, photographer)

Not only did Walter find financial backers in Rowbottom and his contacts, he was able to sell a series of stereoscopic photographs (also called "stereo-views" or "stereographs") to the firm of Negretti and Zambra, which despite its name was English. They were purveyors of optical instruments to the navy and also had a photographic department. Stereo-views were "Victorian TV" as they were a parlour amusement for the middle classes. When viewed with a stereoscope, a photograph taken by a a two-lensed camera with the lenses being as far apart as the eyes in the average human face, a three-dimensional effect is created in the photograph. The individual stereo-view cards were not expensive, frequently came in sets, and could be shared or traded. They were often of exotic places, but they could also be cultural or humorously staged pictures—or naughty ones. Negretti and Zambra marketed the stereo-views quite aggressively. Once the stereo-views were published, *British Journal of Photography* wrote, "Until we had seen the series now before us, we had never been able to realise so vividly the actual appearance of tropical scenery."[51]

Walter got in closer touch with the photographic community and saw the potential in the new format of albums of photographs, sold at high-end prices. (Woodbury and Page's surviving *Vues de Java* still commands hefty price, more than I can afford, at auction.) Walter could produce larger portrait photographs on paper, but realized that, at upwards of £12, not everyone could afford them. Aware of the potential of the more down-market side of his clientele, or perhaps

considering a different market all together, he purchased a *carte-de-visite* ("visiting card") camera, a format popularized by the French photographer André-Adolphe-Eugène Disdéri, who would later try to claim Walter's Woodburytype as his own invention (Ref 510 *The Woodbury Papers*).

The camera had four lenses so that it could take four baseball-card-sized portraits for the cost of one. At the time, this kind of camera, which later could have up to a dozen lenses, was one of the few ways to produce multiple copies of an image relatively inexpensively. The camera was a very successful purchase. The picture format of the cartes-de-visite (CdVs) was small and sturdy as the prints were glued to a stiff card. CdVs became a personal favourite of the Victorians, since you could collect them in albums or mail them to family and friends.

Cartes-de-visite also became a collectible craze. Women of the middle and upper classes paid short visits to each other, visits that often began with the presentation of a card to be brought into the Morning Room or sitting room by the butler. (The sessions were short because after 20 minutes or so, the carriage horses waiting in their harness, would get restive.) If the visit was not at a convenient time, the card was left as a token. Cards could also be left as thank you gestures or in condolence. The carte-de-visite photos weren't usually left, but as the pictures were the same size and cardstock as the visiting cards, the name stuck. *The Whitworth Album*, which provided many of the family portraits in this book is a collection exclusively of CdVs compiled by Walter's niece, Elizabeth Whitworth's daughter Lizzy. The Album in now in the possession of Janet Nelson of Caledon, Ontario, a descendant of Lizzy.

One other idea occurred to Walter while he was in England, specifically when visiting Rowbottom's home. To use Rowbottom's own account:

> But there was a greater advantage to be gained, as it turned out, by Mr. Woodbury's sojourn with me at the time. In one of the windows of my house there was a transparency hanging, and this appeared to attract Mr. Woodbury's attention. He took

> it down, carefully inspected it, and then replaced it without a remark and I did not myself think the incident of sufficient importance to be taken further note of. Later on, however, Mr. Woodbury again took down the transparency and examined it, and seemed to be still further interested in it. I then asked him what caused him to take some much interest in the picture, but he merely replied that it had given him and idea which he could not then explain, and there the matter was left and I did not suppose I should ever hear it referred to again.[52]

This chance experience with a transparency may have been the genesis of the Woodburytype, Walter's revolutionary process which used translucent inks to produce monochromatic prints in high-quality continuous tone. Walter's use of this technique coupled with a hydraulic press changed photography forever. He invented the first photomechanical process for reproducing photographs in significant numbers opening the door for illustrated books and texts.

With his purchases following in another ship, Walter returned to Batavia, taking a boat to Suez, going overland, then taking a steam packet to Singapore, a significantly shorter voyage than the *Serampore's* round the Cape of Good Hope route. Probably this was as much a matter of safety as convenience, as the *Serampore* was lost with virtually her entire crew off Madras in 1853, scarcely a year after Walter sailed on her. Walter commented on it in Letter No. 7, noting that he had become friends with many of the "apprentices."

Now the firm of Woodbury and Page had to pay for all those supplies, so the answer was another "photographic ramble." The panoramic photograph of Borobudur is mine. I thought initially it was a photo of Walter and James Page in front of the ruins of Borobudur, the largest Buddhist temple in the world, but I think now it's Page and Henry James, because Henry James was also on the "ramble." There are two Indonesians in the photo too, but they are in dark "civil service" clothing and are difficult to spot. I'm assuming Walter is taking the photograph. The ruins are spectacular and will feature in Woodbury and Page's catalogue of "views."

Henry James Woodbury and Page with Javanese companions, Borodudur
(Collection of the Author)

Notice the pavilion built atop the ancient stupa. It was removed in 1870, 10 years after this shot was taken. I think it was Henry James looking out over the landscape near the top of the ancient structure with Page, cross-legged, staring into the camera in the middle of the scene.

The "photographic ramble" must have been quite the adventure. Normally, if the men travelled, it was by steamer, because travel through the interior was difficult, slow, dangerous and pricey. A journey from Batavia to Surabaya took nine days by post-carriages as opposed to three days by sea. This journey took nearly a month and was chronicled in three issues of *The Photographic News* (February 2, February 14, and March 2, 1861), in articles written by Walter himself. It seemed that he was beginning to understand the necessity of publicity.

Tourists and the stupa of Borobudur
(Courtesy KITLV)

So, off they went—even packing (or at least the 27 porters were packing) a portable darkroom. Walter had created an ingenious basket that contained everything from collodion pourers to a silk handkerchief to wipe the plates of dew. Mind you, the basket was so large that it took four porters to carry it! Let's let Walter tell his own story:

> With our minds elated by the prospect of a pleasant trip through the wildest and most beautiful scenery in Java, and with a first rate supply of apparatus including Smart's dark tents, which we had just received from England… we (a party of three) started from Kederie, an inland town of Java (over 600 km. east of Batavia…) for a sugar plantation… Our host, Mr. Boyd, a Scotsman, received us with true British hospitality, and after entertaining us with all the amusement the place could afford in the shape of two dancing girls, whose monotonous and unmusical voices soon wearied us, we proposed to take a stroll but were prevented by our host informing us that the neighbourhood was infested with tigers.[53]

Good grief! This sounds like something from *Boys' Own Annual*! Dancing girls and tigers! Oh my! Here's another "Boys' Own" moment. On the way to Ngantang, they stopped for a meal: roasted peacock, a tin of *pâté de fois gras*, a tin of biscuits, and a bottle of wine accompanied by cakes, oranges, and tea obtained from a Chinese opium seller. "We did not fare so badly" Walter allowed.[54] Somewhere along the line, he had lost his teetotal habits too.

OK. I have to confess: I have a point-and-shoot digital camera. I have two SLRs, a Canon and a Nikon, but I frequently find them too heavy and awkward to use. I carry my cigarette pack- sized little Cannon point-and-shoot or use my phone And I use my computer's photo-enhancing program. When I came across Walter's description of the complicated process of taking a wet-plate collodion photograph, and the skill involved, I was I taken aback. How easy photography is now— thanks to Walter and men like him. Here's Walter's description of taking photos in the forest:

> [We] proceeded to select the best point of view, for a rivulet prettily overhung by ferns and hanging rattans, making a nice picture; owing to the extreme darkness of the forest, on looking at the ground glass, it was almost impossible to distinguish the image, even using a half-inch stop, making it very difficult to focus. (I am now speaking of a view camera 7x9). The first plate was underexposed, but then the sun came out and the excessive contrast made photography impossible. In a country like this, to get the softness, pictures must be taken in the shade. The desired moment having at length arrived we proceeded to try again and this time succeeded in obtaining the perfect negative, though with the long exposure of five minutes; after taking a stereoscope of the same subject, we proceeded to take another view. and being better lit up, was done in forty seconds, giving an opportunity of introducing the figures of two Javanese.[55]

Alan Elliott, the expert on all things Walter in Australia, also happened to be a retired research chemist. He gave me this account of how Walter would take photographs in the Javanese jungle, or elsewhere, for that matter: To prepare the glass plate for shooting, Walter would have dissolved gun cotton in alcohol, which created the flammable and syrupy collodion. He had to pour that with a steady hand onto an immaculately clean glass plate. The plate was placed in a silver nitrate bath so that the potassium iodide from the gun cotton would combine with the silver nitrate to produce silver iodide. The plate then went, wet, into the camera where it was exposed. Then it had to be immediately developed, because if it dried, the syrup would gel and repel any developer. So, the plate was dunked into a solution of pyrogallic and acetic acid (later ferrous sulphate), washed in clean water, fixed with a solution of sodium thiosulfate, washed again, and finally dried! All this happened in the darkroom tent the middle of a Javanese jungle. Walter, Henry James, and James Page returned from their ramble with 28 good, saleable photos. They published them and others in *Vues de Java*, which mirrored the time and place: it contained scenes of Indonesia, taken by Englishmen, published by a Dutch publisher, and the title was in French.

Vues de Java was not a "coffee table" picture book as we know it because that will be invented by Walter in 1875 with *Treasure Spots of the World*, which was the very first book in English where the text supported 28 beautiful plates. *Vues de Java* books were not a consistent commodity as the book was sold as an album and the pictures chosen either by the photographers or the buyer, then "tipped in" or individually included. Walter had not yet invented his Woodburytype process and presses, so the chosen pictures would be individual printed. Perhaps the fuss of making this book made Walter consider the possibility of mechanically creating multiple prints.

Some copies featured the houses and clubs of the wealthy. Others featured landscapes, buildings and harbours, ruins, gods, and even photographers.

Two Observers of the Ruins from Vues de Java
(Courtesy KITLV)

The god Ganesha,
Remover of Obstacles
(Courtesy of KITLV)

Above is the elephant-headed god Ganesha, who is a remover of obstacles. The other, playfully titled "Two Observers of the Ruins" even featured one of the photographers, romantically wearing a pith helmet. I suspect he was brother Henry James.

Vues de Java was a success and sold well as a personalized souvenir of Java and a portal to an exciting, exotic world for buyers in Europe.

Rowbottom, whose information on things financial I tend to trust, had this to say about the state of things in Batavia,

> When Mr. Woodbury reached Batavia the photographic business was resumed in good earnest and money came pouring into the firm in all directions so that in a very short time they were in a position, not only to repay me what I had advanced but to send me remittances for fresh material. The first remittance was for £600 and a later communication brought me £1500 more to expend in the same direction. Business increased with them to such a degree that they seen became comparatively wealthy.[56]

The next year when it was James Page's turn for the trip to England, he arrived with a bank note for £1000. That was serious money being spent on supplies: a total of £3700, if you count Walter's capital that he brought on the first visit. Unfortunately, the serious money came at serious cost: Henry James would die at 36 of a constitution weakened by tropical disease; Walter would be sent to Italy for his health in 10 years, and die at the age of 51. Only the last brother Albert seemed to thrive in the tropical climate; he died in his 60s. Despite his coming home to England for treatment with Malvern Waters, James Page would die of sprue at 32. (Sprue is a disease associated with severe gastroenteritis and accounted for one-sixth of all the casualties sustained by Indian and Allied forces in Southeast Asia during WWII. The disease attacks the villi of the intestine so that they cannot absorb water or nutrients.)

In the long run, nobody profited from the success of the photography business in Java, physically or financially. This picture is Albert and Henry James playing chess in the house on Gang Secretarie in Batavia. Henry James is the skeletally thin one. When Sarah Jane Aldersey, his fiancée, arrived in Batavia in 1863, she was shocked at his appearance, as well she might be. Henry James did recover from this first bout of disease, unlike Page, but it caught up with him fatally 10 years later when he was a missionary to the poor in Besses-o'-th'-Barn, Pilkington, Manchester.

Albert and Henry James playing chess c. 1862
(Courtesy of Collection of Luanne Woodbury)

Henry James made a substantial sum of money in Batavia but invested in his sister Lucy's husband's cotton mill at exactly the wrong moment: 1865. The "cotton drought or famine" had dried up supplies from the southern US because of the Civil War's double whammy of lack of production and Union blockade combined with speculation on warehoused supplies, so that the price of raw cotton had gone up by several hundred per cent, and the fashion had become not to wear cotton because that implied a support for the slave-holding Confederacy. In fact, some Quaker millworkers flatly refused to work with American cotton. There were supplies from Egypt, but cheaper woven cotton from India was also being imported.

Lucy's husband and Henry James' boyhood best friend, Frederick Roscow, had bought the mill as an investment, but it did not weather the drought. Within two years of Henry James' investment, the mill was lost and Henry James was left with £100 to his name. Lucy went on to run an agency for domestic servants and supported her six daughters. (The women in the family do seem to have the business acumen.) Henry James was fortunate enough to find "an angel" in the person of

Mr. Lee, who funded his missionary work among the poor in Besses-o'-th'-Barn, a suburb of Manchester, giving him a "church-mouse" salary of £100 a year, although it would have been much more than Henry James' parishioners had. Mr. Lee also supported Sarah Jane and her daughter, Ellen, for several years after Henry James' untimely death, so maybe he really was an angel.

Brother Albert suffered a similar loss. Albert stayed in Batavia, sold the Woodbury and Page Atelier, bought it back several years later then eventually sold the business in 1880 for ƒ 80,000. That sum (guilders) converted to modern US dollars is $1,004,000. The buyer eventually defaulted and Albert was only paid ƒ 12,000, which he invested in a firm making model yachts. The firm sank within a year.

Each of the three brothers made a fortune in Java: each brother lost it. Ellen, Henry James' daughter and our family's waspish history writer and her mother, from whom I suspect she got many of her opinions called this "The Java Curse." In a letter to her cousin Albert-Leonard, son of Albert, on Jan. 4, 1936, Ellen commented:

> Dos'nt (sic) it seem very strange—that after three Woodbury brothers made fortunes there (in Java) and lived in such luxury—that their descendants came to actual poverty, in some cases? Mother used to say that she thought in some way, there was a curse on the money—anyway it never did anyone any good—and just melted away. [57]

Perhaps Ellen's phrase "descendants came to actual poverty in some cases" was self-referencing and explained her anger. She and her mother were forced to live on the charity of Aunt Elizabeth Whitworth after Henry James' death and the end of Mr. Lee's support. At 15, Ellen was working as a governess to the Cornells, a family with eight children under the age 11. At one point, Ellen's family had had a million dollars in modern currency so the penury must have been hard to cope with.

However, all that is in the future. Now that he was successful and seemingly financially secure, Walter's thoughts turned to finding a wife.

WALTER WOULD HAVE SURPRISED HIS MUM

The bad times were far in the future, and Walter was concerned about the present. He had thought about marriage, but had always rejected the idea because he felt he could not support a wife, as he told his mother when she apparently made several pointed inquiries while Walter was in Australia. Walter was a healthy young man and he had an interest in the fair sex; let's put it that way with Walter being a Victorian. He writes to his mum, "You seem to have got it into your head that I am going to embrace the matrimonial state but I assure you that you are mistaken as I do not intend getting married in this colony."[58]

He did enjoy dancing with the girls in The Woolshed near his photo studio at Ovens Creek, Beechworth, though. He wrote about it to his mum:

> There was a theatre here some time ago but it did not answer as the chief amusement here is dancing. Every hotel (of which there are about a dozen) has a large hall built for dancing, also a band. They likewise have 5 or 6 girls at each house who wait at the table in the day and dance at night. They are mostly good dancers as every night they are constantly at it. They are with few exceptions a respectable class of females and although they dislike the sort of life at first, they soon become accustomed to it. I have become quite a first-rate dancer as I have nothing else to pass the time of an evening with.[59]

Although this description of the girls as waitresses/taxi dancers might have set off alarm bells with mother Ellen, Australian historian Alan Elliott offers some reassurance:

> There is little doubt that a brothel flourished on the Woolshed. This establishment, to which the police apparently turned a blind eye, was not involved with dancing girls. On reading the police court notes in the papers one is struck by the fact that amongst numerous cases of horse stealing, grievous bodily

harm, drunkenness, the occasional murder and other crimes there was no instance of a charge of immoral conduct. The evidence suggests... that the hotel dancing girls were, in the main, just that. Surely, these young women must have brightened the existence of many a lonely Woolshed bachelor such as Walter, as well as serving to help transfer some of the gold from the patrons' pockets into the hotel tills.

Elliott also adds the following:

> Emily Skinner, a miner's wife who was at the Woolshed at the same time as Walter, gives us a woman's view of the matter. After observing the scene through an open window, she "was surprised at how really well and appropriately the girls were dressed—not gaudily," as she had expected, "but some, most beautifully," and added that "many of these girls made good marriages and in a few years were the leading members of society in the town."[60]

That these young ladies took advantage of their opportunities and "made good marriages" is a fitting reward for what must have been exhausting work, waiting tables during the day and dancing in the evening. They married "leading members of society in the town," Beechworth, if not Melbourne.

This incident shed light on several things. One was Walter's naiveté as he did not see the potential for immorality that the letter writer to *The Melbourne Age* newspaper, who signed himself only as J. C. G., did, asserting that innocent young women were being recruited as servants in Melbourne only to end up in this den of dancing iniquity.[61] The other was that women were scarce in the Woolshed, so that nobody was likely to bother with a bit of taxi-dancing in the lady's past. Most people, Walter included, worked at jobs they would not have even considered in England, so waitressing/taxi dancing was probably viewed in that light.

That said, the ratio of men to women in Australia was not nearly as imbalanced as it was in Java (at least for *totok* or European-born

people). Australia had had female convicts transported there and in 1832 began an active campaign to attract female settlers. Funded by the sale of Crown land, the government offered assisted passage to any young woman—and by "assisted" they meant "free." In the first year of the program, there were 706 voluntary immigrants and 386 female convicts sailing to Australia. Although 25,327 female convicts were transported (compared to approximately 160,000 male convicts), by the 1850s female convicts were well and truly outnumbered (five to one) by the women who came voluntarily from England and Ireland. The Irish Potato Famine was a factor, so was the £19 bounty that sea captains were paid for women immigrants safely landed on shore in Australia.[62]

The ratio of women to men was not that balanced in Java. In 1860, the female population of totok women was 1,000 to 22,000 totok men. Even after the Suez Canal halved the travel time and made the voyage safer by eliminating the voyage through the treacherous waters of the Cape of Good Hope, women were vastly outnumbered by men. In 1880, there were 471 totok women to every thousand totok men.

There were several reasons for this. First was that the nature of the colonies was very different. Australia was a settler colony where mass immigration was displacing an Indigenous population and establishing an agrarian economy so that the immigration of women was encouraged and even government subsidised. Java was the outgrowth of trading with a sophisticated and well-established Indigenous population, so much so that rather than replace the existing structure of power, the Dutch provided "advisors" to the local royalty—their authority backed by Dutch military/sea power. The object was not to "settle" Java—and the Netherlands would not have had the population base to do that anyway—but to profit from the association, trading in nutmeg, pepper, cinnamon and later sugar, rubber and gutta-percha, made from the sap of Malaysian trees and used for everything from insulating underwater cables to mourning jewellery to golf balls and later to fillings in root canals in teeth.

The Vereenigde Oost-Indische Compagnie (VOC), which we call the Dutch East India Company, had established Batavia in the early

1600s had gone broke in 1800 and was replaced by the Dutch East Indies Colony administered by the Government of the Netherlands. And the Dutch Government had some pretty strict regulations.

Unlike Australia, VOC policy in Java was *not* to recruit women to come out to the Colony. Only single young men were recruited until 1900 and they were forbidden to marry until their first furlough home. (Men in the army below rank of sergeant major were forbidden to marry at all.) That furlough, which was two years of paid leave, would be many years into their service: the normal furlough was granted after 15 years of service, but leave could be granted after twelve for "urgent family business" or health reasons.[63]

The young men fell into two categories, the *trekkers* whose intention was to make their fortunes and return to the Netherlands, and the *blijvers,* who were in the Colony for the long haul, perhaps all of their lives. Both groups of these young men hired Indonesian women as housekeepers who usually did more than housework. Children born of such unions could be recognized as Europeans if they were acknowledged by their father.

In fact, in 1854, more than half the people with status as European in Batavia were actually Eurasian.[64] Later, the criteria for being classed as European became much more stringent: the children had to have had a formal education in a European-model school, speak Dutch, and have lived in a European household, but at this point, the father's word was enough.[65] Eurasian women, as long as they appeared European in dress and manners, could achieve positions of power. Three of the wives of the governors general before 1851 were Eurasians. After 1851, all were Dutch.[66]

Despite the prospect of your children having social status and opportunities (most of the civil servants were Eurasian), being a housekeeper to a European man was not always a position to be sought after. In *Carnal Knowledge and Imperial Power: Race and the Intimate in Colonial Rule* author Ann Stoler comments that if concubinage (i.e., the position of housekeeper, or *nyai/neji*) is glossed as companionship or cohabitation outside marriage, it suggests more social privileges than most women who were involved in such relations would have enjoyed.

They could be dismissed without reason, notice or severance pay. They might be exchanged among Europeans and "passed on" when men left for leave or retirement in Europe. This Indies Civil Code of 1848 made their position clear: native women had no rights over children recognized by a white man."[67]

The union may have offered advantages, but it also came at great cost, as the wife of James Page found out when her daughter was taken away over her protestations and sent to England. I am using the term "wife" because Rowbottom tells us that Page had married a Malay lady, but whether it was a marriage in European terms is unclear. At any rate, Page's unnamed lady had no say in the future of their daughter, Annie.

When Walter had been in Java for a while, he too had acquired a housekeeper. Ever the innocent, he wrote about her to his mother and even sent a picture of the girl in a sarong, which Walter calls "bathing attire." (This is one of the few pictures that Ellen did not keep.) His Victorian mum received "a portrait of a native girl in bathing attire, what they call here a Neji… or housekeeper… nearly all the unmarried men have one of these girls in their houses and so far from being thought immoral, any person, not having one is laughed at by the European ladies here. The name of this one is Mena."[68]

Young girl in sarong—Mena?
(Courtesy Rijkstudio)

I suspect this young lady pictured here is Mena. There are several other photographs of her, some with the household staff, some alone, in the KITLV collection, "Memory of the Netherlands."

Apparently, all did not go well with this relationship because, in Letter 18, dated June 15, 1858, Walter commented, "I am now recovering from a long attack of dysentery brought on it is supposed by the doctor by poison. The natives are very much addicted on the slightest provocation to put some of their herbs in your dinner. The only person I can think could have done it must have been a Javanese girl through jealousy."[69] We can only speculate on what Walter had done to merit this kind of treatment. Perhaps, ever naïve, he had misinterpreted the situation.

Young men were encouraged by the VOC to employ a nyai or neji. Not only would she look after his physical (and carnal) needs; she would be instrumental in teaching him the language and customs of Indonesia; he would *verindischen* (become more Indonesian). And because young men employed by the Dutch colonial government were forbidden to marry until their first furlough after 15 years service, they were expected to enter into a relationship with a "housekeeper" called a nyai or neji. We can assume Walter did, although he does not tell his mum about it in so many words.

The author of *The Social History of Batavia, Europeans and Eurasians*, Jean Gelman Taylor, meditates on the term nyai or neji:

Seated housekeeper (Courtesy KITLV collection)

> I also think that the term concubine that I used for the Indonesian word "nyai" in ... Indies life of the nineteenth and twentieth centuries did not accurately capture the condition and status of the women to whom the label was applied. "Concubine" was not an appropriate word because it carries exotic or pejorative connotations, but I have not succeeded in finding a more appropriate term. "Partner" in modern English usage refers to couples who live together outside a legally registered marriage, but it carries today's connotations of equality, which was not the case for the nyai. "Common law wife" does not accurately convey the status either. Other writers have settled on the term "housekeeper" or" mistress" for "nyai".
>
> It seems to me that a term should be found that signals not the uniqueness of the relationship but its ubiquity to Javanese society. The temporary female in wealthy Javanese and Dutch

> households performed servant-type duties, provided sexual services for the master and could be the mother of some of his children. Motherhood status did not necessarily guarantee the woman permanent residence or honour.[70]

It's clear that Walter's new world was a long way from the customs and mores of society in Manchester. One wonders what missionary-to-be brother, Henry James, thought about the arrangements, although he argued vigorously against Walter actually marrying a Eurasian woman.

It seems obvious what is the advantage of the relationship for the European men, but what about the women in the union? Although not having any legal say in the fate of one's children would be a heartbreaking consequence, the possibility that one's children could be accepted as Eurasian, and have opportunities for marriage and careers not open to Indonesians would be a powerful motivator.

After 1854, when the word of the father alone was no longer enough to grant the status of Eurasian, sometimes being the daughter of a European man meant putting on the full rig-out of the Victorian woman and adopting the customs and manners and language of Europeans. Now if it were me, I would opt for garments developed in and adapted to the tropical climate, as the men did. In fact, the East Indies *was the only place in colonial history*, according to Marianne Hulsbosch in *Pointy Shoes and Pith Helmets*, where men commonly adopted dress based on Indigenous clothing both for leisure and business. Men wore loose cotton pyjama-like pants with a drawstring waist, in white and in batik, with a loose jacket top.[71]

These are the garments that author Joseph Conrad scathingly described on Carl, the brother of Marie Olmeijer, the woman Walter will marry: "He stepped upon the jetty, He was clad simply in flapping pyjamas of cretonne pattern (enormous flowers with yellow petals on a disagreeable blue ground) and a thin cotton singlet with short sleeves."[72] Conrad had called in at Olmeijer's trading post at Tanjung Redeb on the Pantai River. He later used Carl Olmeijer as the basis of Almayer in his novels, *Almayer's Folly* and *Outcast of the Islands*, which preceded the more famous works, *Heart of Darkness* and *Lord Jim*.

A Conradian scholar, Z. Najer, tells us: "Conrad did not get to know Olmeijer at all well... neither the Almayer from *A Personal Record* nor the tragic Almayer from *Almayer's Folly* have much in common with the real Olmeijer. Married... he had eleven children... as a trader he was both successful and influential."[73] In recent scholarship, *The Semi-Detached Empire: Suburbia and the Colonization of Britain*, author Tony Kuchta sees Conrad's treatment of Olmeijer/Almayer as something akin to the caricature of the lower middle-class clerk (think Wells' Mr. Polly or Forster's Leonard Bast or even T. S. Eliot's "young man carbuncular"). That Carl was wearing clothing appropriate to a humid tropical climate only drew Conrad's scorn. Ironically, Eurasian civil servants adopted European dress, wearing black suits, the material for which was part of their salary.

Walter and James Page adopted the relaxed Batavian fashions. One of their first purchases in Batavia was £15 worth of white clothing for the climate. That indicated a whole new wardrobe for both men, not just a few cooler garments. In Letter 16 dated September 2, 1857, Walter commented on the cost of the clothing, and says they must change twice a day and have the clothes laundered (but laundry is cheap.)

Woodbury and Page in comfortable cotton clothing for the climate of Java
(Courtesy e-Bay screenshot)

This photo appeared on eBay where I captured this screen shot. (I tried to buy it but was outbid at the last second.) I think it is Walter and James Page, and if it is, it's one of the few pictures of them together and one of a few good likenesses of Page.. But notice the garments—the wide trousers and long loose cotton tops. And notice the relaxed pose: Few men in Victorian England would have their photo taken while sitting astride a chair or lounging on a divan. Incidentally, you can see these chairs and table at the far right of the front porch in the early picture of the Woodbury and Page atelier.

OK, to get back to my point: Conrad was scathing about Carl Olmeijer' wearing garments adapted from Indigenous dress and far more suited to the climate than a European business suit. (Ironically, the Eurasian men who ran the Civil Service wore black business suits.) Both European and Eurasian women wore European dress; European women did not wear Indonesian dress or any adaption of it. The blurring of European-Indonesian dress in the male population indicates, to me, a more relaxed attitude to race found nowhere else in the Colonial world, but that tolerant attitude does not extend to the dress of women.

Here's a detail of the Borobudur picture. Notice the more formal attire on the Indonesians while Henry James and James Page are in relaxed, loose, pyjama-like garments. There's even a pith helmet. But if you were a Eurasian or European woman, there were no comfortable climate-appropriate articles of clothing

Detail of ruins at Borobudur (Courtesy collection of the Author)

European lady and a Eurasian lady (Courtesy the KITLV collection)

These two CdVs are from KITLV's massive collection of more than 2,000 pieces of Woodbury and Page's work. They have no names other than "Woman in European Dress." I've put them in because they show that totok and Eurasian women's dress about the time that Walter marries Marie. In the year round heat (an average 82°F or 25°C) and humidity of Java, I would far rather be dressing in cool, loose cotton or silk than these dresses. These garments also required underpinnings of corset, shift, crinolines… Incidentally, the wearer could be wearing up to six crinolines. Later, hoop skirts provided a welcome if awkward alternative.

Remember, Walter was rather innocent, and he may not have fully understood this division between Eurasian women who became socially acceptable wives, dressed and educated as Europeans and Indonesian women who became "housekeepers," dressed and educated as Indonesians. He had grown up in a forward-thinking family where women ran the businesses. Also, his grandfather's great friend Audubon was biracial, so Walter might not have seen the dangerous undercurrents that would wreck him in Victorian England, where no matter how European her dress and manners, Marie would always be considered Indonesian, Indian or Black. Other. Not English.

Here's another CdV from the KITLV collection (and mine, courtesy of Gael Newton's generosity), this one titled "Aristocratic Young Woman."

There are many pictures of Walter's household staff, dressed in cotton, but this young lady is nobody's servant. Just look at the self possession in those eyes. Then look at the traditional loose-fitting jacket and the skirt of silk or very fine cotton. This is an outfit that would be far more comfortable in the humid heat of Batavia; however, Marie would not be allowed to wear this if she were to be accepted as a Eurasian and as Walter's wife.

Aristocratic young woman (Courtesy Collection of the Author)

The motivation to wear all this European gear must have been very powerful. I think the power came from two sources: the association with the ruling (or "advising") Dutch (also English, Portuguese, and other European nationalities) and the chance to break free of traditional roles and expectations of the Indonesian population had for women.

In *Pointy Shoes and Pith Helmets*, Marianne Hulsbosch writes the following about Indonesian and Eurasian women's attire:

> Western rather than ethnic identity maintenance had become the mark of distinction as western dress indicated progress and modernity, personal liberty and colonial citizenship. Ethnic dress denoted inferiority and submission to colonial rule. Adopting western dress also included acquiring embodied mannerism and posture related to western dress. Western dressed women sat on chairs, walked faster and with a longer stride, shook hands, ate with a fork and knife, played tennis and rode bicycles.[74]

So Western dress was more than a fashion choice—it was a political statement about colonial rule and modernity. (Well, clothing choices have never been about merely covering the body.)

Not only did adult women wear full Victorian dresses, children did, too. This is a close up of the porch of the atelier from a photograph of it in the collection of the Rijksmuseum. I am tempted to identify the man sitting in the chair behind the pillar as Henry James. Notice his batik pyjama pants. The round-like-a-chihuahua brachycephalic Woodbury skull is there and he seems thinner than Walter ever was. The two young girls, the older in the white dress and her companion in the plaid dress, were subjected to Victorian fashions complete with stockings, pantaloons, boots, high neckline, and over-jacket, a tight waist, and elaborate sleeves while the men lounge about in loose cotton. At least the girls were not in full-length skirts.

The Woodbury and Page Atelier with figures on the porch
(Courtesy Rijksmuseum)

Detail of Woodbury Atelier with figures on the porch (Courtesy Rijksmuseum)

The album page features the atelier, with a porch full of people, three of whom were female. I assume Walter took the picture. I'm not sure who the two girls were, because the photo was taken between 1861 and 1863, the times when Walter acquired his studio and the time when he acquired the Dutch Royal Crest over the workshop door. It's not in this picture. Given that time frame, the girls would be too old to be Page's children, as his oldest would be seven at the most, and there is only a record of one child, a daughter, Annie.

These two girls stand tall, but the third female is almost hidden behind the tree branch; she was the only person to have her gaze turned away from the camera. The Indonesian servants sit and stand around also facing the camera, but this lady sits across from Page, in very elaborate European dress. You can tell that this is Page from his head shape, hair line and colour, and also by his forthright gaze into the camera, like his gaze when on the stupa at Borobudur ruins.

His companion is literally swathed in yards of fabric that falls in tiers and flounces, and her hair hidden and contained by an elaborate net, far more elaborate than the one Marie wears in a CdV taken of her years later in Manchester. Could this lady be the elusive and unnamed Mrs. Page? Rowbottom says Page married "a Malay lady" and is later tasked with bringing the daughter, Annie, to England to be raised by Page's sister after his death. Hannah Boese, the sister, died a few years after Page did, so her husband, a clockmaker from Germany, raised Annie with his several sons. The last we hear of Annie was that she had left England for South Africa, perhaps because, like the Woodbury children, she was perceived as "not white enough" for English society.

Closer detail of Woodbury Atelier; could this lady on the far right be Page's wife? (Courtesy Rijksmuseum)

This group of men and women in this next picture, which was sent to me by historian Alan Elliott, seemed typical of colonial Batavian society. The photograph is in the collection of the Rijksmuseum and is entitled *Behind Van Leeuwen's House*, which is written below it on the

album page on which it is mounted. The avenue of trees frames and dwarfs the couples; it's like the nave of a cathedral.

Behind Van Leeuwen's House (Courtesy of the Rijksmuseum)

It's tempting to identify the man on the left as Henry James. The hairline and brachycephalic head shape are the same as the man behind the column in the picture of the people on the porch of the atelier. The women are all elaborately dressed in western fashion while the men wear more comfortable looking, looser clothing. The average temperature is Jakarta (the original and current name of Batavia) is 25°C (82°F) with 80 per cent humidity and doesn't vary much with the seasons. The daytime temperature is 31°C (87 F) and nights are 24°C (75°F). There is no cool season. Despite being in silk or cotton, the ladies are wearing a lot of clothing, layers of clothing, close-fitting clothing (with appropriate layers of undergarments we assume) in the heat.

Detail of the group in the avenue of colossal trees (Courtesy the Rijksmuseum)

Here's a close up of the couples, with the women in full, mid-Victorian, voluminous dresses while the men wore loose trousers, shirts, vests and ties—still a lot of clothing. I would suspect that this was a formal occasion, because in the 19th century, people did dress up to get their photos taken. In *Walter Woodbury, a Victorian Study*, the Royal Photographic Society of Victoria Australia speculated that this might be a wedding photo of Walter and Marie, but I subsequently have discovered two CdV portraits of Marie, and she was not one of the women here.

This was most likely a "photo opportunity" for a wealthy European/Eurasian family, the Van Leeuwens. Or the people's presence could be due to the keen eye of the photographer because the carefully posed figures in the middle ground gave a size reference for the colossal trees. Walter used the same technique in his study of the ruins of Borobudur, the largest Buddhist temple ruin in the world, placing two figures in white and two in black between the camera and the ruin as a reference.

Front of Van Leeuwen's house (Courtesy the Rijksmuseum)

This was the front of the house, a picture, taken the same day, I presume, as the women were in the same dresses. This photograph is also in the collection of the Rijksmuseum. In it, you can see the calm mix of Indonesian/Eurasian women with European men. These were the ladies in the picture in the aisle of trees: one was wearing the flounced dress, the other the plaid dress, and the third the collared dress. There were children in uncomfortable Victorian clothing in which one could never run and play, let alone fall down a rabbit hole and have adventures.

Also notice the servants, dressed in Indonesian attire and in an inferior position up against the wall, waiting to attend. The women in the European dresses were very much their superiors. And there's the inevitable carriages, grooms and coachmen. The Van Leeuwens had a very substantial home and comfortable lifestyle.

Detail of front of Van Leeuwen's house (Courtesy the Rijksmuseum)

At a less grandiose house, Walter recorded the same calm family of inter-racial couples and children.

The Schenk's more modest establishment—detail of their porch sitters (Courtesy the Ruijksmuseum)

In a world where totok women were a tiny minority and Eurasians actually substantially outnumbered Europeans, Walter married a Eurasian woman. He saw her aboard a ship and fell, impulsively, madly in love. In Letter 15, he commented to his mother that one never saw let alone met well-bred girls, so the meeting was fortuitous. The girl was Marie Sophia Olmeijer, daughter of a wealthy and influential Dutch gutta-percha plantation owner in Surabaya and his Indonesian wife, Sophie. Marie was probably three-quarters Indonesian as her father, William Carel Olmeijer, was also born in Java, probably to an Indonesian mother. Marie had European status and was on her way to school in Singapore. Walter was smitten. She was 15. In the words of waspish Ellen: "Walter became enamoured of a girl of 15, the daughter of a Dutchman and a Malay and was determined to marry her. Henry <u>begged</u> him to think of the consequences. She was such a child and could not speak a word of English! But marry her he <u>would</u>!" [Emphasis original]

As soon as Marie turned 16, on January 22, 1863, they married with Walter's protesting brothers standing as witnesses of the ceremony. The marriage in itself was an indication of Marie's social status and Walter's regard for her. This young woman was no "housekeeper." This was yet another of those impulsive, romantic moves that Walter made: chucking his apprenticeship with one year left and going to Australia for gold, buying a camera when he's almost broke, sailing for Java…

I find it interesting that, according to family history writer, Ellen, neither brother supported the marriage, and that neither brother, Henry James nor Albert, married a Eurasian Javanese woman. Both brothers married Caucasian women, born in or near Manchester. In fact, the wives were related; Katherine, Albert's wife, was the niece of Sarah Jane, Henry James' wife. Both came out to Java, had one child and returned to England within three years. Henry had a long "understanding" with Sarah Jane Aldersey, in Manchester, who was four years his senior (we know this was a longstanding relationship because Walter mentioned Sarah several times in his letters home from Australia), but his mother advised against actually proposing because Henry James had no means of supporting a wife. He himself described his salary as "a pittance."

This to me is an indication that the shoe business may not have been doing so well or that there was no room in it for Woodburys after it had been taken over by Ellen's third husband, successful businessman and shoe manufacturer, Edward Lloyd. In fact, one wonders why Walter did not inherit the shoe factory as the eldest son, after Ellen died on December 26, 1861, and he went home to England.

When Henry James was established as a successful photographer, Sarah Jane came out to Java and they married on August 5, 1863, the same year as Walter and Marie's marriage. Two years later, Sarah Jane gave birth to Ellen, who became our bitter family historian, on July 1, 1865. While still a babe in arms, Ellen was taken back to England.

Sarah's niece Kathleen followed much the same pattern. Albert, the younger brother, courted Katherine Louisa Knott and they were married 1879 in Prestwich, Lancashire. Katherine was twenty-four when she was married, 15 years Albert's junior. She was not a naïve 16-year-old like Marie. Since her aunt had lived in Java, experienced the climate and culture, and had a child there, we can assume Katherine thought she knew what she was getting into. She and Albert returned to Java, presumably through the Suez Canal, for the photography business. Little Albert Leonard was born on October 6, 1881, in Batavia. As a babe in arms, he was brought back to England with his *amah* or nurse.

Leonard Woodbury and his Amah (Courtesy the Collection of Luanne Woodbury)

Despite the 16-year gap between the birth of Henry James' daughter and Albert's son, the pattern was the same: marriage to a woman from home, the woman's brief migration to Java, birth of a child and the couple's rapid return to England. Did neither woman want to raise her child in the medically dangerous tropics? (Batavia was known as "the graveyard of Europeans" for its lowland, damp, humid climate. That the area was criss-crossed by canals built by the Dutch colonialists may have contributed.) Were the parents concerned that the child

should not grow up "English"? Did neither woman feel comfortable in the exotic setting of Java? Or perhaps neither brother wanted to go down the road that Walter had chosen for himself and his family, the results of which would, by now, be very apparent.

Sarah Jane and Katherine Louisa had the option of returning to a familiar world. Marie did not, and the more we look at the world Marie had been taken into, the more we see how alien it must have been for her. Not even a space flight would be a good analogy for the journey that Marie undertook because Mission Control would be in constant contact. There was no Mission Control for Marie.

Again, let's go back to Jean Gelman Taylor's perceptive study. The author outlines the remoteness of what she calls Mestizo society, the society that would have been Marie's. In our modern, hyper-connected world we have no inkling of the distance between the society of England and the society of the outer reaches of Java. Gelman Taylor makes the point that Walter and Marie were coming from worlds that are almost unimaginably different.

> To generalize, the key elements for the evolution and continuation of the Mestizo style on Java were white men, Indonesian mistresses, Eurasian wives. Then there were the distant, competing models of upper-class European and Javanese aristocracy to be reverenced, imitated in some form where possible. There were the part-European, part-Asian children, some entering the Dutch group, others raised as Indonesians. There was the awareness of the colonial caste system that judged living as an Indonesian and being accepted as such to be a degradation to the part European.[75]

Private house in Surabaya (Courtesy KITLV)

This photograph, from the wonderful collection KITLV (The Royal Netherlands Institute of Southeast Asian and Caribbean Studies at Leiden) is described as a "private house in Surabaya." I have no evidence for it, but I would like to think it could be similar to Marie's house. After all, she was the daughter of a wealthy, well connected man of that town.

The issue is not simply social class and perception of the power of being European or Eurasian. Gelman Taylor points out that the differences between European and Mestizo culture go much, much deeper:

> [In the Mestizo world] there was the distance from concentrations of Europeans and their culture, and there was the immediacy of the Indonesian. There was the lack of reading materials with the tie of thought and language. In their place was emphasis on oral and visual arts. There were the numerous slaves, thinly disguised after 1860 as free servants. There was the

> daily intercourse in Malay or Javanese. There was the distance from church and its social functions of sanctifying marriages and blessing the dying. In its place were local values, sayings, reliance of divining good and evil days. In the absence of European doctors, there was the trust in Indonesian magical and herbal forms of medicine. There was the cooler Indonesian costume and Indonesian food. There was the seigneurial style of living for the wealthy that European status and exploitation of local peoples made possible. Mestizo too were the practices concerning women: the Indonesian mistress remained hidden from public view; the partially confined Eurasian wife was surrounded by women attendants; the daughter was married off when barely in her teens.[76]

Marie would have been that "daughter married off while barely in her teens," although I'm not sure whether her mother was Eurasian or Indonesian. We only know her name, Sophie, although from the European name, she may have been Eurasian. Also, Sophie was referred to as Olmeijer's wife, which might also indicate her Eurasian status. To convey the sense of the difference between worlds, Gelman Taylor borrows the metaphor of driving down a dark country road and only seeing what is illuminated in the headlights, yet there is an enormous area on either side which we don't see.

This might be applied to Walter's marriage to Marie. Repeatedly, we've seen Walter's naiveté and impulsivity. Those traits were in this marriage. The headlights did not illuminate the different worlds Marie and Walter came from very well. There was much that neither of them would have seen coming, Walter because of his sometimes-endearing naivete; Marie because she was a starstruck 16-year-old. She had just married a man who was popular, wealthy, handsome and moved professionally in the social circles of the elite and powerful in Batavia. And he was madly in love with her.

The Dutch divided totoks into *blijvers* and *trekkers.* Walter and his brothers were *trekkers,* people who went to Java to make a fortune and hen return home. The *blijvers* were in Java for the long haul, with little

or no intention of returning to Europe. They settled permanently in to the new life. I do not know who this little family was, other than their portrait was taken by Woodbury and Page and is in the collection of the Rijksmuseum. The child is unapologetically Eurasian, front and centre of his or her parents. They are proudly recording themselves for posterity in a world that accepts them.

Had Walter and Marie remained in Java, they too might have been this proud couple (only with seven more children). The differences between Mancunian (of Manchester) and Javanese cultures might have been socially and psychologically surmountable. But they did not remain. Walter took Marie back to England with him, to a world as alien to her as hers was to him, possibly more so, because Walter had acquaintances and colleagues, a support system that helped him navigate the unknowns of colonial and Javanese society. Marie, it seems, had no one except Walter, who was not the most socially perceptive of people. He spoke a little Malay and she perhaps spoke schoolgirl English. She spoke Dutch but he didn't. His family, according to family historian Ellen Woodbury Ferguson, his niece, was not welcoming.

Interracial couple posing proudly with their child (Courtesy Rijkstudio)

Walter's motives were professional: he needed to be in England to patent his revolutionary Woodburytype photographic process, which used transparent inks to create a photograph of extraordinary beauty, detail and permanence, and create it in numbers significant enough to change the course of photography and publishing. Others were working on new processes and Walter needed to be "where the action was."

I know nothing of Marie, beyond the facts recorded in census and legal documents, snippets of information (she was interested in wild plants and flowers),three pictures-- two family pictures from the *Whitworth Album* and one taken during one of Walter's experiments, and Ellen Woodbury Ferguson's handwritten family history. I do not

know what kind of a person she was, what she liked and disliked, what she feared, what she loved, or whether she had any say in her uprooting to England. I can only imagine what her life might have been like.

Ellen Woodbury Ferguson, Henry James' daughter, wrote the somewhat uncharitable family history in 1935, when she was 70, much of it from recreated memory as she was not witness in person to most of the events. She had this to say:

> Walter and Henry, worked together and had a jolly time—it was said in Batavia that there was nothing you could ask for in the Woodbury ménage, that was not forthcoming in the way of entertainment.
>
> Then came the tragedy!
>
> Walter became enamoured of a girl of 15, the daughter of a Dutchman and a Malay and was determined to marry her. Henry <u>begged</u> (tr. note-- Ellen's underlining) him to think of the consequences. She was such a child and could not speak a word of English! But marry her he <u>would</u>![77]

Sara, Ellen and Henry James returned to England c. 1868 (Courtesy the Collection of Luanne Woodbury)

Apparently, only 10 to 15 per cent of European man–Eurasian woman unions were within Christian marriage, so Walter's decision was highly unusual by the standards of Batavia.[78] Ellen, Walter and Henry James' mum, had passed away in 1861, before Walter and Marie had married or arrived in England, so we don't know what her opinion of the marriage would have been. We know that Ellen-the-mum was concerned with financial security, but we have no idea about how she would have felt about an interracial marriage. From the vantage point of nearly a century later, it's easy to disapprove of the tone

of Ellen-the-historian's comments, but in a contextual way, she was speaking for her times. And her place. And the awful thing is that her opinion had some validity. But only some…

The adorable, chubby babe in arms was Ellen with her parents, Sarah Jane and Henry James. As you can see from the clothing in this picture, the couple were back in England with their young daughter. It's 1866. They have also brought back Annie Page, Page's young daughter, taken by Rowbottom, the executor of her father's estate, under protest from her mother. Henry and his family never returned to Java: going to there had been an adventure that served their purposes. Henry James had made enough money to marry Sarah Jane, and they had wed and borne a child. Java had served its purpose by making them rich.

Another excerpt from Ellen's writing captured the sense of entitlement of a white person in a non-white country, which echoes Miriam Hulbosch's comments about colonials living life on a much higher social plane than they would "at home." Ellen recalls the circumstances of her birth in a letter to her cousin, Albert-Leonard (Albert's son, also born in Java) on October 22, 1935:

> Father and Mother were travelling in Java when the time came for my entry into this mundane sphere—they had reached the little town of Paseareuaen—near Sourabaja—Father tried in vain to hire a house—finally he appealed to the Resident Colonial [Dutch government representative]—now at that time the prestige of a white man had to be upheld—it didn't matter if you were a dustman or a road sweeper in your own country—in Java and the East—you were WHITE and therefore entitled to the BEST! So the Resident promptly turned out the native Sultan, and his retinue because they lived in the best house—and so it came to pass that I was born in the marble floored palace of a Sultan! I am very much afraid that my arrival was not greeted with blessings!![79]

Steven Wachlin, who had included this snippet in the references of his book *Woodbury and Page: Photographers Java*, noted that there

was no Sultan at the time in Paseareruaen.[80] I suspect Ellen's memory was about as reliable a source as Rowbottom's. Much of her account was from recreated memory or shared memory with someone who was there before Ellen was born, but the words are redolent with her feeling of racial superiority and entitlement. My main suspect here is Sarah Jane Aldersey Woodbury. And if one race felt superior, then that race must have viewed the other(s) as inferior as by inference Ellen did here. That perception of superiority/inferiority could have bled onto the mother and daughter's attitude to Marie. Also, perhaps in this account was Ellen's bitterness at lost status and wealth, because mother and daughter ended up as paupers living on the charity of Great Aunt Elizabeth Bentley Whitworth.

Henry James' untimely death in 1873, when he was 36, was from heart failure exacerbated by a tropical disease picked up in Java, so perhaps the women were right to bring their children home to England. After Henry James' much mourned death in Besses-o'-th'Barn, Sarah Jane and Ellen lived with Elizabeth Whitworth, Henry James' aunt and the "Collector of Lost Woodburys." Although widowed and impoverished, Sarah Jane did *not* live with Walter and Marie's family; instead, she lived with her aunt by marriage. Perhaps there wasn't room as Walter and Marie had six children at this point with two more to come. Frankly, Sarah Jane could have navigated Marie through the murky waters of middle-class English society and had a home where she was doing useful work. Perhaps Sarah Jane and Ellen did not want to be associated with Walter's racially mixed family. Ellen must have gotten her opinions on the unsuitability of Walter's marriage from someone. I suspect the source was her parents.

On the journey home (a voyage to Singapore, then the steam packet boat to Suez, overland to the Nile, up the Nile to the Mediterranean and on another boat to England) Henry James, Sarah and Ellen were accompanied by James Page's daughter, Annie, and the servant, Jackaman, both of whom were never photographed; if they were, the photos were never kept and identified. Rowbottom wrote about several episodes he considered amusing in which Jackaman ran afoul of cabbies, etc. Jackaman did not stay in England long (understandably, to a 21st century reader.)

In fact, Rowbottom, who was the executor of Page's will, seemed quite put out that he had to pay Page's widow £40 to part with Annie. To be fair, Page did not leave very much money: his will was flagged as being an estate of under £2000. Page's will divided his estate between his sister, Hannah Page Boese, and his daughter, Annie. The wife in Java was not mentioned in the document. Did Page actually formally and legally marry her as Walter did Marie? (Rowbottom said that Page married her, but Rowbottom is not the most reliable of sources.)

Was she left destitute in Batavia? Was she a nyai referred to by the courtesy title of "wife" when the daughter was born, which Walter was too naïve to realize? If she were, according to Javanese law, she had no rights regarding her daughter and Page (or Page's executor, Rowbottom) was well within legal bounds to take the child from her mother. (Perhaps that's why he was so annoyed at having to pay £40.) Was it expected that the Woodbury and Page firm will look after her? Did Page leave her with money in Java because his estate seems small in comparison to what the Woodbury brothers brought home from Java? If so, and the wife could have supported Annie, her being wrenched away (legally) seems all the more cruel.

We don't know. We don't even know Page's wife's name. We have one picture of her where she is on the edge of the group on the Atelier porch, in voluminous European dress, but not really a part of the European group. We do know that Walter refused to treat Marie this way, and, over the protest of his brothers, he married her with them as witnesses, took her with him to England (as Page did not do with his wife), and stayed with her and the children for the rest of his life.

What would *not* have been a "tragedy" in the more tolerant society of Batavia, a Eurasian woman married to, living with, and having children by a European man, played out as a tragedy in Victorian England. In the world Marie was born into, Eurasians were accepted as Europeans, and Eurasian women far outnumbered European or totok women, even after the opening of the Suez Canal in 1869 halved the travel time to the East Indies. By 1900, when the Dutch East Indies government had lifted its restriction on married men and began to actively encourage Dutch women to come out to Java, even running schools to prepare

them, the imbalance remained. But in England, Marie was a curiosity, not even a tiny minority, and I would be pretty certain that she was not held in the same esteem as a Eurasian in Manchester as her Eurasian status in Java afforded.

I am tempted to think that Walter, ever naïve, took Marie to England with expectations that were fundamentally unrealistic. First, in the society of the Dutch East Indies, racial groups may not only have mixed socially, but they were also commercially connected. Walter's Batavian world consisted of royalty—the Indonesian Rajahs and Sultans and their families and followers like the painter Raden Saleh—the politically powerful, being the Dutch "advisors" to Indonesian royalty, and the higher-ups in the Dutch colonial government—and the financially powerful like the Chinese merchants. All came to Walter to have him take portraits of themselves, their wives and children and their clubs and houses. And he did, hundreds and hundreds of them. There seems to have been no turning away of the rich and powerful.

Walter, although he did make the modern (2021) equivalent of between £627,000 and £4,500,000 (if you are converting real wealth or labour equivalents, according to the website "Measuring Worth,") was not one of the politically and commercially powerful. He did, however, live like a lord or at least minor gentry such as a country squire. Miriam Hulsboch, author of *Pointy Shoes and Pith Helmets*, points out that the European colonials' lives were much closer to the upper class of their home countries than their actual class origins. Remember Ellen's comments on her birth: a European had to have "the best" even if he were a street sweeper in England.

Walter, although probably he is rather oblivious to it, lived at a far more luxurious level than he would have above a shoe factory in Manchester. His mother, in the census for 1851 only had two servants, despite having six children at home and running the family business. Walter's household had over 20 if you count his housekeeper, house servants, grooms, coachmen, porters, groundskeepers, and assistants. It would have been a shock for Walter as well as for Marie to go back to Manchester's middle class.

And then we have to consider Indonesia's real middle class: the Eurasian population. They were the people who staffed the civil service. They staffed the government offices. They had their own proud uniform—the black suit. They were one of the factors that made the "idle rich" lifestyle of the colonials possible. And they could rise to power, at least in Batavia, not in England. Four Eurasian women were wives of four Batavian governors. Marie was Eurasian. She came from a wealthy plantation and was carefully dressed and educated to European standards. She married a successful, popular and loving European man. At 16, she seemed to have achieved every Eurasian girl's dream. But the dream didn't turn out as planned because of the double whammy of racial intolerance and middle-class expectations and circumstances Marie encountered in Britain.

VICTORIAN ENGLAND

Walter and Marie arrived in England in late 1863, Walter intending to patent his inventions, further his career and continue making a fortune. That's not how it happened. Walter's career skyrocketed, then crashed and burned most spectacularly. He had taken Marie with him on this wild ride, and they were going to have a rough time of living in England—particularly Marie—particularly when the money ran out and she was a visibly foreign woman with eight mixed-race children in a civilly hostile environment.

Marie, who had been raised to a life of privilege as the daughter of a successful plantation owner, with plenty of female attendants and servants, was eventually reduced to running a household with eight children and one servant. Ellen, the historian, commented that Marie was a good cook and handy with a needle, so she was making the children's meals and clothes, things the small army of servants would have done for them in Batavia. I think that the real measure of the cultural, psychological, and financial discomfort the family felt was that within seven years of Walter's untimely death in 1885, eight of the nine remaining family members fled England looking for a better life.

WALTER'S CAREER SKYROCKETS AND CRASHES

Let's face it: Walter was in part responsible for his own career fiasco. I can't blame the debacle only on racial intolerance and Marie's inability to fulfill the "Woodbury businesswoman" role. The man was mercurial and would have preferred to invent things rather than effectively promote, market, and manufacture his inventions. The main decisions in his life so far had been impulsive: chucking his apprenticeship when it was 80 per cent completed to go to Australia to seek gold; buying a camera for £4 when he only has £6 to his name and was 17,000 km from home with no means of buying chemicals to use in photography; falling madly in love with Marie at first sight and marrying her against the custom of Java and over the objections of his brothers.

Another measure of Walter's mercurial nature was that the family moved—constantly. Rowbottom, who was Walter's financial advisor for a time, called him a "rolling stone." Walter's membership in the Royal Photographic Society listed five London-area addresses. Florence and Walter were born in Brooklands, Cheshire, but the next child, Constance, was born in Rusholme, Manchester. Next, they moved to Worcester Park in Surrey but by the 1871 Census, they were in Harley Villa in Penge, Surrey. The family stayed at Craven Cottage in Fulham from 1872–75. Next was Manor House in South Norwood and Java House on Manor Road in S. Norwood, although Manor House and Java House may have been the same establishment. Mayence was born in Brompton, London, while Valence was born in Fulham, and Hermance, Fayance, and Avence were registered as being born in Greenhithe, Kent. That's quite a few moves in twelve years, not counting Walter's trips to the USA, France, and Germany, and his stay in Italy for a winter with Marie. The constant moving would have prevented either Marie or the children having a sense of belonging to a community, if that degree of toleration were possible in Victorian England. Walter himself did belong to a community—of scientists and inventors, as you can see in the photograph of the all-male, all-photographer Solar

Club, but Marie and the children did not have that. They were socially isolated and, in Marie's case, culturally, and linguistically isolated too.

A significant piece of the puzzle here is the "businesswomen" factor. In Walter's family, the men embraced causes (the Early Closing Movement) or followed various scientific enthusiasms (the purchase and exhibition of the skeleton of Chunee, the establishment of the Manchester Zoological Gardens, the meaningful support of Audubon's work), while the women raised the children and ran the business, which provided the funds which allowed the men the time and means to follow their enthusiasms.

As a child, Walter was able to experiment with photography, a hobby that was not cheap, rather than work in the family shoe business. He apparently was not required to have anything to do with the shoe factory, even being apprenticed to a profession (drafting and engineering) rather than helping to run his twice-widowed mother's business. He was, after all, the eldest son. Nor did he seem inclined to stay at home and help his mother raise seven fatherless children. Nor did he seem to have much financial acumen. Until Rowbottom took him in hand, Walter had no success in getting funding for supplies for his thriving photography business in Java. The world of business was likely more alien to Walter than the dense jungle in Java.

Arthur Rowbottom, with his ties both to the East and to the world of business, was an important presence in Walter's return to England. Ellen, his mum and rock, had died two years before Walter's return, and her widower did not seem to have any degree of commitment to his wife's family. In fact, he may have even taken the shoe business as his marriage settlement, leaving Ellen's children without a penny from it. Ellen's will made no mention of the business and daughter, Ellen, found herself living with her Aunt Elizabeth. Daughter/sister Ellen had to make her own way as a governess/companion which was the usual path for genteelly raised women with no money.

Brother Frederick vanished, apparently lost at sea at the age of 20. Little Emily, the posthumous baby, was living with her Aunt Lawson, the sister of the father she never saw. Brother Henry James' widow and daughter, once their fortune from Java had been lost, lived on the

kindness of strangers (their angel, Mr. Lee) and on the charity of Aunt Elizabeth Whitworth. When she was 15, this Ellen was earning her own way as the teacher/governess to a family with eight children under eleven years of age. By the time Walter returns home in late 1863, the Woodbury family was beginning to experiece difficult financial times.

Walter, as eldest son, might presumably have inherited the business, not that he would have wanted to run it, but he did not. Here's Rowbottom on Walter's early days back in England, when the newlyweds stayed with him rather than Sister Lucy or Ellen's widower, Edward Lloyd. The excerpt indicates how close Walter and Rowbottom were; however, it also sounds to me like he's trying to sneak some of the credit for Walter's invention of the Woodburytype as this account, like family historian Ellen's, is recreated memory. Here he recalls an event in 1864 in the book he published in 1893:

> After a while, Mr. Walter Woodbury, who had married a Malay lady, thought he would like to come to England again, and he did so, bringing his wife with him, the couple staying at my house in Birmingham. I had forgotten all about the transparency incident, but not so Mr. Woodbury. It was one of the first things he wished to look at, and it was quite marvellous to see how he tried to make his wife see with his eyes what there really was in it. It appears that since his former visit he had been making experiments in connection with this transparency idea, and he was now prepared with an invention that promised, as he thought and believed, a great fortune. He explained some of this invention to me and wished me to assist him in the matter of obtaining a patent for Europe and America. I introduced him to the firm of Tangye Brothers, and they rendered him a good deal of assistance in the matter, the result being that the Woodbury-type process was launched before the world, and made a great impression upon the artistic development of the time.
>
> Now it seemed that the ball of fortune was at his feet, the process was taken up by various firms throughout Europe, and

> from the royalties that they paid him he accumulated a great deal of money. He took a beautiful place with large grounds on the Thames, called Craven Cottage, formerly the residence of a well-known peeress, and it seemed as if he were about to settle down for good in his native country and live the life of a wealthy gentleman. But he was of a very restless disposition; in fact, so much of a "rolling stone" that he could never long be content in one place, so in spite of his great expenditure of the Thames-side estate, he after a time gave it up and went to live in Croydon.[81]

One wonders why the Walter-Rowbottom alliance fizzled out. Perhaps Rowbottom didn't want to be associated with Walter's financial fall as he was with Walter's financial rise. Maybe Walter was too busy inventing to ask for Rowbottom's financial advice. He probably should have.

What Walter was doing was developing a process that would revolutionize the way we see things. His work changed the nature of photography and in many ways made it more accessible to the public. In his book, *A History of the Woodburytype*, Barret Oliver says, "The Woodburytype signals the transition of photography, in technological and symbolic ways, from the classical period to the modern period. It marks the turning point in technology between prints made by hand on a small scale and prints made with the aid of machinery as part of mass production."[82]

Walter was ever seeking to improve on things, whether it was the cases used to carry photographic supplies in Java or the idea that occurred to him as he first looked at a transparency in Rowbottom's house. He combined the technique of the photos he had been taking in Java with a transparent ink to create the Woodburytype. I won't go into the process here: rather, I will again refer you to *A History of the Woodburytype*. Barret Oliver is a practising wet plate photographer who has become enamoured with the beauty of the Woodburytype. He can explain the impact of process far better than I can.

Oliver also puts the Woodburytype into historical context:

> Like the carte-de-visite a decade before, the Woodburytype changed the way people lived with photographs. For Victorian readers accustomed to seeing traditional prints in books, which were re-interpretations of the original, or photographs hung on walls, photographs in books were something novel and special. Not only did the reproductions afford a more accurate study of the subject, but their portability had the added value that it could be shared with others. Liberated from re-interpretation, illustrations now had a higher scientific and social value… people saw photography as an extension of literature—as a way to distribute information, both aesthetically and as document. With photomechanical printing, and the Woodburytype in particular, a whole new era emerged. It made possible publications devoted to disseminating pictorial information by photographs. The publishing boom in the 1870's foreshadowed our modern idea of photography for the masses.[83]

Alan Elliott, who as well as being a Woodbury scholar was a retired industrial chemist, explained what Woodbury was doing with the process, chemically:

> Shortly after returning to England in 1863 with capital from his Java business, he devoted himself to solving the serious problems which were inhibiting the sale of photographic books—the slow production rate of albumen prints and their tendency to fade. He moved from silver-based chemistry to the permanent but imperfect dichromate-based carbon process of Alphonse Poitevin, the main shortcoming of which was the poor rendering of half-tones. After much arduous work he was successful in combining Poitevin's process with aspects of Fargier's carbon process and innovations of his own. Woodbury arrived at an entirely novel solution to photomechanical printing for which he held British Patent no. 2338 of 1864. He later improved the process by incorporating the technique of nature printing in which the hardened gelatin matrix was forced into a sheet

of lead under high pressure. Prints in pigmented gelatin were then cast from the resulting lead mould. The salient features of the Woodburytype printing process were that it was suitable for high production rates of high- quality images while avoiding the use of introduced grain or the half-tone screen. The half-tones and delicate detail were reproduced smoothly and precisely by the varying thicknesses of pigmented gelatin.[84]

The Woodburytype was revolutionary because it was a photomechanical printing method, not a photochemical one. At this point, many chemically created photographic prints were subject to yellowing or fading. They were also inconsistent and messy to produce—and they had to be produced singly even if they were multiple copies produced from a single negative. The Woodburytype used gelatin ink printed on a mould formed from a carbon print, applied with great pressure. The result was a print that does not fade (I have half a dozen on my walls that are from Java in the early 1860s and so are, at the time of my writing this, more than 160 years old. They are exquisitely detailed and do not show the ravages of time, although the paper they were mounted on does.)

The really revolutionary development was that Woodburytypes could be mechanically produced in multiples—enough for the press run of a book. Before this, the only multiple copies were the images produced one at a time from a glass negative or by the multiple lenses (up to 16) on a carte-de-visite camera.

Having created a superior product in details and resistance to fading and copies which could be printed, Woodbury found himself in a battle. As soon as he returned to England, Walter was engaged in patenting his Woodburytype process, which involved a scientific standoff with the established inventor, Sir Joseph Wilson Swan, who invented an incandescent light bulb—10 years before Edison, although to be fair they were both working on an idea that had been around since 1800. Swan's house in Gateshead was the first in the world to be illuminated by electricity. Swan was a "heavy hitter" and he was known to the English scientific community. Walter was the outlier.

Swan had come up with a photo-relief technology of printing. Apparently both Swan and Woodbury had similar ideas for refinement of the carbon process simultaneously. Swan called his process photo-mezzotint. Duelling articles appeared in the *Photographic News* and *British Photographic Journal* almost every week from April to June of 1865. Swan had begun speaking of his process in February of 1864. In September of that year, Woodbury was granted a patent for his process and published full details of it in March 1865. But Swan had published the working details of his mezzotint process in October 1864.

This was not a scientific squabble for bragging rights in a scientific journal. There was big money involved here. The crux was being able to produce quality photographic prints in large quantities. Walter was awarded British Patent 2338 in 1864 and began a campaign to publicize his invention. He printed and distributed thousands of copies of the photograph called *Mountain Dew Girl*, from a negative by H. P. Robinson free in the *Photographic News* of Jan. 26, 1866. Walter was getting an education on the politics of inventing and the value of publicity. A lesson he learned at his grandfather's knee was that people understand what they see, whether it be the comparative anatomy of skeletons or a superiority of a photographic process.

Mountain Dew Girl, Woodbury's promotional photo print distributed free in *Photographic News*, Jan 26, 1866

Now, obtaining and keeping a patent was an expensive proposition until the radical lowering of the patent fee on Jan 1, 1884, which was a bit late for Walter as he only lived until Sept. 5, 1885. According to Alice Kuegler in *The Responsiveness of Inventing: Evidence from a Patent Fee Reform*:

> Before the reform, the costs involved in patenting in the UK were high in terms of average local living costs and impeded inventive activities …. The pre-reform fee of £25 is approximately equivalent to £11,400 in 2015, when deflating by

> average earnings. To relate the fee to the earnings of a middle-class employee, the yearly salary of a clerk employed in the UK Patent Office was £177 in 1883 and that of a Patent Office draughtsman was £131. When introducing the new patent bill in 1883 Joseph Chamberlain, then the president of the Board of Trade, called the initial patent fee of £25 'an insurmountable obstacle in the way of the poorest inventors.' In addition, cumulative renewal fees of £150 had to be paid to keep the patent in force until a full patent term of 14 years...For renewals before 1884 a renewal fee of £50 had to be paid to keep the patent in force after the first three years. A payment of an additional £100 was required after seven years to maintain the patent until the full term of 14 years.[85]

Consider that keeping the patent in effect for 14 years cost the equivalent of a year's salary of a clerk in the patent office. The patent office clerks were relatively well paid in contrast to servants and labourers who received a quarter of that sum. The UK National Archives Currency Converter says that £175 in 1870 would purchase 11 horses, or 32 cows, or pay for 875 days of a skilled tradesman's work. (Scrooge's Bob Cratchit's "15 bob a week" salary works out to £39 a year.) Walter had over twenty patents in England alone, so we begin to see the huge expenditure of Walter's Java capital. He also had patents for the Woodburytype in France, Australia, Italy, Belgium, Germany, Austria, and the United States. And that's not even considering the cost of the materials for experiments or the fact that, by experimenting, Walter was not working for a wage. He had a household and eight children to provide for and educate.

He ran the Manchester photographic studio for a time but gave it up. He had speaking engagements to promote his inventions. He frequently spoke to learned societies, entered his work in exhibitions, and wrote for the photographic press. He did magic lantern shows. He travelled to other countries (France, Italy, Germany, the USA) to promote his inventions and investigate their inventors' work. He still went bankrupt.

In 1866, Woodbury formed the Woodbury Photo Relievo Company, with the intention of buying Swan's patent for his Mezzotint process. Swan refused to sell and the company was quietly dissolved on April 10, 1867. Its offices were at 60A Market St. in Manchester, which happened to be Walter's photographic studio. But later in the year, Walter sold the French patent rights to the Woodburytype to Bingham, who promptly sold them on to Goupil et Cie for £6,000, little of which Walter would actually see.

The Goupil Factory 1873 (Courtesy *L'Illustration*, no 1572, April 1873)

This engraving is of the Goupil Factory and it looks to me like it had a production line going long before Henry Ford (but then, the Venetians employed one to turn out a war galley in a 24-hour period in the Arsenale at the height of their sea power; Ford refined the idea of the production line, but he didn't invent it.) The Woodbury presses were on revolving tables and one workman worked each station, inking the first press, then the second, and by the time he had finished (there could be up to 10 presses) the first press was finished, back and ready to be re-inked. Goupil printed approximately 60,000 Woodburytypes each year.

Woodburytypes were exhibited at the Paris Exhibition of 1866 and drew favourable notice from the Emperor, Napoleon III. You would think that all was going well, but fast forward to 1870: Goupil's printing enterprise was badly damaged during the Franco-Prussian War. Worse than that, Goupil stopped payments in January 1870, claiming that the patent was invalid in France and offering Walter a rather paltry lump sum to buy him out.

Thinking perhaps that some payment was better than none, or perhaps urgently needing the money for other inventions or school fees for eight children, Walter sold the patent completely, and after lawyers' fees and payment to Bingham, walked off with £588—not a great sum for one of the seminal inventions of photography, and one-tenth of what Bingham made in selling the rights for a time. But we

have established that Walter was no businessman... Incidentally Goupil continued to use the Woodburytype process until it was succeeded by more modern processes in the 1890s (fragmentary document, *The Woodbury Papers*, Ref 509 W/B).

In fact, once the presses were running, one of the uses of the Woodburytype was in medical text, where the photo rendered the condition in brilliant detail. Another use was in books like *Men of Mark* where the Woodburytype portrait of the Great Man (always men. This was Victorian England and the only Great Woman would have been Victoria) would be accompanied by a flattering potted biography by Thomas Cooper. Like Audubon's seminal study, *Birds of North America*, *Men of Mark* was published in parts, with men of business, or actors, or scientists being the focus of the installment. Volumes were published between 1876 and 1883, each with 36 luminaries featured.

A single volume book publication was John Thomson's brilliant *Street Life in London*. This Woodburytype is called *The Crawlers*, which was street slang for a beggar. Thomson had, like Walter, travelled and photographed the East, taking photographs of Malaysia, Cambodia, Vietnam, and China, but he is best known for his study of the destitute of East End London, a work he began in 1872 and published in 1877 (two years after Walter's *Treasure Spots of the World*) with written commentary by Adolphe Headingly. It was one of the first books, as is *Treasure Spots of the World*, where the illustrations were supported by the text. Like Audubon, Thomson often posed his subjects, but they and the background were authentic.

The Crawlers, by John Thomson, *Street Life in London* (Courtesy Wikipedia free commons, National Library of Scotland)

As a wonderful epilogue to the Woodburytype process, not only is it being revived by lovers of beautiful photographs; a Woodburytype press in working order and still being used (albeit retrofitted to be a regular hydraulic press) was discovered in 2000 in the Eveleigh Railway

Locomotive Works in Sydney, Australia. The Victoria, Austalia branch of the Royal Photographic Society was over the moon.

Woodbury also patented the PhotoFiligraine process in 1867, thinking that it would provide a more accurate and better basis for printing than watermarked paper. He felt that it could add security to banknotes and print on cloth, but nobody seemed particularly interested in the process, at least legally. According to Peter Jackson's article in John Hannavy's *Encyclopedia of 19th Century Photography*, "the photo-filigraine process was used by a famous forger, Leon Warneke, to forge Russian banknotes."[86]

Years after its patenting, in a visit paid to the Woodbury studios in Manor House in 1882, the writer and practising photographer Henry Baden Pritchard enthused over PhotoFiligraine:

> Lastly, here is the filigraine process. "I call this the cheapest photographic image ever made," says Mr. Woodbury; he takes a carbon print developed on paper, hard and dry, of course, and sends it through the little rolling press, in company with a sheet of plain paper. The consequence is that when the latter comes out, it has a water-mark of the same design as the carbon print with which it has been pressed into contact. Any design may be thus impressed. Here are visiting cards, with the portrait of the visitor to be seen if you hold them up to the light; writing paper with all sorts of fancy designs; trade-marks, labels, &c. Filigraine, if it tis the simplest, it is also the most fascinating of Woodburytype applications.[87]

In 1869, we find Walter at The Solar Club, which was an informal "upstairs room" club of practising photographers in London. (An upstairs room club was one with no fixed club premises.) The club ran until 1890 when it was disbanded. I find this picture of the club's members fascinating, not only because of the technical difficulty of taking a group portrait indoors in 1869, but because at the mid-left, the burly bear of a man with the burly beard, leaning forward with his elbows on the table is William England, the father of my

great-grandfather, Walter England. On the far right of the photograph, leaning slightly back, we see Walter, clean shaven but for his moustache, with his thick head of hair. He is the father of my great-grandmother, Hermance. But more of Hermance and Walter later. Much more...

The Solar Club (Courtesy Collection of Alan Elliot)

Since the photographer, O. G. Rejlander, is also present in the photograph, it must have been taken by a time delay mechanism or an unnamed assistant. Several of these gentlemen collaborated with Walter to produce his ground-breaking book, *Treasure Spots of the World*.

In 1871, Walter went to the US, where John Carbutt had acquired the patent rights to the Woodburytype. There, Walter saw North American advances in photography, such as Albert Moore's work on enlargements. He visited the studios of William Nottman in Montreal, Quebec, and made a lifelong friendship with Edward Wilson, editor of *The Philadelphia Photographer*. In Philadelphia, he also met Lorenzo James Marcy who had improved the magic lantern, calling it the "sciopticon." Marcy was an optician so he had combined a superior lens with the latest technique in light production to produce what was then called a "magic lantern" or projector. Sciopticons or magic lanterns

were used for lectures in church halls and public spaces. They never caught on as a Victorian parlour entertainment as the stereo-viewer had, perhaps because they were much more technically complicated with their internal light sources. Stereo-viewers had no light-producing mechanism and slide was viewed against a light source like a table lamp. Early sciopticons ran on small reservoirs of kerosene so possibly they would have been rather smelly in a stuffy Victorian parlour.

The sciopticon or magic lantern (Courtesy Victoria Museum, Australia)

Walter was so impressed by the machine that he acquired the rights to produce it for the UK market, added a few tweaks of his own, wrote a manual for it, and some articles about it for the magazine *Science at Home*. He created the Sciopticon Company to sell the lantern in England. Then he produced a series of lantern slides for it, mainly based on his photographs from Java, but branching out to Egypt, Jerusalem, and even microscope slides. He also did a "potted" lecture on "Life in Java," illustrated with 48 slides of "Java Types" such as this slide of "opium user."

Opium User, glass sciopticon slide, from the Java Types series (Courtesy KITLV)

Also, Walter founded the Woodbury Photographic Printing Company, which actually lasted for 20 years until it merged with Eyre and Spottiswoode after Walter's death. Eyre and Spottiswoode were the Queen's Printer. To found the company, Walter had to buy back the patent for the Woodburytype from Disderi and Co. Then he created a production line for magic lantern slides. (I have several Woodburytype

lantern slides of Landseer's sentimental paintings of dogs, but then, I am a sucker for dogs.) Walter calculated that he could make 20 moulds from a negative and run perhaps 500 to 600 glass sciopticon slides from each mould. He really was the link between artist-inventor and producer. He just didn't seem to have the business acumen to profit from that link. Nor did his wife.

In 1872, things began to go "a little pear shaped." Walter's patent on the sciopticon was "poorly written and incomplete" according to Trevor Beattie in his article for the Magic Lantern Society, "Walter Woodbury and His Sciopticon." Beattie goes on to say that "this lazy oversight would cost him dear"[88] and the lantern was quickly copied by rival companies. Walter's company produced and sold 400 lanterns, but in 1873, one of the rival companies who copied the patent because of the loopholes, sold 1,000 lanterns.

Walter should still have had enough of his Java money left to afford the "continuation" fee the patent office charged, but he may simply have had his mind on other inventions, or perhaps since the sciopticon was only in part his invention, he wasn't careful enough in wording the patent. We know from Walter's many articles in photographic journals that he was a very competent technical writer, so this incomplete patent is puzzling. The only thing I can think of is that the initial invention wasn't his own work (he made some improvements to the lighting system of Marcy's improvement on a device that had been around for several hundred years) and he didn't know it as well as he would have known his own work. Walter tried to refile the patent, but got nowhere with that.

Woodbury was a much better as an inventor than as a businessman. He generated widespread commercial success but somehow never managed to make much money for himself. All his spare cash went into new inventions and patents."[89]

Walter decided to find a new way of bringing photographs to the public. He had published *Vues of Java* years earlier, but that book was in effect a photo album with prints chosen by the purchaser or photographer, so that each was different. This time, Walter created what will be the precursor of the "coffee table book" (and even magazines like

National Geographic) by publishing *Treasure Spots of the World* with the entire press run having identical pictures which were supported by the text. There was nothing like it in 1875.

In this revolutionary new format, Walter published 28 Woodburytype prints of landscapes by various photographers, including himself (views of Java, unsurprisingly), William England, who was known for his views of the Alps but here contributed two photographs from his Rhine series, and John Thomson, who was better known for his Woodburytype photos of the street people of London but had photographed extensively in Asia. Thomson contributed a view of Amoy (Xiamen) Harbour, China.

Cover of Treasure Spots of the World (Courtesy of the Rijksmuseum)

Here's Walter's introduction to the book:

> The object of this, the first gift book of its character, is to place before the public a selection of the world's beauties and wonders, which being all pictures of the unerring sun's work are necessarily true to the places they represent without any flattery. The Editor's aim has been to make the selection pleasing from its very variety, and to represent the most interesting places to be found in the principal countries of the world. The photographs are all taken by gentlemen whose names stand high in the photographic profession; and the proofs being printed imperishable pigments by the Woodbury process are thus guaranteed from fading or ever losing their brilliancy. The endless choice of earth's beautiful scenery will enable us, should the present volume receive the esteem of the public, to present yearly a collection of the camera's choicest renderings. W.B.W. Cliff House, Greenhithe.[90]

Colossal Figure, one of Walter's own photographs in *Treasure Spots of the World*
(Courtesy the Rijksmuseum)

Walter had planned to publish a similar book each year but did not. Perhaps, although the book was acclaimed by the photographic press, its price of one guinea was too high for the buying public—or perhaps its format was too new. Or perhaps Walter's mercurial mind had moved on to other things. Or perhaps health issues intervened.

Walter and Marie spent the winter of 1875–76 in Italy, which may have been for his health as he had suffered a severe illness. (Remember, his partner died of sprue at the age of 32 and his brother died of "a disease contracted in the tropics" possibly malaria, at the age of 36. His father died at the age of 36. Walter is 44 at this point.) Or maybe it was because he was taking landscape shots, a la William England who had established a small, thriving photographic empire based mostly on his stereoscope views of the Alps in Switzerland and northern Italy.

Walter was taking photographs and views for sciopticon slides, his rival to the parlour stereoscope. He knew William England personally and knew how successful he and his family firm were in producing stereoscope slides. In fact, William England employed his son, daughter, son-in-law, and niece in an enclave in St James, Notting Hill. Later, the

family would be united by marriage—at least for a while—as William England's son, Walter John (my great grandfather) married Walter and Marie's daughter, Hermance (my great-grandmother). It didn't last, which was unusual for a Victorian marriage.

Alarmingly, while taking pictures in Italy, Walter and Marie nearly got blown to bits in a quarry accident. Walter recorded the incident with his characteristic self-depreciating humour. He was setting up the camera to photograph a landscape view from the vantage point in a quarry near an erupting Mt. Vesuvius. Well, let Walter himself tell it. He called this episode, published in *The British Journal of Photography*, "The Imaginary Brigand."

> We had one morning wandered along a rugged path to some distance up the mountain side and at last pitched on a suitable point of view. After manoeuvring and chancing position of the camera at least a dozen times to obtain a suitable immediate foreground, I buried my head, in time-honoured fashion, under the velvet with a view to focussing or focussing a view. Everything was perfectly still and quiet and no signs of life in our vicinity. I had just got the image on the ground glass to my entire satisfaction and my wife being close by in her usual occupation when with me—that of searching for new sorts of ferns and wild flowers—when I was startled by a cry near, and on throwing off the focussing cloth what was my astonishment to see a man who had a tight hold of my wife, and was dragging her along as hard as he could tear up the mountain. The shock was rather sudden but not so much as to prevent me giving chase. My first thought (and what a lot one can think in a few seconds!) was of *brigands*! I remembered that the mountain above us had been celebrated for these gentry and ransom the next. With all due respect to the party being abducted, I wished they might get it.
>
> At any rate, I left my camera and tore after them, tumbling every second into the crevices on the mountainside and getting

scratched all over with the brambles through which I had to pass. In a moment more, the whole mystery was explained by a tremendous explosion that shook the ground under us, and was echoes from far and near in every direction and which proceeded from the spot where I had left my camera. A second after, an immense mass of portions of rock, stones and debris shot high in the air, and came falling all around. It seemed that, hidden by a thick mass of brushwood, and just below where I had planted my camera, blasting operations on an extensive scale were being carried on, and an Italian working in the neighbourhood, whose presence we had not previously observed, having perhaps heard the signal and seeing the imminent danger we were in took the surest step to get us away, doubtless feeling certain that by running off with my wife I would be sure to follow, while valuable time would have been lost in any attempt at explanation.

On returning to the spot the camera was found uninjured, though several masses of rock formed a new foreground that I had not previously calculated on. But for the energetic actions of our imaginary brigand one of us might possibly have come to grief. His wages for that day exceeded, I expect, what he was usually in the habit of receiving.[91]

The tone of this account is much like the tone of Walter's letters to his mum from Australia. He recounted the event with a touch of humor rather than drama or anger. Walter came home with a series of photographic prints of the area. They were hung in the 1876 Exhibition of the Photographic Society (now the Royal Photographic Society) and were very well received.

Someone must have been at home minding the children, as Marie was with Walter and except where Walter was tipping their saviour, this was a firmly "we" narrative. Despite what family historian Ellen had to say about Marie's inadequacies, this was a "works for them" marriage.

In 1875, Walter also began working with colour printing in an invention he called stenchromatic printing. Another first for Walter, the process, also called photochromes, was the first photomechanical process for printing colour. It didn't seem to catch on in the public imagination.[92]

In 1877, Walter invented the balloon camera, which was a compact surveillance camera hung from a balloon, that could be flown over enemy lines, a sort of 19th-century proto-drone. A contemporary writer, Henry Baden Pritchard, enthused about the camera in his book, *The Photographic Studios of Europe,* published in 1882:

> We must come to the present day. (1882). Mr. Woodbury has plenty to show us and here at Manor House he has laboratory and workshops full of interesting matters. This oblong little box standing on end, about fourteen inches high and six inches broad is Mr. Woodbury's balloon apparatus. It is not difficult to explain. It is carried into the air by a small balloon which is tethered to the ground by an electric wire. It hangs down from the balloon exactly in the position in which we see it standing upright on the table. The lens is uncapped at will by a revolving disc, which revolves once every time the operator sends an electric current from below. He sees when the balloon has done gyrating and between the turns makes his exposure. He can make four exposures for every ascent of the balloon for he has four plates. These four plates are fixed to four faces of the cube and this cube also makes a quarter turn (bringing another face or plate, into position. The system has a double advantage that only a small balloon is necessary and that no risk is incurred by an aeronaut; for according to recent experience, there seems to be no difficulty about bringing down a war balloon if you can get a cannon within two thousand yards of it.[93]

WOODBURY'S BALLOON CAMERA.
DIAGRAM SHOWING METHOD OF ATTACHMENT TO BALLOON

Camera suspended within outer casing.
Outer casing (sectioned)
Electric circuit wires.

Diagram of Woodbury's Balloon Camera (Courtesy Royal Photographic Society, Victoria, Newsletter Feb 2003)

Woodbury's invention was championed by Lt. Baden Powell, of Mafeking and later of the Boy Scouts, but the army was not interested in such newfangled technology, such as this proto-drone. In a rather bitter note on a fragment of paper in the RPS Archives, (Ref 513 W/B) Woodbury wrote, "Electricity seems to have scared them but photography thus applied would have been practically more useful... Since that time, nothing has & probably nothing will ever be done by our war officials—until we hear of the system being used against ourselves."[94]

The invention did not go unnoticed however; the cartographers mapping the glaciers of Antarctica used names of the pioneers of aerial photography for their maps and named the glacier right next to the Montgolfier Glacier, the Woodbury Glacier. (See Appendix 10.) Walter recouped some of his time and investment by reworking the small camera for amateur use, called the Scenograph or Woodbury Tourist

Camera. He wrote a manual for it. Walter was an excellent technical writer—most of the time.

The year 1879 was one of highs and lows. Walter was a guest of honour at the April meeting of the Photographic Society of France, where he demonstrated his photometer, later sold by Sciopticon. It was a device that allowed the photographer to compare the darkness of the developing photograph accurately.

On March 28, 1879 the *London Gazette* announced the closure of the Sciopticon Company, a new low in Walter's career. The company was sold; his assets were liquidated in November.[95]

> **The Bankruptcy Act, 1869; In the County Court of Surrey, holden at Croydon.**
>
> In the Matter of Proceedings for Liquidation by Arrangement or Composition with Creditors, instituted by Walter Bentley Woodbury, of Manor House, South Norwood, in the county of Surrey, formerly carrying on the trade of a Dealer in Scientific Instruments, at 157A, Great Portland Street, in the county of Middlesex, under the style of the Sciopticon Company, but now out of business. NOTICE is hereby given, that a First General Meeting all of the creditors of the above-named person has been summoned to be held at our offices, No. 60, St. Paul's Churchyard, in the city of London, on the 9th day of April, 1879, at twelve o'clock at noon precisely.—Dated this 24th day of March, 1879. PLUNKETT and LEADER, No. 60, St. Paul's Churchyard in the City of London, Solicitors for the said Debtor

This did not mean that Walter was facing a Dickensian debtor's prison, but the proceedings would have been unpleasant, public, and humiliating. In the *Debtors' Act of 1869*, prison was not an automatic consequence; it was a possibility. First Walter had to do the following:

> Fully and truly disclose to the trustee administering his estate all his property, real and personal, as well as provide full details

> of when, how, and to whom, he had disposed of any part of his possessions.
>
> Deliver to the trustee all of the real and personal property in his possession or under his control.
>
> Deliver to the trustee all books, documents, papers, and writings relating to his property or affairs.[96]

If Walter had made any attempt to hide assets, then he could have been imprisoned.

The next step was a public examination in front of creditors, held usually at the offices of the official receiver. Details of Walter's finances were revealed in the meeting on April 9, and the press had the right to attend. (In this case, thankfully, the press did not pick up on the story.) In fact, anyone had the right to attend—neighbours, customers, employees... Then request was made for creditors to provide proof, which was published and kept the bankruptcy in public consciousness.

Bankruptcy was a terrible thing to Victorians. It features in popular novels as a worst-case scenario: think Gaskell's *North and South*, Dickens' *David Copperfield* or *Little Dorrit*, and Thackeray's *Vanity Fair*. In the Victorian mind, bankruptcy was a not only a financial failure but also a personal failure, a failure of character. In this case, though, the creditors seem to have been kind. The business was sold and continued with another owner, and the family did not lose Java House, their home in South Norwood, a suburb of London.

This is a CdV of Walter around the time of the bankruptcy, sent to me from *The Whitworth Album*, my companion piece to the CdV of Marie, although taken much later. Walter wrote on the back that he was using up the old stock and had sent it to Elizabeth Whitworth and/or her daughter Lizzy, to show "how fat I am." I'm assuming Lizzy printed the "introduced photography to Java" note (which isn't exactly correct because there were two photographers in Java before Walter but they weren't as popular). These CdVs of Marie and Walter are two of my most prized possessions.

CdV of Walter, complete with notation in his own handwriting
(Collection of the Author)

Walter bounced back after the bankruptcy, inventing the stannotype process in 1881 and writing a manual for it, and he formed Woodbury, Treadway and Company to exploit the new process. Stannotypes eliminated the need for the expensive presses and some other problems with the Woodburytype. The Woodburytype needed extensive "after printing" work—an alum bath, careful drying, and trimming and mounting on paper of just the right weight so the print didn't curl at the edges or "cockle." Two of the real problems with the Woodburytype were that it couldn't be printed in really large format and that it couldn't be integrated into a page with text. Each Woodburytype had to be "tipped in" or manually put into the book, attached to bindable paper. Woodburytypes could, however be printed in quantity. Walter once did a print run of 30,000 and the Woodburytype was the print of

choice not only for high-end illustrated books such as *Men of Mark*. It was also used to create the ephemera of publicity given to an actor's adoring public.

This time there was no rival inventor claiming rights, and Walter was acclaimed. In fact, the *British Journal of Photography* noted:

> The number of medals and other awards that Mr. Woodbury has gained is very large. A portion only of them fills a good-sized frame, forming a trophy of which anyone might be proud. Curiously enough, until comparatively recently England was almost the only civilized country that failed to recognize the merits of her own son; but this defect has been remedied by the award of the progress medal of the Photographic Society, and again, a medal for the Stannotype process at the latest exhibition.[97]

John Hannavy in the *Encyclopedia of Nineteenth Century Photography* comments that the invention of the stannotype was not popular because the gelatin process was too complicated and time-consuming for amateurs and the professionals had already put much investment into the hydraulic presses needed for Woodburytype printing, so saw little use for it.[98] (The stannotype process eliminated the need for the powerful hydraulic presses required by regular Woodburytype printing by using soft metal plates.) The invention was patented in 1881 and garnered more medals but it came too late. Cheaper, easier, but inferior processes had taken up the niche the stannotype was meant to fill—everyday printing.

Manual of the Stannotype Process written by Woodbury (Courtesy the Collection of Alan Elliott)

The Woodburytype was still the gold standard for medical texts and art and portrait books, but its days were numbered. To this day, no other process can rival it for beauty and fine detail, but the process was just

too cumbersome and labour-intensive to be profitable anymore. So, if it is practised today, it is by art photographers who understand and appreciate the beauty of the result.

In 1883 Walter had been awarded the Progress Medal of the Photographic Society, now the Royal Photographic Society, and the Society's Exhibition Medal, for the stannotype process. Unfortunately, custom did not follow all these accolades and Woodbury, Treadway and Company did not thrive, despite its business being run from Java House so that no business premises needed to be hired. Java House served also Walter's laboratory. Again, here is Henry Baden Pritchard in 1882, speaking of a visit to Walter's Manor/Java House:

Progress Medal of the Photographic Society (Courtesy the Collection of Alan Elliott)

> "What a capital workshop you have here!" we say; It is divided into four compartments for workmen, a broad passage running along at right angles to the divisions. "It is a very useful one says our host, then adds, briefly, "I made it out of a four stalled stable." And so he had; verily Mr. Woodbury is an inventor to some purpose.[99]

The Woodbury Photometer for Measuring Consistent Tones in Photographs (Screen Shot ebay)

Despite his seeming cheerfulness and Pritchard's enthusiasm, Walter was again in dire financial straits. He was working out of a converted stable. He had to sell virtually all of his shares in Woodbury, Treadway and Co. to pay off debts, but because this crisis was not an official bankruptcy, he was allowed to sell 250 shares to his brother Albert. In the end, he had virtually no holding in the company.

Walter wasn't through inventing. In this last year of his life, he invented a musical railway signal (British Patent No. 10,911) for use

during fog, in response to a dreadful train accident caused because signals were not visible. He invented a device which measured the moisture content in linen—a star-shaped paper which turned up the ends of the points according to the dampness of the cloth (British Patent No. 5164), and a provisional patent for recording sound on discs (British Patent No. 14,943). The man's mind was mercurial and ranged far beyond photography, but these inventions found little market.

Not only did Walter have financial difficulties, he had health problems as well. He was never robust and commented on his health in letters to his mother from Australia. He had lived in Batavia, known as "the Graveyard of Europeans" because of its swampy tropical setting. Walter's close work with noxious chemicals was bound to affect his health, although he never quite became a Mad Hatter, one of those unfortunate workers poisoned by the mercury used to treat and stiffen beaver fur for top hats. He was temporarily blinded by experiments with arc lighting as a source for light in photographic developing—an experiment he gave up on and had to rely instead on sunlight through skylights which would be an inconsistent source in Manchester or London!

This experiment may have contributed to the macular degeneration Walter suffered in later life. In "The Electric Light in Photography: A Warning," an article in the *Yearbook of Photography and Photographic News Almanac for 1885*, Walter recalled his terrifying experience with temporary blindness after spending several hours printing ordinary silver chloride paper with an arc light in 1866: "I was told that the white part of the eye was simply a mass of blood." Walter's sight returned the next day, but by 1883, he says

> my sight has rapidly deteriorated, not in the usual way, that is called old sight coming on, but in the form of a white glare or spot covering the centre of vision, so that, as I write this, the word I am writing only becomes visible when I get to the next one, spectacles being of little avail. Reading has also become entirely out of the question. I can only conclude that the centre of the retina has got damaged by the image of the strong arc

> lights, much in the same way as a piece of brown paper is set on fire by condensing the sun's rays on to it.[100]

So, by his own account, Walter was suffering from macular degeneration and suspected the arc light experiments were the cause.

His last patent was shared with his financial backer and co-worker, Felix Vergara, because Walter could no longer read on his own. The patent was filed on August 11, 1885 (British Patent 9575), for making paper transparent so that it could support a negative emulsion—like "the tissue film" that was developed by George Eastman and founded the fortunes of Eastman Kodak. Walter knew of this work and commented that Eastman was "demanding" to work with.

In 1884, Walter had been diagnosed with diabetes, which, although common and controllable today, was a death sentence before the discovery of insulin, by Canadians Banting and Best and their research team in 1921. Diabetes diagnosis usually meant death within a year for a child and within two years to ten years for an adult. The symptoms were blindness (and this may also have been a cause of Walter's macular degeneration), kidney failure, loss of limbs to diabetic gangrene, stroke, or heart failure. There was no cure: physicians tried cupping, bleeding, and starvation, reducing the daily intake of calories to a mere 450—so restrictive that some patients actually starved to death.

Walter drank—rather heavily, in fact, up to a bottle of brandy a day, so he was not on the Allen diet, which restricted caloric intake in a draconian manner. He took laudanum, the only effective painkiller available. Laudanum was a 10 per cent solution of opium in alcohol and contained the full spectrum of opiates, including morphine and codeine. It was used to remedy anything from insomnia to menstrual cramps and was even medically prescribed to relieve the depression of diabetes. But the diabetes would have altered Walter's body chemistry. He himself said, "I have had a bad time of it—'diabetes'—a nasty weakening disease."[101]

In the early 1885, Walter's health was so precarious that he was unable to work and a collection from the photographic community raised £316 and 13 shillings with a substantial proportion (£60)

coming from the Manchester Photographic Society. The fund was in part spearheaded by Edward Bent, a disbarred lawyer and old family friend. In a letter posted in photographic journals, the organizers of the Fund argued the following:

> [T]he subject of notice (Woodbury) has had his successes and his disappointments and taken each with equanimity. Recently, however, his health became seriously undermined before its cause was suspected and without health, the prosecution of his business enterprises was impossible. The crisis of affairs being serious, and becoming known to friends, the regard and sympathy and goodwill toward Mr. Woodbury found expression in the shape of an influential committee, determined to appeal to the photographic and literary world for subscriptions to a fund which should afford him means and leisure to recover his health; and therefore the opportunity of establishing his Stannotype process and completing improvements in block printing, which he has begun.[102]

Although the collection helped Walter and his family over a difficult period, and Walter was gracious, it was woefully inadequate and Walter was hurt rather than helped by the exercise. The Editor of *The Philadelphia Photographer*, Woodbury's long-time friend Edward Wilson felt that the results of the Woodbury Fund were an affront to Woodbury " Owing to the unappreciative element in human nature, the result (of the fund) was but a 'sop.' Deeply did our friend feel it. Rather would he have had no effort made than to have had so little result when scarce an art store exists without a stock of the lovely pictures produced by one of his processes."[103]

THE DEATH OF WALTER

Recovering after a few months, Walter took his two youngest daughters, Fayance who was eleven and Avence who was nine, for a treat, to Margate, a seaside resort. The girls were going to go with Marie, but

Walter, ever subject to whims, decided to take them himself. They took a room in a boarding house at 40 Milton Road, had a late tea, which North Americans would call supper, and Walter promised the girls that, if they let him sleep in in the morning, he would take them for a donkey ride on the beach.

On Saturday morning, the excited girls woke early, at six a.m., but didn't bother their father. Then he didn't come down to breakfast. They waited and waited all morning and finally, near noon, tried to wake him. The landlady intervened—and discovered Walter dead in his bed. He had overdosed on laudanum. He was 51.

I cannot believe that so fond a father would deliberately set up a situation in which his body would be found by his two youngest daughters. Walter was a loving father and a scientist used to measuring chemicals precisely. The fatal change in the power of the dose would have been in Walter's body chemistry, caused by the diabetes, exacerbated by tiredness. I am convinced that his death was an accident—not a suicide.

At the Coroner's Inquest, Marie testified that her husband had been ill for the past year:

> For some time, he had suffered from an attack of diabetes and great restlessness at night and he had been in the habit of drinking to excess, sometimes having as much as a bottle of brandy a day. She last saw him alive at quarter to eleven on the morning of Friday, when he, in company with their two youngest daughters left home to proceed to Margate for a day or two. He had recently obtained a very valuable invention in connection with photography, and in an important engagement, which had reference to it, was made by him for the following Wednesday. It was originally arranged that she (witness) should bring the children down, but he suddenly made up his mind to come himself instead. She knew that he had taken laudanum but he never let her see him use it. They had lived on very happy terms, and now that everything seemed bright, and his future almost provided for, it seemed inexplicable to her that he could have taken his life intentionally.[104]

"His future almost provided for" is both typical of Walter in its optimism and dreadful in its irony. One of the inventions that Walter was working on at this time, with the now-necessary help of Vergara was using paper as the backing for photographic film, rather than glass. George Eastman was also working on this and it was yet another seminal point in the history of photography associated with Walter. If Walter had been able to patent and perfect his "tissue film," the finances of the family would have been assured. But he did not.

Also, at the Coroner's Inquest, there's testimony from Edward Stanley Bent, who would marry Marie in 1889:

> Mr. Edward S. Bent (who had been instrumental in the formation of the Woodbury Fund Committee) said that he had known the deceased for the past 30 years and deposed to the fact that his had been in the habit of taking laudanum. He recognized the bottle produced and had repeatedly seen it at Java House. Woodbury was a great brain worker and it was not an uncommon thing for him to be awake and walking around the house all night. He was also eccentric in his ways, and would often cover his writing-table with unintelligible scrawls which were neither understood nor related to his business.
>
> On Saturday morning, he (Bent) received a post card from Woodbury saying that he had arrived safely and that he had secured lodgings at 40, Milton Road. On arriving at the lodgings, Woodbury took a light tea and between eight and nine o'clock, together with his two daughters, he retired to his room. A few minutes later, one of the girls saw him drinking "some dark stuff" and when finished he requested her and her sister to be good girls and not disturb him as he was "very tired and wanted a good sleep, and if they did not make a noise and wake him too early in the morning he would take them for a donkey ride."
>
> The next morning the two girls arose about 6 o'clock, quietly dressed, believing their father to be asleep, and went out. On

> returning between eleven and twelve o'clock, they found him still in bed and not being able to wake him, they called the landlady who found him dead. Dr. White was called and the police were casually informed later in the day. Dr. White found that Woodbury had been dead about twelve hours and a bottle containing a small quantity of laudanum and an empty tumbler were discovered in his room.
>
> During the course of the enquiry, it was elicited that a piece of paper on which was written some incoherent writing by Woodbury was also found in his room. The top portion of this paper, said to have contained some "French expressions" had been torn off and destroyed by the elder daughter (Fayence). The coroner, commenting on this, chastised Dr. White for not informing the police earlier and so possibly preventing the loss of this piece of evidence.[105]

Medical evidence was given "that in the case of a man of Mr. Woodbury's temperament and in his weak state of health, a dose of the drug which would do him no harm at home, might, under the circumstances and after a fatiguing journey, prove fatal." The jury debated for a longish while then returned a verdict "that the deceased met his death from the effects of an overdose of laudanum administered by himself, but the evidence is not sufficient to prove whether it was accidental or otherwise."[106]

The photographic community was shocked at his sudden death, and a bit guilty, too. Here's an obituary published by Walter's long-time friend, Edmund Wilson of Philadelphia:

> Walter Bentley Woodbury is dead. The sad news comes to us through our English exchanges, just as we (*The Philadelphia Photographer*) go to press. The warm-hearted friend, the able scientist, the ingenious inventor is dead. To us it is a personal bereavement for we had been friends for nearly twenty years... We do not hesitate to place him at the head of all the inventors

in our art, who ever lived. He was only fifty-one years old, and it will be fifty more before our loss can be repaired.[107]

In the following issue, Wilson published this angry and pointed tribute:

Lovely, amiable, tender-hearted generous Woodbury, how our heart sank when we learned of his premature end and how our fists clenched and resentful feelings arose. Some have dared to insinuate that our friend was a suicide. Shame on them! He was murdered, rather. There are men—wealthy men—alive now upon whose shirts his bloodstains are. Men who have robbed him of his rights—who are making money and have been doing so for many years, from the fruits of his inventive genius, and upon whom we call now to divide with the widow and the fatherless, before their names are made public.[108]

This is strong stuff and it touched at least one nerve. Walter's old rival Swan was among the contributors of money to the funeral and the family. It was needed.

Walter left Marie with debts, eight children and very little in the way of an inheritance. His will was probated on October 22, 1885, and left Marie £246, which is the modern equivalent of $23,000 US. All but two of the children were living at home in Java House, South Norwood, in the 1881 Census, so Marie was left with six more or less dependent children and very little money.[109]

Edmund Wilson laments:

now the greatest inventive genius ever given to our age is gone. We shall see him no more but as long as we live our fraternity will profit from his labor. When his applications for the American patents came before the veteran Patent Office examiner Titian R Peale, Esq. he said, "This is an invention…most of the things which come before me are modifications but this is truly an invention.[110]

Now that inventive mind was gone.

In a small ceremony, Walter was laid to rest on September 11, 1885, in Abney Park Cemetery in Stoke Newington, in London. There were four carriages of mourners, but the ceremony did not last long because of the threat of inclement weather.

In 1888, Walter's partner, Felix Vergara, sold Walter's gear and experimental items the the Science Museum in South Kensington for £45.[111]

Walter, "The Edison of Photography," "The Caxton of Photography," died a virtual pauper and was buried in an obscure grave. The cheap headstone quickly weathered into illegibility. It was replaced by his great niece, Luanne Woodbury, in 1998. Its inscription reads: "Some Men Labour: Some Men Enter into Their Labour."

MARIE'S VICTORIAN LIFE

CdV of Marie from the *Whitworth Album* (Collection of the Author)

My knowledge of Marie's life in Victorian England is much more speculative than my knowledge of Walter's because very, very little was written about her. She was Walter's wife and companion, the mother of his children, and the object of Ellen Woodbury Ferguson's waspish sympathy. She is an enigma. But we can try to get to know her a little better...

This is Marie. This is Marie in England. The background props are from Walter's Manchester studio, so the date of this picture is between 1864 and 1868. Her costume is a model of Victorian propriety, with even her hair covered in a net. I would guess her to be around 17 here so it's probably 1864 or 1865. The dress is fashionable and voluminous, with

crinoline, a modest train, a high collar, and long sleeves. It looks to be cotton, perhaps worn in solidarity to the cotton mill owned by Walter's sister, Lucy, and her husband, Frederick Roscow.

The placement of the arm shielding the waist may be disguising her pregnancy, as she will have both Florence and Walter before she is 18. Her the expression is forthright. Marie looks right into the camera, actively engaged with it. I own this CdV and it is one of three photos of Marie known to be in existence. Another remains in the *Whitworth Album* and a third was taken with her daughter Florence much later. Not one depicts Marie in Indonesian dress.

I'm trying to imagine how Marie's life had changed. She was barely 16 when she was uprooted from a world that accepted her biracial ethnicity, where she was a person of status being the daughter of a wealthy planter and the wife of a successful European businessman, where she dressed and was educated in European ways, where she spoke the language, where food was familiar, where there were familiar spices and fruits, where the weather was warm and predictable, where there were few social minefields to negotiate, where she knew how households operate and what to expect from servants.

She found herself after a two-month trip (and I really hope she was not pregnant during that trek, but she might have been because her first child, Florence, was born on July 2, 1864, so Marie was probably in her first trimester on the voyage) in a strange, cold, land where everybody regarded her as a curiosity and where she her only close companion was her dear, naïve husband whose mind was fixed on inventions and the struggle to patent his revolutionary Woodburytype.

Her body was doing strange things in her first pregnancy—and there were no female family members to support her. There was not even a servant who spoke Malay accompanying them. Both brother Henry James and his wife, Sarah, and brother Albert and his wife, Kathleen, returned to England with accompanying Javanese servants, although this may be because they had children in tow. Marie would have been fluent in Malay and Dutch and may have had a smattering of English from her schooling in Singapore, which lasted less than a year. Family historian, Ellen Ferguson, said Marie "didn't speak a word" of English,

but she was not the most reliable source. Whether Marie could speak their language or not, Walter's family and friends seem like they didn't want to speak to Marie.

At first, Marie and Walter stayed at Rowbottom's house and we already are acquainted with his apparent lack of respect and sympathy for women. He never gave women names in his writing: Marie was "Walter's Malay wife" and Hannah Boese was "Page's sister."

Staying with Rowbottom was telling. Walter's mum, Ellen, had passed away and her third husband seemed not to welcome Walter and his bride into his already established household. Edward Lloyd had several resident adult daughters from a previous marriage and a resident grandchild. In fact, Lloyd did not even welcome his step-daughter. Ellen, the daughter, was at this point living with her aunt, Elizabeth Whitworth. Elizabeth was widowed, had three small children in her household as well as her sister Ellen's daughter (also called Ellen) and her niece, Anne Green, to support on her earnings. She was listed as a grocer in the 1861 Census and 1871 Census rolls.

This Ellen, Walter's little sister, seen here in the CdV portrait, never married and eked out her living as a governess and companion until her death in Conwy, Wales, in 1909, living her entire life in that shadowy world of genteel poverty. Ellen Woodbury was born in 1837 which made her four years Walter's junior, which would mean that she was 27 in 1864. Yet this Ellen was never employed as Marie's companion, despite needing to work for her living. Nor was the other Whitworth refugee, Anne Green, employed.

Ellen, Walter's sister, in later life (Courtesy the Collection of Luanne Woodbury)

Little Emily, Walter's youngest sister from his mum's second marriage, who would now be 14, was not living with Ellen's widower, either. She was living with her aunt, Marie Lawson, who was her father James Lea's sister. She too could have been hired as a companion to Marie or invited to live in

their household (at this point, Walter still had a lot of money) but she was not. Was this because the family disapproved of Walter's inter-racial marriage or was Walter just oblivious to Marie's need for companionship and guidance in the murky waters of Victorian domesticity?

Marie would probably have been in desperate need of a companion/confidante in her lonely existence. Yes, lonely: she was an outsider in her society and a new mother, with none of the support structures that she would have had in her home country and little possibility of any from family, neighbours or her husband's circle of friends. The attitude of the family seems to be summed up in the closing line of the handwritten "Family History" by Ellen's niece, Ellen Woodbury Ferguson: "Walter was very hospitable, generous, kind-hearted, clever, but his marriage ruined entirely his life and career."[112]

Children frequently view the world as their parents did, so Ellen-the-historian most likely would have picked up this simplistic sentiment from her parents as she noted that her father, Henry James "begged" Walter not to marry Marie. Ellen was not born when this incident had happened, so she had heard that story from somebody. Did the bonhomie of the Woodbury atelier fall apart when Walter went against the advice of his brothers and married? He and Marie did not linger long in Batavia.

But look a little more closely at Ellen's statement: This is scapegoating, pure and simple: Walter's career crashed and burned for many reasons, such as his impulsive nature, his mercurial mind that lost interest in a project once he had a patent on it, and his just plain bad business sense such as writing the patent for the sciopticon so poorly that competitors were able to produce it. Yes, marriage to a woman who could not be a business partner would have been a factor, but his marriage to Marie didn't "entirely ruin his life and career."

Lucy Woodbury Roscow
(Courtesy Collection of Luanne Woodbury)

The formidable Lucy, Walter's closest sister, had a home on Park Avenue in Manchester. Her husband was the owner–manager of a cotton mill with many employees, but Walter and Marie did not stay with them, either. Perhaps it would not do to have a "black" relative living on Park Avenue. Alfred the youngest brother and Henry James the middle brother were still in Java, but Henry James, wife Sarah Jane Aldersey Woodbury and daughter Ellen, the future historian, arrived home three years later. They did not stay with Walter who was now settled in Brooklands, Cheshire. One wonders what inspired Ellen's splenetic sentiments towards Marie. Could they have come from her female relatives who apparently were having very little to do with Marie?

The family had few reference points for dealing with a person of visibly different ethnicity. According to Rozina Visram, in her book, *Asians in Britain: 400 Years of History*, there were "several hundreds" of Asians living in Britain at the time of Marie's arrival. Visram refers to people from the Indian subcontinent in the main, but most people in Britain, Walter included, did not make a distinction between "The Indies" and "India." Most of these people were *ayahs* (nannies) and *lascars* (sailors) in the port cities. The ayahs, called amahs in Java, were women hired to accompany the family and mind the children and the luggage on the voyage, usually from India to England. Many were cast off in the port of arrival and left to find their own way back to India.

Albert and Katherine brought an amah to care for little Albert Leonard on his voyage home, but she fared better than most of the women, not being cast off in the port, but choosing to leave because of the climate, with her voyage home paid. In the port cities, many ayahs were simply abandoned as not necessary to an English household and had to survive and find a passage home by themselves. London eventually had a Home for Ayas, which housed the ladies and preached to them. The establishment seems as concerned about converting them to Christianity as caring for them; nevertheless, it offered shelter and established a network for finding the ladies a working passage back to India.

Like the ladies, the seamen of colour, or lascars, could be found in the ports. They were indispensable to shipping; in fact, the P. and O. (Pacific and Orient) line used entirely lascar crews after 1840. The lascars worked for wages significantly less than white sailors (no surprise) and soon became a staple of shipping and shipping profits, especially in the East. The lascars were not welcome to stay in Britain. In 1854, an Act of Parliament was passed to make sure they got back on their ships, fining the ship owners £30, a huge sum almost equivalent to a labourer's annual wage at the time, if the lascar seaman was unaccounted for at sailing.

In 1871, a further act created a kind of port police, the Lascar Transfer Officials, who had the power to seize and force the men back to their ships. Still, some did stay, marry and earn a living, some (the lucky ones) by running lodging houses or restaurants, others by being "tam-tam men" beating a drum and singing songs or selling tracts on the streets. According to Visram:

> [I]n Edinburgh, several Indians, described as 'professional beggars' were found in the lodging-houses in the West Port. Referred to as 'those Malays' (although some were from India), who 'shiver in turban and thin printed tunic', they earned a living selling religious tracts on street corners. Able to speak 'English fluently' (which suggests they had been living in Britain for some time), yet they communicated by making 'signs'. Why they had adopted this mode of living is not stated: it is possible that, unable to find work, they had resorted to this 'professional masquerade'.[113]

There were also some few students who came to study. Some became doctors or lawyers. But their numbers were very small, and they would not have moved in the social circle into which Walter thrust Marie. And, given the education system, they would have been male. Neither Oxford nor Cambridge grudgingly accepted female students as auditors until the 1870s nor did they grant women degrees until 1920. Marie would have been truly an alien among the middle class matrons of Manchester, Penge, Fulham, and South Norwood.

Marie was the woman who Ellen, the uncharitable family historian, dismissed as "a dear little thing." To examine the language of this comment closely I would pounce on Ellen's condescending diminutive. I'm not sure how tall Marie was, but Ellen doesn't seem to be referring to height. Even worse is "thing": not "person"—"thing." I'm quite sure that Ellen was trying to be charitable, but our word choice can give our true feelings away.

Marie's visible otherness was not the only issue: she was bound to make embarrassing mistakes, the kind of mistakes that the Indonesian servant Jackaman made, which amused Rowbottom so much. Imagine trying to negotiate the minefields of Victorian propriety when you've been raised in another world and have a husband who doesn't quite "get" the niceties of society. (Remember that Walter is the son who sent his mother a photograph of his "housekeeper" and had no idea why one of his female servants attempted to poison him.)

And Victorian social mores were complex. For instance, a lady could not ride in a carriage with a man who was not a relation, nor could she sit with her back to the horses. A gentlewoman never turned to look back at anyone or anything in the street, nor did she turn and stare at any event such as a church service. There was a specific time allowed for paying calls and, of course, a specific protocol involving visiting cards as *The Ladies' Book of Etiquette and Manual of Politeness*, by Florence Hartley, tells us. In 300 plus intimidating pages, the book catalogues the social faux pas that lurked everywhere.

> As they come under no particular head, they will merely be mentioned here, as habits carefully to avoid.
>
> It is rude to look over the shoulder of a person who is either reading or writing, yet it is done every day.
>
> To stand with the arms a-kimbo, the hands on the hips, or with the arms crossed, while conversing, is exceedingly unlady-like.

Avoid restless movements either with the hands, or feet; to sit perfectly quiet, without stiffness, easily, yet at the same time almost motionless, is one of the surest proofs of high-breeding.

If you wish to make yourself agreeable to any one, talk as much as you please about his or her affairs, and as little as possible about your own.

Avoid passing before persons seated in the same room with yourself. If you must rise to move from place to place, endeavor to pass behind the chairs of your companions.

Avoid personal remarks; they evince a want of judgment, good taste, kindness, and politeness. To exchange glances or significant smiles with a third person, whilst engaged in a conversation with a second, is a proof of low-breeding.

Suppressed laughter, shrugging of the shoulders, rolling of the eyes, and significant glances are all marks of ill-breeding. If you meet a gentleman at the foot of a flight of stairs, do not go up before him. Stop, bow, and motion to him to precede you. He will return your bow, and run up, leaving you to follow him.[114]

And so on for three hundred exhausting pages... Even if Marie had read the book, how could she have assimilated all these social nuances? I'm sure Javanese society had similar nuances and protocols, but Marie would have learned them

The other C.dV. of Marie in the *Whitworth Album* (Courtesy of Janet Nelson)

at her mother's knee—or her amah's. There was no one here to teach her except Walter, who was a head-in-the-clouds scientist on a mission to patent his Woodburytype against some significant opposition. The women of the family seemed to be nowhere in evidence. Eventually, a guidebook to the mysteries of British behaviour was produced for Asian students, but only in 1871, eight years too late to cushion the shock and alienation of Marie's arrival in England.

Besides the strangeness and the isolation, the climate of England would have been a shocking factor. In his letters from Java, Walter commented that he would find the cold of England hard to endure. Marie was taken to Manchester, which so underwhelmed John James Audubon 20 years before with its dank smog (see Appendix 2), and had probably not changed for the better.

Gone were Java's palm trees, blue skies, tropical fruits, scents of flowers, and lush vegetation that so enchanted Walter when he first sailed into Batavia Haven. In fact, much later, when brother Albert Woodbury eventually sold the Woodbury and Page business, he brought his family home with him to England and, as was the custom, an amah or nanny accompanied the family caring for little Albert Leonard. (He was the father of Luanne Woodbury, one of the historians to whom this book is dedicated.) When the amah arrived in London, she was not impressed by English weather and took a boat back to Java, declaring the country too cold. Let's hope all she meant was the weather.

Dickens' marvellous beginning of *Bleak House* describes English winter weather in horrific images (totally in sentence fragments!). and November is likely when Walter and Marie arrived.

> Implacable November weather. As much mud in the streets as if the waters had but newly retired from the face of the earth, and it would not be wonderful to meet a Megalosaurus, forty feet long or so, waddling like an elephantine lizard up Holborn Hill. Smoke lowering down from chimney-pots, making a soft black drizzle, with flakes of soot in it as big as full-grown snow-flakes—gone into mourning, one might imagine, for the death of the sun. Dogs, undistinguishable in mire. Horses, scarcely

better; splashed to their very blinkers. Foot passengers, jostling one another's umbrellas in a general infection of ill temper, and losing their foot-hold at street-corners, where tens of thousands of other foot passengers have been slipping and sliding since the day broke (if this day ever broke), adding new deposits to the crust upon crust of mud, sticking at those points tenaciously to the pavement, and accumulating at compound interest.

Fog everywhere. Fog up the river, where it flows among green aits and meadows; fog down the river, where it rolls defiled among the tiers of shipping and the waterside pollutions of a great (and dirty) city. Fog on the Essex marshes, fog on the Kentish heights. Fog creeping into the cabooses of collier-brigs; fog lying out on the yards and hovering in the rigging of great ships; fog drooping on the gunwales of barges and small boats. Fog in the eyes and throats of ancient Greenwich pensioners, wheezing by the firesides of their wards; fog in the stem and bowl of the afternoon pipe of the wrathful skipper, down in his close cabin; fog cruelly pinching the toes and fingers of his shivering little 'prentice boy on deck. Chance people on the bridges peeping over the parapets into a nether sky of fog, with fog all round them, as if they were up in a balloon and hanging in the misty clouds.[115]

Growing up in a land where the temperature year-round was in the mid 20s C, Marie would have found dressing appropriately and even keeping warm a challenge. And that is to say nothing about the psychological effect of grey skies, day after day after day (or English food).

Now, Marie was married to a man who loved her inordinately and had come from a family with loving relationships. Frequently, when he travelled (Italy, Manchester), Marie

Walter, as he would have looked in Java (Courtesy *The Whitworth Album* and Janet Nelson)

was with him, even if it meant leaving the eight children at home. (The 1881 Census found Walter and Marie in Manchester while the eight children were in Manor House, under the eye of teenaged Florence and a visitor with the marvellously Victorian name of "Letitia Doidge.") He was, as he signed his letters to his mum, a "loving and dutiful son," and we have no reason to suppose he wasn't as loving as a husband as he was a son. Against custom of the islands and over the objections of his brothers, he had made Marie his wife. But he was also a dreamer and a restless soul. And he was naïve. We've seen that in his letters to his mum as when he tells her about the taxi dancers and his "housekeeper." Did Walter expect Marie to be welcomed with open arms by his family and society? Perhaps he did.

His family had welcomed and accepted Audubon, and he was the son of a plantation owner and a mixed race housekeeper, who had been acknowledged by his father and sent to France, then America for schooling. Marie was the daughter of a successful gutta-percha plantation owner in Surabaya and his Indonesian wife, her father had acknowledged her and she had been sent to Singapore for her education. But Audubon also had a vision, the patronage of powerful men and a whiff of the Romantic artist to make him palatable. And he was a man.

Men were the gender allowed individual pursuits while women were firmly in a supporting role. In Walter's family, the women seemed to be the ones with the business acumen. Ellen Bentley Woodbury, Walter's mum ran the shoe factory while her dad, Walter Bentley, was off buying elephant skeletons and escorting Audubon around London and her first husband was working for the Early Closing Movement. Her younger sister, Elizabeth. was cut from the same cloth. She worked in the family shoe business, then married and had three children, Harry Kossuth, Frederick Bright, and Lizzy, from whom we have the album with so many wonderful family CVDs, courtesy of her descendant, Janet Nelson, in Ontario.

Elizabeth supported her family and various "stray Woodburys" as a grocer, meaning that she bought things in large quantities (a gross…) and broke them into smaller parcels to sell in a storefront location. It

must have worked, because in the 1881 Census, she was listed as "living on own means" which is census code for "retired with money." When Frederick Roscow's cotton mill went bankrupt, it was Lucy Woodbury Roscow who supported her six daughters by running an agency for domestic servants.

How could Marie keep up this tradition of these formidable Woodbury women? She came from a culture where women were sequestered, kept apart from the society and business of men. Walter noted that well-bred girls are rarely seen, only meeting Marie by chance as she was on a ship when she was on her way to school in Singapore while he was travelling to buy supplies. Marie would have been unfamiliar with the customs, laws, and possibly even the language of her new country. We suspect that she had studied English because she was going to school in Singapore, an English-speaking colony. That was probably "schoolgirl English" but she became fluent because she testified at the Inquest into Walter's death and no note indicated her accent or lack of fluency.

How could she manage a household and servants as a middle-class matron should even if she had a smattering of English? She absolutely could not be the business-running helpmate that was the norm for women in Walter's family. Again, to go back to family historian, Ellen:

> Had he (Walter) married an educated English woman who could have saved him financial worries and gone with him into society—there is no telling what heights he <u>might</u> have climbed or what inventions might have been his. Marie did her best—poor little thing! She was clever with her needle, a good cook and tried hard, but, no one would associate with the children, or her.[116]

Let's look at this "Ellen-ism" a little more closely, especially the phrase "saved him from financial worries." Obviously, the Woodbury women would have been expected to shield their husbands from the everyday drudgery of actually earning enough money to keep household and business going. Marie's father Carl would have been in

charge of the gutta-percha plantation business, and the household, an entirely different sphere, would have been run by her mother, Sophia. She was the wife, not the naija; she had a plethora of maids, servants and undoubtedly a cook. Now her daughter was doing the cooking and dressmaking for the family, neither of which she would have been trained to do in Surabaya.

Perhaps like young Victorian ladies, Marie had learned some needlework, but she not only learned dressmaking (probably because she had to with seven daughters and not a lot of cash) but became proficient enough to teach those daughters who in turn used the skill to set up in businesses in the far-flung corners of the world when they had left England. Florence was listed as a seamstress in the Canadian census rolls of 1891 and 1901. Mayence began her career not as a hotelier but working as a milliner and dressmaker in Nairobi, Kenya. So, Marie did, indeed, try hard to be a good wife and helpmate to Walter in ways that she could never have foreseen and seemed to have been successful in some aspect, such as teaching her daughters skills that could and did support them.

Craven Cottage—only a cottage if you own a manor
(Courtesy of the Collection of Luanne Woodbury)

Walter moved his family multiple times in 16 years. This would have exposed Marie and the children to the scrutiny of the new neighbourhoods, but also made it probable that the mixed-race family would remain a curiosity rather than being accepted as familiar neighbours.

In part, the moves seemed to be a necessary to Walter's business and mercurial interests, but they would have been hard on the family.

Rowbottom, who is usually a pretty good source regarding things financial, said that Walter had made another small fortune on his return, enough to allow him to move into Craven Cottage on the Thames. Patents granted to him in 1872–1875 list Craven Cottage as his home. To most people, Craven Cottage is the name of a football stadium in Fulham, but there really was a Craven Cottage on the site of the stadium first and it was only a cottage if you lived in a mansion—it had 19 rooms. It also had history and decoration. It was built in 1780 and had been home to such luminaries as author Edward Bulwer-Lytton ("It was a dark and stormy night...") who entertained the deposed king of France, Louis Napoleon, and other luminaries there.

Before it burned down in 1888, and was replaced by the Fulham Football Club, the cottage had rooms decorated in various styles, notably Gothic and Egyptian with painted palm trees on the walls. Perhaps Walter was desperately trying to make Marie feel at home. But a house on the dank banks of the Thames wasn't the answer, no matter how many painted palm trees it had. In the 1871 Census, the family were in Penge, Surrey, with a nanny, two servants, and five children, so they still had money. I presume at this stage of their life in England, Walter was still financially sound. (I tend to gauge the financial health of a family by how many live-in servants they employ.)

What must their Victorian neighbours have thought? The sticking point remained that the family that has just moved into the neighbourhood was inter-racial and the children visibly so. Interracial marriage alarmed the Victorians even more than mental disability, incest, and domestic violence, which were an acknowledged if not an accepted part of life. In her book, *Family Secrets: Living with Shame from the Victorians to the Present Day*, author Deborah Cohen comments:

> ...in the mid Twentieth Century, families sought to hide away for a lifetime mentally disabled children whom their Victorian grandparents had cherished at home. Enlightenment generates as many family secrets as ignorance. Incest, the most shocking of

> modern secrets, was viewed as the deplorable but also unexceptional consequence of life in a one-room tenement. Similarly, domestic violence is today more secretive than it was in the late nineteenth century when many, especially in working-class neighbourhoods, tended to view it as inevitable.[117]

There was even a column in census forms for recording household members who were "feebleminded." We take a very dim view of domestic violence and incest and tend not to "cherish" our mentally challenged family members at home. (Possibly because asylums were so horrendous, the Victorians did.) While today inter-racial marriage is no longer much of a matter for comment, censure or even a raised eyebrow, it was a very serious issue in Victorian England. It was a political, scientific, and religious problem.

The British Empire tried to overlook many aspects of their imperialism, among them the relationships between British men and Indigenous women in far-flung outposts of Empire. There were instances of men having been in India, bringing home their children to be raised in Britain. Such children were tolerated (barely) by society, especially if their fathers were wealthy (nabobs) when the practice began in the 18th century. The courts upheld that these mixed-race children could inherit estates which makes us question why an inheritance by a mixed-race son or daughter would even be considered actionable. For the courts to rule means someone took a biracial person to court, claiming he or she was un-fit to inherit on the grounds of ethnicity.

Britain had rather contradictory attitude to race. It was among the first countries to abolish slavery, and this was not something that was accomplished by simply passing a bill in Parliament. The slave owners were compensated for the loss of their "property" to the tune of £17,000,000,000 in modern currency. That's right: seventeen billion pounds. The Government budgeted £20,000,000 for paying the slave holders out—40 per cent of the GDP. This was not an action lightly taken. The University College of London has been working with the claim documents, which are based on a census of slaves in the West Indies, taken in 1817. The Bill actually passed in August of 1834,

emancipating all those under six completely and designating those over six as "apprentices" for several years. It held force for not only the West Indies, but for all British territories, including Ceylon and India, although a separate act was needed for India, passed in 1845. Bear in mind that this is a good 25 years before the Dutch abolish slavery and even longer before the USA did.[118]

However, what went on in the halls of Parliament and the Finance Office was not what went on in the actual lives of people. Slavery was abolished, but the human consequences of imperialism could not be "bought out" as easily.

In the early Victorian era, the attitude changed in India:

> From the 1820s and 1830s, the stream of half-caste children sent to Britain slowed to a trickle. Although early in the eighteenth century the East India Company had encouraged marriages between its officials and native women, by 1818, Indian mistresses were frowned upon and intermarriage strictly prohibited. It became apparent too that Britain was even less welcoming than India to those of mixed race. The idea that Britain would succour Eurasian offspring had always been something of a fantasy—indulged in by men who also recognized that the news of a half-caste bastard would hardly please their relatives. Long before the Victorians invented modern, scientific ideas of race, there was a nearly unbridgeable gulf between what British men did in India and what they were willing to acknowledge at home.[119]

In the mid-Victorian era, the attitude to mixed-race children had become less accepting, especially after the lurid "Black Hole of Calcutta" reports of the 1857 massacres of the Indian Mutiny (or First War of Independence, depending on which history book you're reading today). Since the average British citizen did not discriminate between India and the Indies and, indeed, Walter himself didn't at times, as he refers to Batavia as "about one of the hottest places in India" in Letter 16 to his mother dated September 2, 1857. A family coming

from the East Indies perhaps became viewed with the same suspicion as a family from the Indian subcontinent. The high-mindedness that caused a nation to spend 40 per cent of its GDP to end slavery two decades before seemed to have dissipated with the unrest reported in mid-Victorian times.

Following the Indian Mutiny came the Morant Bay Rebellion in Jamaica and the subsequent very public controversy about Governor Eyre's brutal handling of the rebels who were people of colour or biracial, highlighted that the attitude to race had shifted considerably. The Rebellion and its fallout were the talk of Britain in 1865, barely a year after Walter and Marie arrived. The Rebellion began with appalling conditions of the black population in Jamaica. Freed by the 1834 *Slavery Abolition Act*, and truly freed after the six-year "apprenticeship" expired, theoretically, black men had the right to vote. (Women of any colour did not have the right to vote, of course.) But vote registration involved a poll tax, which few black men could have afforded, so that only 2,000 black men could vote, out of a population of 436,000 where the blacks outnumbered whites 32:1.

So, in effect, governance of the island was in the hands of the small minority of citizens, overwhelmingly white, who could afford the poll tax. A perfect storm of circumstances caused the initial riot/rebellion: the poverty of the black peasants, crop failures two years in a row in 1864 and 1865, floods in 1864, decades of plagues of cholera and smallpox. The Jamaicans of Saint Anne Parish sent a petition to the Queen asking for help; Governor John Eyre sent a letter to Queen Victoria, describing the situation. Queen Victoria appeared to reply by telling her desperate, impoverished subjects to "work harder." (Actually, some functionary in the government worded the reply. Nevertheless, the reply indicates the government's indifference to the plight of the Jamaican people.)

The actual rebellion began with Paul Bogle, a preacher, leading a group of peasants to protest conditions at the courthouse in Morant Bay, the capital of the Parish of St. Anne. There was a scuffle in the courthouse resulting in warrants and arrests, Bogle's being one of them. The group which rapidly became a mob was confronted by the

volunteer militia on the courthouse steps. The mob began to throw sticks and stones; the virtually untrained militia retaliated by firing into their midst. By the end of the day, the mob controlled the town and 25 people were dead.

Governor Eyre invoked martial law, and in the subsequent action, 436 people were killed outright by soldiers or arrested and summarily executed. More than 600 people were flogged and 1,000 homes burned. There was no organized resistance to the military force. Bogle was captured, tried, and executed the same day. George William Gordon was another casualty. He was a biracial businessman, solid British citizen and payer of the poll tax, and a rare person of colour who was a member of the Assembly of Jamaica. He also had been openly critical of Governor Eyre. Gordon was arrested and transferred from Kingston to Morant Bay where he could be tried by military law. He too was summarily executed. The Charter of the Jamaican Assembly was suspended and Jamaica became a Crown colony ruled directly by London.

The matter of how the rebellion was handled caused much debate in England, just as Walter and Marie were settling in. One side was the Jamaica Committee, highly critical of the brutality of the response, which considered Governor Eyre should be tried for the murder of George William Gordon. They also contended that Eyre's invoking of martial law was hasty and not legal. The proponents of this view included Charles Darwin, Thomas Henry Huxley, Herbert ("Survival of the Fittest") Spencer, and John Stuart Mill. On the other side of the debate, The Governor Eyre Defense and Aid Committee, which supported his actions, included Thomas Carlyle, Charles Dickens, Alfred, Lord Tennyson, Thomas Babington Macaulay, Charles Kingsley (author of *Water Babies*, who described the Irish as "white apes"), and John Ruskin. This group held a banquet in Eyre's honour when he returned to England.[120]

Look at the names here: Darwin, Huxley, Spencer and Mill vs. Carlyle, Dickens, Tennyson, Macaulay, Kingsley, and Ruskin. This was a high-profile issue in both scientific and literary circles. And how much of this debate was over law, how much over race? Well, quite a bit of it was over race, especially races that had the unmitigated temerity to

question British rule. In fact, this controversy seemed to have been as much about the optics of the repression as the repression itself.

Mill argued that the actions of Governor Eyre were an "infringement of the laws of England" and that "acts of violence committed by Englishmen in authority, calculated to lower the character of England in the eyes of all foreign lovers of liberty" were "likely to inflame against us the people of our dependencies."[121] Carlyle, who founded the Governor Eyre Defense and Aid Committee, shot back that the government, "instead of rewarding their Governor Eyre, throw him out the window to a small loud group" of "rabid Nigger-Philanthropists, barking furiously in the gutter."[122] Good grief!

The debate raged on for two years, with the Jamaica Committee rejecting the findings of the Royal Commission and calling for Eyre's prosecution for murder. The Defense Committee raised money to defend Eyre. An article by Richard Huzzey in the Christmas 2015 issue of *BBC History Magazine* speculates why such high-profile men were drawn to Eyre's cause:

> We might point to three general influences. First, they included some of the most passionate champions of workers against free-trade industrialists; men such as Carlyle and Dickens had previously attacked middle-class philanthropists as too interested in American slavery or African civilisation rather than with the plight of workers in Britain. Second, Carlyle and his admirers, including Kingsley, venerated a cult of manly leadership and prized authoritative rule, allowing them to interpret the governor's actions accordingly. Third, the sharp power of a belief in racial superiority led Eyre's defenders to trust a white governor's judgment and doubt the trustworthiness of people of African descent.[123]

Mill, in his autobiography, recalled "there was much more at stake here than only justice to the Negroes."[124] Nevertheless, the debate, whether it was about rule of law or the government's indifference to desperate conditions which had provoked the rebellion, brought the

race question to the forefront of scientific, political, and literary consciousness. Incidentally, Eyre was eventually indicted for murder, twice, but neither case proceeded to trial. He lived out his life on a government pension.

Ironically, Darwin was a member of the Jamaica Committee, which called for legal retribution for Eyre's draconian actions, yet it was his work with others, especially Francis Galton, that had set off the debate that was the foundation of scientific racism, and would end in the horrors of Aktion T4, the Nazi order responsible for euthanasia of "undesirables" such as mentally defective or physically handicapped children and adults, and the Holocaust itself.

In fact, Walter was very aware of Galton's theories on anthropometrics and even did some experimentation with Galton's "Identiscope" as Walter seemed to call it in his notes. This jotting was found in Woodbury's notes, passed by Debbie Gill to Alan Elliott, who sent me his research notes. I wonder what the implications were for Walter's biracial family. Was Walter supporting or disproving Galton? Or was he just curious?

> **The Identiscope [?]**
>
> I quite agree with the views expressed in the Editorial note on the use of the above instrument. When Mr Galton first published his researches I took a great interest in them and have made many curious experiments, the principal result being that almost any two photographs will, if taken same size and angle of face, almost blend certainly near enough to be hardly noticeable. I have combined the Emperor of Russia with superior class of China men and with the Javanese Emperor but it was only after I explained that there were two portraits combined that the fact was noticed— The one was from a photograph of Downeys [?] & the other one taken many years before in Java, but I picked them out simply as being somewhat near the same size & turn of the head—
>
> I was experimenting with my filigraine process at the time and, as the most handy thing took two reliefs and laying them one

over the other pressed them both into a sheet of paper so that the combination is equal. Of course they do not exactly coincide but so near it that 9 out of 10 people would not notice it—I presume the so-called Identiscope [?] would give pretty much the same effect.[125]

Walter's conclusion seemed to be that racial differences are not that obvious…

Victorian "scientific racism" in an illustration by H. Strickland Constable (Courtesy Wikipedia Free Commons)

The suspicion of people of other races, especially people of other races living next door, would have been exacerbated by the scientific controversy raging around the recently published works on evolution. Fuelled by the furore around *On the Origin of Species*, published in 1859, debate raged between monogenism and polygenism. Monogenists believed all of human kind came from a single origin and the superior forms (such as the English) had risen to prominence and dominance. The polygenists believed that mankind came from multiple origins and some (such as the Irish) were markedly less thriving and fortunate than others.

The Irish were considered an inferior race, with scientific "proof" like phrenology to back up the claim. There were nearly 100,000 Irish in London, survivors of the Famine, who occupied the "rookeries" or slum tenements and scraped a living any way they could. Charles Kingsley, author of that children's classic *The Water Babies*, describes the Irish: "I am haunted by the human chimpanzees I saw [in Ireland]… I don't believe they are our fault… But to see white chimpanzees is dreadful; if they were black, one would not feel it so much."[126]

Irish inferiority was signalled by the "prognathic" jaw and lower forehead. Even in the Sherlock Holmes novels, Moriarty invoked anthropometrics, exclaiming that he expected Holmes to have a higher forehead. Here is Thomas Huxley on the subject:

> No rational man, cognizant of the facts, believes that the average negro is the equal, still less the superior, of the white man. And if this be true, it is simply incredible that, when all his disabilities are removed, and our prognathous relative has a fair field and no favour, as well as no oppressor, he will be able to compete successfully with his **bigger-brained** and **smaller-jawed rival**, in a contest which is to be carried out by thoughts and not by bites.[127] [Emphasis in Huxley's text.]

The shock of these words is, in part, that they come from a member of the "progressive" anti-Eyre faction.

This debate became embroiled in social class as much as ethnography. What to us today is pseudoscience was used to prove the lesser peoples were justly served by their (colonial) lot in life. In its most extreme form, so-called gentlemen met at "The Cannibal Club" where they spent many titillating hours discussing the sexual habits of other cultures, speculating on cannibalism, and relishing their own arcane rituals. Fortunately, the club did not last long and disbanded in the mid-1860s but notables like Sir Richard Francis Burton and Charles Algernon Swinburn were members. When Darwin published his *Descent of Man and Selection in Relation to Sex* in 1871, the text made the polygenist's position passé and the club disbanded. That did not stop the controversy.[128]

Henry Mayhew took the idea of evolution to the classes of society, developing classes like "the deserving poor" who work, the poor who cannot work, and the "underserving criminal classes." Later, we would call this Social Darwinism. Suddenly, race (and racism) had come to the forefront of British consciousness.

Despite the controversy, there were interracial marriages in Britain, but mostly in the Docklands areas, not in nice middle-class neighbourhoods. Nor were the upper classes welcoming to other races, although in later life Queen Victoria had an Indian adviser, Mohammed Abdul Karim, called "the Munshi." Although Victoria liked and trusted the Munshi, the Court did not, snubbing him by sitting him among the dressers at a theatre performance or returning his Christmas cards

unopened. As soon as Victoria died, the Munshi and his family were evicted from Frogmore Cottage and packed off back to Agra. Nor apparently, was Scotland any more welcoming. I was appalled when I came across this quotation from then Chancellor of the Exchequer W. S. Gladstone, who later would be Prime Minister for 12 years, in A. N. Wilson's book, *The Victorians*:

> Princess Alice has got a black boy here that was given to her, and he produces a great sensation on the Deeside where the people never saw anything of the kind and cannot conceive it. A woman, and an intelligent one cried out in amazement on seeing him and said she would have fallen down, but for the Queen's presence. She said nothing would induce her to wash his clothes as the black would come off! This story the Queen told me in good spirits.[129]

It's not just the cheerful account of the ignorance of the "intelligent" woman in the quotation, it's the date that's appalling: 1863. That's the year Marie and Walter married, the year they arrived in Manchester.

The Beloved by Rossetti (Wikipedia Free Commons Courtesy Tate Gallery)

It's at this time that Dante Gabriel Rossetti was painting *The Beloved*, also called *The Bride*, which you can see in the Tate Gallery today. The painting showcases a fair-skinned, blue eyed, reddish-haired woman framed by women of increasingly darker skin tones—the darker the tone, the farther back—and a weeping negro child who was a slave Rossetti had borrowed as a model to replace the original figure—a biracial girl.

In his writings, Rossetti said that he encountered the slave boy and his owner in a hotel and was intrigued by the boy's skin tone and particularly the colour values of tears on the skin so the girl was replaced when Rossetti reworked the painting in 1877 by a more acceptable "exotic."[130] The painting was meant to illustrate the Song of Solomon, but the surrounding of the beautiful Caucasian woman with "less Caucasian" attendants was an interesting wordless comment on the tenor of the times.[131] Slavery had been legally abolished more than forty years before (except lands held by the British East India Company), so why was the child Rossetti used as a model considered property? The law may have altered but attitudes had not.

Those attitudes were probably making themselves felt closer to home. Walter and Marie were living in nice middle-class neighbourhoods. Walter and Marie were having children. In England. Eight children. Eight biracial children. The blind eye that was turned on nabobs' children, who were already an established fact, especially when insulated by lots of money, would not have been turned on Walter and Marie and their offspring: Florence born July 2, 1864; Walter born June 22, 1865; Constance, born February 26, 1867; Ellen Mayence, born April 17 1868; Marie Valence born April 11 1869; Hermance Edith (my great-grandmother) born January 31, 1872; Fayence born October 10, 1875; and Avence, born February 7, 1876.

Florence taken at Walter's Manchester studio, circa 1868 (Courtesy Collection of Janet Nelson)

Again, here's the uncharitable Ellen's voice: "Of them all—Fayence and Walter were the best-looking, having blue eyes and fair hair—but the others did not come off so well."[132]

This photograph is from the *Whitworth Album*, owned by Janet Nelson, and passed down from descendants of Elizabeth Bentley Whitworth, Walter's aunt. The background is the fittings in the Manchester studio, so this is one of the children who came off "not so well," probably Florence. This little girl looks to be about three or four years old and we know that Walter had his family ensconced in Craven Cottage near on the Thames, near London in 1872. I'm guessing that she may be Florence. But what is "unacceptable"? The child's dark skin? Her curly hair? Her forthright gaze rather like her mother's? Notice the posture and the almost-clenched fist. This is not a happy child. Of course, she may simply be annoyed with having to stay still for the photograph. Or it could be something else, like having no playmates?. Ellen tells us Walter and Marie's children were ostracized. Walter and Marie's children were perceived as "Other."

> Victorian "Others" were members of marginalized groups whose collective identity was perceived to differ in fundamental ways from the white, Protestant, English-speaking Victorian mainstream. Majority writers often perceived a group's Otherness as an ineradicable barrier to its acceptance into the full rights and privileges of citizenship. This perceptual barrier reinforced and was reinforced by immigration policies, economic and political restrictions, newspaper articles, social scientific reports, Darwinian racial rankings, and, not least, the representations of Others in novels, poems, and plays.
>
> These texts gave voice to the suspicion (growing, at various heated moments, into a widespread conviction) that members of non-white, non-Protestant, non-English-speaking groups were unalterably alien, unassimilable, and inferior. The texts frequently posed questions about how England's marginal groups might be brought into relation with the apparently unified nation-state and empire. Victorians debated the social

and political status of Jews, of freed slaves, of immigrants from the colonies, of migrants from occupied domestic regions, and of non-conforming Christian groups.[133]

Some of that perception of "Other" was found in the Victorian nursery and school, and its textbooks, or primers. It was considered unseemly for educated women to join in the scholarly debates of men—if "educated" is the right word as women were forbidden formal higher education in universities and even admission to public schools. But writing for children was an acceptable "feminine" field of endeavour. I think that modern readers are now appalled by this denigrating of the intellectual resources of half of the population, but women themselves, as authors of the primers promoting the superiority of the English and the need of lesser races to be converted and governed, were also participating in the denigration of the intellectual resources of others. There's an irony there.

Besides the readers and missionary tales, there were popular novels, beginning to be written for children, with children or youth as the protagonists. While *The Coral Island* is now mostly remembered as the distant ancestor of William Golding's dystopian novel, *The Lord of the Flies*, Ballentyne's book was extremely popular in the mid-19th century. In it, Ralph Rover and his pals Jack and Peterkin are shipwrecked on an island that offers food in the form of fruit, crabs, and wild pigs. (Sound familiar?) But the savages are not the boys' own inner natures as Golding portrays. The savages in this book are external. The boys thrive until some Indigenous people from another island show up, bent on war and cannibalism. Adventures ensue, including stories of babies being sacrificed to eels and encounters with pirates and missionaries. The book ends with the Indigenous peoples of the islands being converted to Christianity and burning their idols. How's that for a reference for your erstwhile playmates?

Yet another favourite was *The History of Little Henry and His Bearer*, published in 1814 by Martha Sherwood. The book was printed 18 times in its first 10 years and was reprinted every three years after that until 1883. It was a staple of nursery libraries until the turn of the

century. It had a companion volume also by Sherwood, *The History of Little Lucy and Her Dyah*, for girls published in 1823, although it was not as popular. Both books had the premise that the early affection for and attachment to their Indian caregivers by English children was an impediment to the development of the children's "Englishness." The caregivers were neutralized by being converted to Christianity and all was well—except that Little Henry managed the conversion of his bearer, Boosy, while on his own death-bed. But then, Victorian novels usually were not complete without a dramatic death scene.

Only slightly more subtle were the depictions of "otherness" in popular novels for adults. Of course, Dickens' Fagin from *Oliver Twist* springs to mind, but there is also Scott's Rebecca in *Ivanhoe* who was ultimately exiled rather than wed, even though she was the romantic heroine of the story. Miss Swartz in Thackeray's *Vanity Fair* had a name befitting her dubious heritage, being the offspring of a Jewish entrepreneur and a mixed race slave. There was the suspicious, disconcerting swarthiness of Heathcliff in *Wuthering Heights* and even that realist, George Eliot, created *Daniel Deronda* who ultimately left England altogether because of his discovered Jewish heritage. None of these were positive depictions of racial harmony.

Children's literature continued in this vein featuring virtually exclusively white protagonists and thinly disguised racism—if it was disguised at all. In that classic of childhood, *The Secret Garden*, although it was first published in 1910 after Walter and Marie's children would have been out of the nursery (but not after their grandchildren would be), the child protagonist, Mary, having been sent from India where her parents have died, to make a home with her emotionally distant uncle, had this dialogue with her maid Martha: When Martha said she thought Mary would be black because she was from India, Mary bursts into tears and says, "You thought I was a native! You dare! They are not people—they are servants who must salaam to you."

Did this racist outburst get punished, corrected, or even commented upon? No. And later on, Martha excused Mary's bad behaviour by her being brought up in India where there "are a lot of blacks… instead of respectable white people." Ouch! The other interesting aspect of this, apart from its overt racism, was the use of "black" to describe Indians.

Remember, Walter in his letters frequently referred to being in India rather than the Indies, so the distinction seems to be a moot point.

And let's not even get onto the subject of Golliwogs...

Robert Louis Stevenson's *A Child's Garden of Verses* included this gem, titled "Foreign Children."

> Little Indian, Sioux, or Crow,
> Little frosty Eskimo,
> Little Turk or Japanee,
> Oh! don't you wish that you were me?
>
> ...
>
> You have curious things to eat,
> I am fed on proper meat;
> You must dwell upon the foam,
> But I am safe and live at home.
> Little Indian, Sioux or Crow,
> Little frosty Eskimo,
> Little Turk or Japanee,
> Oh! don't you wish that you were me?

The poem was redolent with smugness with a whiff of irony, as Stevenson left Scotland for the South Seas and never returned. Did he still think this way on the beaches of Samoa?

Are you beginning to see places like Kenya or South Africa or the US or Australia or Canada might be considered friendlier than England? Those were the places that the Woodbury children fled to after Walter's death.

How did Marie and the children cope? We know Walter tried to help because in 1871, when the couple were flush with money from the success of the Woodburytype, Walter had hired Bessie Marshall, 26, from Birmingham as "governess and companion," and there were two other servants, a nursery-maid and a general servant. Of course, there were five children at this point. Later, in the 1881 Census, there was no companion, and one servant which, for a household with eight children indicated straitened circumstances. Well, Walter did declare bankruptcy in 1879 after the Sciopticon debacle.

And Walter may well have been oblivious to what he had done in uprooting Marie from her familiar world. As with the comments on the Australian aborigines, the chauvinism of the Victorian Englishman was audible in the words with which Walter would close each magic lantern presentation about Java:

> We have now had a peep at one of the most lovely and romantic Islands in the world, peopled by a nation whom to judge by the ruins and relics of days gone by have once been great. We have been presented at court and seen something of the manners of an eastern Prince. We trust it [the magic lantern slide show] has afforded both instruction and amusement and now we can look back on our native land and thank God we were born in Christian England with all its advantages and privileges and we are ruled over by a Princess who possesses the love and esteem of all her subjects, "and sing with heart and voice," GOD SAVE THE QUEEN.[134]

This coda to the magic lantern show may have been a ploy to have the audience go out the doors feeling enlightened and superior. Or was there part of this sentiment that Walter truly believed, sentiments he might, even unconsciously, have taken home to his wife?

So, what *do* we know about Walter's wife, Marie? The answer is "precious little." We know that she had formal schooling, because she was on a ship on her way to school in Singapore when Walter first saw her. This indicated that she may have spoken English and Dutch as well as Malay. (She might also have studied English and have been intended to improve her spoken English at St. Margaret's School, as Singapore was an English-speaking colony. She would have been at St. Margaret's for less than a year because she married Walter as soon as she turned 16, less than a year after he first saw her.)

Walter did not speak Dutch, although he did learn Malay. We know that Marie was much younger than Walter—14 years in fact, so that when she was widowed, she was 37. We know that Walter cared for her as a companion, because he tried to explain his ideas to her (to the

amazement of Rowbottom), she accompanied him on the trip to Italy, and the 1881 Census found Walter and Marie in a boarding house in Manchester, while Florence held the fort at Java House. We know that Marie must have learned to speak fluent English, because she testified at the Coroner's Inquest into Walter's death and there were no comments about her accent or fluency. And we know that she was a competent homemaker, from grudging praise from the waspish Ellen Woodbury Ferguson.

I suppose I should cut Ellen Woodbury Ferguson a bit of slack. She was the voice of her time, as Walter was in his description of Australian Aborigines. Ellen grew up in trying circumstances, beginning life the daughter of a "millionaire" only to be plunged into penury.

From Ellen's family history, we know that Marie made the children's clothes being "handy with a needle" and she was a good cook. In the 1881 Census, after the 1879 bankruptcy, there was but one servant in the household, with eight children at home. There was no evidence that Marie did or could act like a "Bentley woman" in being a business partner, or running the business end of things herself to support her family or allow her partner to pursue his own interests. Yet Marie was a partner in this marriage, doing work she would have left to servants in Java, accompanying Walter and even being his model.

Possibly Marie and Florence, circa 1882 (Courtesy of Lunimous Lint)

I think this is a portrait of Marie and one of her daughters in the early 1880s. The bustle dress with the flounces is a style from that time. Marie still looks young, and she is, probably in her early '30s, and she wears her hair pulled severely back, which as any woman knows works as an "instant face lift." I date the photo this late because a second photo of the younger lady wearing the same dress and earrings exists, but it is taken on film instead of glass. We know that Walter was experimenting with printing onto film in the 1880s. In fact, his last patent, filed in April of 1885 is for photography on film. His photogenic daughter would have been a good subject. She could be Florence, given Florence was born in 1864, which would make her in her late teens at this point.

The torn tissue film portrait: note the similar hair style, complete with hairnet, earrings and neckline (Courtesy Victoria and Albert Museum, London)

Marie still does not look happy, but after viewing 600 pictures of people in the KITLV archive of photographs from this era, I have yet to see one smile. In fact, smiles seem to be a phenomenon of later photography as no members of Walter's English family smiled for the camera either. Perhaps the exposure took so long that a smile would fade into a rictus grin. Perhaps getting yourself recorded for posterity was considered serious business. People did tend to wear their best clothes for a photograph.

After the death of Walter, the Inquest and the funeral, the family was left more or less destitute. The Photographic Community clubbed together for Walter's headstone in Abney Park Cemetery where it weathered away for 110 years, until Luanne Woodbury, Walter's great niece, put in a fitting headstone in 1998. Some old colleagues (and an old rival, Swan) contributed funds to the family. Walter had left them only £246 in his will, and Marie had eight children, six at home.

Marie was a young widow (by our standards if not Victorian ones). She was 37. Perhaps used to being with older men or unsure of her

status as a widow, Marie turned to Edward Stanley Bent, who had been a mainstay of the family for years and was well acquainted with the family's perilous financial position. He was the force behind the rather unsuccessful drive to raise funds to support them when Walter fell ill. He mentioned at the Coroner's Inquest that he had been a family friend for 30 years. Marie married him in 1889, a decent four years after Walter's passing.

Edward had an interesting, if checkered history. He had been to prison, sentenced to five years for harbouring stolen goods that he received from a client in a high-profile case in which a member of Parliament was involved. The sentence was harsh because he had been an attorney; even if he didn't know, he should have known the goods were suspect, considering his client. Also, there was press coverage. He served his sentence in Her Majesty's Prison (HMP) Dorset.

Since you are unlikely to be able to read the newspaper cutting, here's a transcription.

> *The Times*
> *February 09, 1877*
> *Page 4 Issue 29025 Column C*
>
> A CHARGE AGAINST A SOLICITOR: At the Manchester City Police Court yesterday, Edward Stanley Bent, a solicitor practising in Manchester, was charged with feloniously having received two portmanteaus knowing them to have been stolen. The two portmanteaus, one being the property of Mr. Parnell, M.P., and the other of Mrs. Prosser of Stretford—had been stolen from the platform of the London-road Railway Station by a man named Frankel. One of the portmanteaus contained jewellery to the value of 60 pounds sterling. In an attempt to steal a third portmanteau some days later, Frankel was captured

and brought before the City Magistrates where he was defended by Mr. Bent and committed to the sessions for trial. Having no money to pay Mr. Bent for his defence at the sessions, Frankel told Mr. Bent that he had left two portmanteaus at his lodgings and offered them to him in lieu of payment to conduct his defence. Mr. Bent accepted the offer and fetched the portmanteaus from Frankel's lodgings. At the sessions Frankel was convicted. Police subsequently traced the portmanteaus to Mr. Bent's possession and preferred the present charges. The defence was that Mr. Bent had no guilty knowledge that the portmanteaus were stolen; and that Frankel had abstracted the valuable contents before Mr. Bent obtained possession of them, particularly the jewellery, of which nothing had been heard. The magistrate decided to send the possessor to the Assizes for trial, but admitted him to bail in sureties of 50 pounds each.[135]

Bent (what an appropriate name for a disbarred lawyer!) did hard time in Dorset prison. The penal system was given to psychological punishment as well as physical punishment, because there was no meaningful occupation. Prisoners walked in patterns in silence in the courtyard or did physical labour, such as turning a crank that was attached to nothing, so the work was patently meaningless. Bent's sentence would have been unpleasant, and it was meant to be.

Edward Stanley Bent had also been married three times and had several children by several wives. He was married Sarah Atkinson in 1847. She had one child, Edward Stanley Frederick Bent, and she died the next year at 21, probably in childbirth. The boy died when he was five. Bent himself had gone to the US, but returned and married Marion Beever Farrell in 1852. They had seven children by 1866, one of whom is Walter Stanley Bent. Marion died in 1875, which spared her from being the wife of a convict.

Edward married Emily Gaunt in 1876, when she was 30, which was older than the average Victorian bride, and he still had children who needed care, the youngest being nine. I presume it's Emily who suffered the stigma of being the wife of a convict. I can't find Emily or the children

in the 1881 Census, which had Edward in prison, and by that time the youngest son George Albert Stanley Bent would have been 15, which was old enough to make his own way in the Victorian world. At any rate, the family seemed to vanish in the 1881 Census—and who can blame them?

The question needs to be asked: What happened to wife number three? Did she die? Did she change her name and create a new life for herself? Was she still alive, and if so, it's unlikely that Edward had divorced her, given the legal obstacles in the way of dissolving a marriage. If Emily had been missing for seven years, she could have been declared dead in time for Edward to marry Marie. Or maybe Edward, a lawyer who is capable of bending the law, was a bigamist. He married his fourth wife, Marie, in 1889, at least eight years after Emily vanished. Edward and Marie had no children.

Edward's son, Walter Stanley Bent, became Mayence's common-law husband in Kenya after accompanying her to South Africa—at least until she met Fred Tate. Even if they wanted to, Mayence and W. S. could not have married as they were considered brother and sister because their parents were married. But more of this later.

At the Coroner's Inquest into Walter's death, Edward said he has been a family friend for 30 years, which would take us back to 1855, several years after Walter went to Australia, but at that time Edward was a successful and practising solicitor in Manchester so may have known Walter's family socially or professionally. He would have been newly married to his second wife, Marion Beever Farrell. Walter's family was probably one of the few who kept contact with Edward after his release from prison, and it indicated Walter's ignoring social norms and niceties—which would have been to cut Bent out of all contact. At the time of his marriage to Marie, Edward was listing his profession as "African trader," although at one point, after the death of his first wife, he practised briefly as a photographer, which may be the connection. As with Rowbottom, I wouldn't trust everything that Edward says.

One thing that interests me is that Edward's mother, Brigetina Clarke Bent, came from the West Indies. Her family name, Clarke, is used as a middle name of Edward's son, Charles Stanley Clarke Bent, so this argues that the connection was important to the family. In the

1851, 1861, 1871, and 1881 Census results, Brigetina was listed as being from "Foreign Parts" and "The West Indies." Perhaps, having had a mum from "Foreign Parts," Edward Bent understood the challenges his mother would have faced coming from a world far removed from England, so that he also understood something about the challenges and situations facing Marie and her family. Perhaps he was a little more accepting than the average Victorian about people of colour or people born in a different climate and culture.

When Edward died in 1896, Marie was on her own again—really on her own as all the children except Fayance and Avence had married and/or left the country—so she too left England. What I find significant is that she did not return to Java. She went to the West Indies. Did Edward have family there? Or connections? Or property? By this time, Albert had sold the Woodbury and Page photography studio in Java and returned to England. All of the Woodbury families had fallen on hard times. Albert had been paid only a fraction of the full sale price for the Woodbury and Page Atelier and managed to lose what little remained through bad investments. Henry James was long dead and his wife and daughter had lived on the charity of others and were now living with Ellen's not-too-successful husband. Lucy, now a widow, was supporting six daughters by running an agency for domestic servants. Youngest brother Frederick Lea, from Ellen's second marriage, had disappeared at sea and was presumed dead. Ellen, the sister, was eking out an existence as a governess and companion. Posthumous Emily had married and her husband was in an institution "for incurables" as the Victorians bluntly phrased it. There may have been no connections left in Java. There was no help to be had from the Woodbury clan.

There had also been a change in the culture of Java in the intervening 30 years, especially for Eurasian women, ironically making Marie less welcome in her native country. By the 1890s the nature of the colony was changing, with improved transportation from and communication with the Netherlands and Europe. More people were going out as *trekkers*, to make their fortune, rather than emigrating permanently as *blijvers*. More women had arrived from Holland, making marriage to or co-habitation with Eurasian women less acceptable.

> With the shift in cultural orientation and the increasing number of white women, colonial society *verhollandste* [became 'westernized' — the opposite of *verindischen* (turned Indonesian)]. The Dutch wife became preferable to a Eurasian wife or native housekeeper, and a marriage between two totoks was considered as the symbol of civilization. Because of the growing number of white women in the colony, the group of Eurasians within the colonial elite became smaller. To an increasing extent, they ended up in the lower classes or ranks, as a result of which the centuries-old mestizo culture—in which Indies clans were salient—slowly but surely had to make room for a white elite-culture.[136]

And why would Marie have remained in England when most of her children had left? Marie was a visibly biracial woman, again without a husband to protect her. So she emigrated, probably in the year before this poem was published in the *Times* of London (February 4, 1899), Kipling's jingoistic "White Man's Burden," which he originally intended for Queen Victoria's Diamond Jubilee in 1897. This is stanza one; the rest is much the same:

> Take up the White Man's burden—
> Send forth the best ye breed—
> Go bind your sons to exile
> To serve your captives' need;
> To wait in heavy harness,
> On fluttered folk and wild—
> Your new-caught, sullen peoples,
> Half-devil and half-child.

The catchphrase soon pervaded other aspects of life. Witness these ads for Pear's soap. The first ad, circa 1899, cannot be called subtle by modern standards, but the second is utterly blatant. Note the delighted smile of the "cleansed" child in the second.

158 MURIEL MORRIS

Advertisement for Pear's Soap Widimedia Free Commons
File:1890sc Pears Soap Ad.jpg

"Washing the Blackamoor White" Christmas 1884 Pears' Soap advertisement
Blackwiki https://blackwiki.org/index.php?curid=260381

Rather than remain in a culture that perceived her as "half-devil and half-child," Marie moved to Hamilton, Bermuda, eventually remarried—a younger man this time—Toby Baker, and she lived until 1931, dying at the age of 83. Her daughter, Avence, unfortunately died on the sea voyage to Bermuda in 1898, according to family historian, Luanne Woodbury, but Marie's granddaughter Constance Bentley Woodbury Mather Clarke, who seemed to have the same "travelling feet" as the rest of her family, made several trips from Canada, later with

her son Neville Clarke, to see Marie. At least that's what I'm assuming was the purpose of their voyages to the West Indies. I truly hope Marie again enjoyed the warm climate, the palm trees, and tropical fruit, a more accepting society and another compatible partner. Her life in England would not have been easy.

THE FAMILY DIASPORA: ABILITY, PASSION, AND INTELLIGENCE FLEE ENGLAND

I can only call this section "the family diaspora" because Walter's family dispersed to the four corners of the Earth, literally. After enduring racial prejudice, even from within the family, English weather, and straightened circumstances, all but one of the family left England for places where being "not white enough" was measured by different criteria. The leavers perhaps sought a new country with a recognized Indigenous population who were distinctly non-white, which in contrast, might have made the Woodbury children "white enough."

None of them returned to Java. Well, why would they? They were born and raised in England and spoke English; Java used Malay, Dutch and French. With a colonial culture and Indonesian culture, Java would have been as foreign to them as England was to Marie. And with the opening of the Suez Canal and the influx of Europeans (employees of the government were now allowed to marry before their first furlough), the status of Eurasians, especially Eurasian women, had plummeted. Eurasians ceased to be the "middle class" of Java. When Woodbury's

children, especially the visibly biracial children, left England, they went to places that were English-speaking, usually in the Commonwealth.

Allow me an editorial opinion here (as if I haven't been opinionated throughout this writing!) These were talented, capable, hard-working people, several of whom did spectacularly well in their new surroundings. A modern term for it would be a "brain drain" as the Woodbury children (well, all except Valence) left for places where they were perceived as "white enough." Their emigration was England's loss.

FLORENCE WHO WANTED TO BE NORMAL

As the eldest girl, Florence had responsibilities, and in this family, she seems to have had more than the usual middle-class young lady would typically have faced. Florence was one of the "unacceptable" children, with her darker skin and hair. She acted *in loco parentis* for her seven siblings as Walter and Marie travelled together. The 1881 Census found Florence, then 17, listed as head of the household at Manor House, aka Java House, a household which consisted of her seven siblings, a visitor and one servant. Walter and Marie were in a boarding house in Manchester at the time of the census. I am guessing that Walter was making a presentation to the Manchester Photographic Society.

Florence: note the same hairstyle, earrings, and neckline as in the torn portrait (Courtesy KITLV)

Florence married David Steet when she was 20, a year before Walter's death. He is difficult to find in genealogy records because he's often mistranscribed as "Street." He was the son of George Carrick Steet, who would win accolades as the longest-practising physician in London, justifiably, after a distinguished career of nearly 70 years. Perhaps part of the attraction was that Florence and David were ordinary children of extraordinary parents who wanted to make a life of their own, away from family occupations. David did not go into medicine, nor did he have a long and distinguished career in any professional field. He was a salesman.

This is a CdV from the KITLV "Memory of the Netherlands" collection, attributed to Woodbury and Page. The collection has a very large range of dates (1856–1880) since the it also includes Woodbury's later portraits of Theo van Gogh and his wife, Vincent's brother and sister-in-law. This portrait would have been taken in England. The neckline and the hairstyle and the earrings are similar to the young lady in the portrait with Marie and the ripped "tissue-film" portrait which was among the items that Felix Vergara sold to the Science Museum in South Kensington.

Florence's biracial appearance bolsters waspish Ellen's contention that most of the Woodbury children were not fortunate enough to be born with blue eyes and blonde hair. In Ellen's words, Florence was one of the children who "didn't turn out so well." In today's world, most people would consider her quite lovely.

In 1887, three years after their marriage, Florence and David emigrated to Canada, with two children in tow, Charles Beverly and Grace Violet. Florence listed herself in the 1891 Canadian Census as a dressmaker, a skill which she would have learned from Marie. David was a commercial traveller, then an insurance salesman—definitely nothing medical. They had no servant and one boarder so they were not well off. After Charles and Grace came Evelyn (1892) and Percy (1895). But there also was Florence (1894–1894) and two more girl babies who did not even live long enough to be given names in the Ontario Registry of Deaths; they were listed as "Unnamed Steet infants, 10 June, 1899 and 26 April, 1900."[137] In the 1901 Census, Florence was still listed as a dressmaker, David was still a travelling salesman, there were four children in the house—and no maid.

Then came disaster: Charles died on June 9, 1901 at the age of 17. No cause of death was listed. Four days later, June 13, 1901, Florence died of septicemia peritoneum, complications of another childbirth. She was 37. The baby did not survive.[137] In 1922, Son Percy died from double paralysis of the larynx at the age of 27 , ironically after surviving WWI (which might have been the cause of the paralysis of the larynx) and Evelyn died the same year at the age of 30 but not before marrying Herbert Walker and giving birth to four sons. Grace Violet married

Sidney Hugh Shambrook and lived until 1948. David remarried and had a second family after Florence's death but was not any more successful financially.

Grace Steet headstone in Ontario, Canada (Courtesy Find A Grave Website)

Florence and her children did not inherit Marie's longevity. Both Evelyn and Grace Violet had children and the Walker and Shambrook lines went on. This is Grace's headstone in Ontario.[138] The Walker descendants still live in Canada, in Cambridge, Ontario.

WALTER E., THE OTHER WALTER WOODBURY

Being the only son of a famous father must have put inordinate pressure on Walter Edward as a young boy and, later, a young man—pressure and a shadow that he never quite got out from under. He was and still is "the other Walter Woodbury" in photographic circles.

The blonde-haired, blue-eyed Walter was one of the children deemed "acceptable" by Ellen Woodbury Ferguson. Here he is in his father's Manchester studio, when he is five or so. The dress/tunic would be typical Victorian children's clothing, but you can tell he's a boy from his short (blonde!) hair. As with Florence in the companion portrait

from the *Whitworth Album*, printed earlier in this book, the props are the same, although Walter's facial expression is less forceful, less defensive than Florence's. Perhaps she already knew that people responded differently to her than to her "more acceptable" brother.

Walter, incidentally, was the only one of the Woodbury children who did not marry. I wonder perhaps if this was because of his fear that his children might be "less acceptable" because of their genetic heritage. He lived in the United States, not a country then noted for its toleration of people with darker skin any more than England; the birth of a dark-skinned child would have been irrefutable proof that Walter E. was "not white enough."

Walter Edward, also taken in Walter's Manchester studio (note the props) (Courtesy Collection of Janet Nelson)

Walter also carried a huge burden. He wanted to make his name in photographic circles, but his name was his father's. So, he did what almost all the Woodbury children did—got out of England.

In the 1881 Census, he was living at home in Manor House. He was 15 at the time, listed as "a clerk in a colliery office." One would expect a 15-year-old boy to be in school, but perhaps there was no money for school fees: there were six younger siblings who were in school and Walter senior was in financial difficulty, yet again, having had to sell his shares in the Treadway Company that year. Perhaps Walter E. did not like the constraints of the classroom.

Like his father, Walter E. did not seem to like office work much, so he enlisted in the army, in 1883, becoming a sketch artist for the Royal Dragoons! I find it interesting that his medium was not photography, but this may have been youthful rebellion. Successful stereo-photographer William England's son Walter did the same thing, attempting to make a name for himself as a painter in oils. Walter E. was in the army when his father suddenly passed away.

In the 1891 Census, Walter E. was visiting a friend and the Census listed him as a "scientific journal writer." He was also working for the Paxton Perfect Plate Company, which dealt with photographic equipment. He was a member of the Royal Photographic Society as well. But Walter E. did not seem to be a photographer. He apparently was more comfortable writing about taking pictures than actually taking them.

In 1893, when he was 27, Walter E. made the big break and emigrated to the US. His father had connections with the American photographic community, notably Edmund Wilson of *The Philadelphia Photographer*, connections that felt Walter B. was badly used by his English compatriots. These contacts may have taken the son under their wing, because, before long, Walter E. had landed a plum new job: editor of *The Photographic Times*.

The Photographic Times had begun as a free weekly in 1869, and was now published by the Scoville & Adams Company, which had formed from a merger in 1889 and was the largest photographic supply company in the US until the advent of Eastman Kodak. The magazine was sent to any photographer who would pay the postage, but 25 years and several changes of editor later, it became vastly different than a technical publication—especially with Walter E. Woodbury at the editorial helm. It morphed into a monthly magazine dedicated to the science and art of photography, with far more pages of editorial comment, illustrations, and a fashionable Art Nouveau look. Walter E. scrapped look the old cover and hired the noted book illustrator, George Richard Quested, to produce one featuring the Roman goddess Veritas, or Truth. There were new writers, fewer advertisements, and a new publication date. And it was no longer free. Walter E. was making his mark.[139]

I have a copy of the January 1899 issue, and it is a thick, heavy magazine, rather larger than a *National Geographic* magazine, full of advertising, technical, and human-interest articles and *two* "frameable" photographic prints. It's an impressive volume.

The new look of *The Photographic Times* (Courtesy Photoseed Website, David Spencer)

This was the reaction from the *American Annual of Photography*, Vol. 10, Jan 1 1896:

> With the beginning of 1895, it (the *Photographic Times*) was converted to a sixty-four-page artistic and scientific magazine of the very highest order, under the editorship of Mr. Walter E Woodbury. Each monthly issue is indeed a work of art. It contains, besides a beautiful frontispiece suitable for framing and alone worth the price charged for the magazine a number of illustrations which are reproductions from the choicest photographs of the principal photographers of the world.[140]

Letter from the desk of the editor—and the editor himself
(Courtesy Photoseed Website, David Spencer)

The real historical legacy of Walter's editorship was the magazine's inclusion of a cutting-edge art photograph as its photogravure frontispiece. For 10 years, the readers of *The Photographic Times* were introduced to the works of photographers like Stieglitz, Eickemeyer, Frances Benjamin Johnston, Charles Berg, Alfred Clements, William Fraser, and Zaida Ben-Yusuf.

Walter also included the scientific side of photography as well as the artistic, in articles on taking a picture of a speeding bullet—and as strange as using a beetle's eye as a camera lens.

Walter E Woodbury, dashing editor (Courtesy Photoseed Website, David Spencer)

The Artist, a Journal of Applied Art, in its January 1895 issue, says this:

> The *Photographic Times* of New York keeps up and even improves upon the appearance and value of its first issue as a monthly. The June number is admirably illustrated by a photogravure frontispiece of Mr. Alfred Stieglitz's "The Old Mill" and a very fine collotype of Mr. Kidson Taylor's "Hampshire Farm," besides numerous half-tone blocks of American excellence, printing, paper, head-lines, tail-pieces and initials, are all deserving of high praise. The literary matter too, is carefully selected, and many of the articles are of first rate importance. Mr. Walter E. Woodbury is to be congratulated.[141]

Photograph Using a Beetle's Eye as Lens (Courtesy Photoseed, David Spencer)

The English publication, *Photography*, conceded the following in its April 30, 1896 issue:

> The *Photographic Times* is the brightest and best illustrated of any of the photographic magazines which reach us from across the water, and leaves nothing to be desired in the way of printing and set up. There is only one English illustrated monthly which is of the same price-the *Pall Mall Magazine*—and though that is lavishly illustrated, the photographic journal, pictorially, holds its own.[142]

A Photographic Feat (Courtesy Photoseed, David Spencer)

Walter E. also seemed to have had a sense of humour such as posing for this photograph titled "A Photographic Feat".

Walter E. also worked on other projects. Photographers were inventing works with photographic tricks, such as "clone photographs" featuring multiple images of the same person, sometimes merely from different perspectives and usually done with mirrors. Some images were with the same individual in different but related poses in a double or triple exposure. Multiple images were even produced as postcards at amusement parks. There were also spirit photographs where double exposures were presented as ectoplasm.

Walter E. and later his co-author, Frank Fraprie, published *Photographic Amusements Including a Number of Novel Effects Obtainable with the Camera* in 1896 with Scoville & Adams as the publisher. The book was a "how-to guide" for making trick photographs, like having multiple exposures of the same person or putting the face of a living person on a bust... sort of a Victorian Photoshop. This is an engraved illustration of a "spirit photograph," which involved using a double exposure. Incidentally, the man being haunted looks remarkably like Walter E.!

Remember this was the age of Conan Doyle and faeries at the bottom of the garden. There were a lot of hoaxes—rather like some of the content of today's internet—and Walter was setting the record straight that these were hoaxes by explaining just how they were done. Remarkably, the book remained in print until long after Walter E.'s death. It was even reprinted in 2016.

An engraving (not a Woodburytype) from *Photographic Amusements* (Courtesy Photoseed, David Spencer)

Walter E wrote a book about the aristotype, which was a one-bath development of a coated paper and much more suited to amateur photographers' abilities and capabilities than the more elaborate wet-plate techniques. Walter E. also worked as editor of *The Encyclopaedic Dictionary of Photography: Containing Over 2,000 References and 500 Illustrations*.

While all three of these books were important in their time, it was Walter E.'s support of some of the greatest photographers of his time that may have been his lasting legacy. You see, the real irony here is that Walter E. was neither photographer nor inventor himself. He wrote about photography. He encouraged photography. He encouraged talented photographers. He supported the science of photography. He was an eloquent defender of photography as an art form.

He did not seem to take photographs himself.

Since you probably can't read it from the small illustration of the original here is the text:

When the discovery of photography was first announced, no little sensation was created. Artists were astounded, and a celebrated painter was heard to declare: "Alas! With this discovery our occupation is gone forever." The absurdity of this lament was soon evident, however, for photography quickly took its own place in the field of sciences and instead of being detrimental to the interests of artists, proved of material benefit to them.

Here is one of his greatest "encouragements"—the introduction to "Picturesque Bits of New York," a portfolio of photogravure prints of New York (and Paris and Venice). Walter E. wrote the introduction. It's a very eloquent defense of photography as art form.

It is a curious fact, however, that during more than fifty years following the announcement of the discovery, very few attempts were made to secure, with the aid of the camera, anything more than mere records of things and places. The manufacturers of the sensitive plates which record the image, vied with each other in obtaining such marvelous degrees of sensitiveness that a bird in flight or an express train running at sixty miles per hour could be faithfully depicted, and the makers of lenses employed the most skilled mathematicians to assist them in securing instruments giving the most marvelous definition, and the photographer was happy, for with these improvements he was able to make photographs of everything on the earth, above or below, and the artists smiled and said "There is no art in photography."

Gradually, however, it began to dawn upon a few that it was possible to make the camera a tool in their hands as a painter uses his brush. They began, too, to realize that the human eye does not see nature as it is, but merely receives a number of signs and impressions, and that the photograph, with its microscopic detail in every stick and stone, was rarely, if ever, pleasing to the eye, for it left nothing to the imagination—no suggestions for the feelings.

The pioneer in this country of Pictorial Photography is undoubtedly Mr. Alfred Stieglitz, some examples of whose work form the contents of this portfolio. A glance over the pictures contained herein will now doubt cause the reader to remark how little like photographs they are, that is to say like the photographs we are accustomed to seeing. Wherein then lies the difference? The scenes depicted are all more or less familiar and have in all probability been photographed many hundreds of times, but the difference between the photographs made by the ordinary amateur or professional photographer and the one we have here is this: the former are mere statements of facts, topographical records, imitations of nature as the photographic lens depicts it upon the sensitive plate. The maker is simply the manipulator; he relies upon the camera to give him the view he wants. He has no higher aim. But in the pictures we see here, we detect at once the work of an artist. Take for instance, the picture entitled "Winter on Fifth Avenue." Here only so much is included as will stimulate the poetic imagination. The effect of a cold winter's day with the blinding snow and misty atmosphere are all faithfully rendered.

Whatever the subject chosen for pictorial expression we see the same master hand in the composition, the light and shade, the general feeling and motive, a completeness and harmony throughout all, the character and individuality of the photographer are at once evident in each picture.

> Mr. Stieglitz has undoubtedly done much to raise photography to a higher position and to cause it to occupy a much larger share of artistic esteem and appreciation.
>
> *Walter E Woodbury* [143]

Winter on Fifth Avenue, Alfred Stieglitz
(Courtesy Photoseed Website, David Spencer)

Walter E. turned *The Photographic Times* from a weekly journal for photographic "tecchies" to a "high quality art magazine." We can see the same zeal in this introduction: Photography is more than "the mere records of things and places." I wonder if this assessment included his father's "bread and butter" views of Javanese landscapes, "Java types," and portrait sitters.

Of course, when you think about it, his father's work was seminal in the expansion of the role of photography, being Walter B. was the person who was the link between the photographer producing single images and the photographer being able to print enough works

mechanically to publish a run of books—or a magazine. It was Walter B.'s inventiveness that allowed creation of the multiple copies of the Stieglitz book that Walter E. introduced and *The Photographic Times*, which he edited.

It could be that Walter E., having seen how financially unrewarding his father's career as an inventor was, had chosen another path, the path of the advocate and publicist. A case in point of Walter E.'s advocacy of the expansion of the role of photography would be the publication of a groundbreaking article on radiography. On May 22, 1896, Walter E. wrote to University of Pennsylvania physics professor Arthur Willis Goodspeed that he (Walter E.) had written an article called "Radiography and its Application," which he intended to publish in the July issue. He was willing to hold up the publication of his article until he could include photographs showing the dry plate X-ray negatives that he knew would be electrifying.[144]

From left: Professor Arthur Goodspeed c. 1906; the 1896 photo of Goodspeed's hand; John Carbutt who took the photograph and invented the specialized plates for radiography (Courtesy Photoseed, David Spencer)

Walter E. writes:

> With a view to developing the sensitive plate to produce the best results possible, Mr. John Carbutt has given untiring attention and made many experiments. The Carbutt plates have most of them been tested by the writer in comparison with other makes, and those now in use give by far the best results of any yet tried. The negatives from which the illustrations

accompanying this article have been reproduced are samples of the plates referred to.[145]

So here Walter E., by proxy anyway, had become a member of the photographic scientific community.

The heady mixture of art critic, editor, and scientific prophet didn't last. In one of the many moves and changes at Scoville and Adams, the company merged with its largest US distributor and became Anthony and Scoville in 1902. New brooms swept clean and Walter lost his position as editor. Walter E. went home to England where he visited his Aunt Lucy. Only Valence of his immediate family remained there and she was married with a brood of children.

Aunt Lucy, her six daughters, son Albert (left) and Walter E (right)
(Courtesy Collection of Luanne Woodbury)

Aunt Lucy is the matriarch in the improbable wedding-cake hat in the centre surrounded by her six daughters. On the left is Albert Woodbury Roscow, her son, who was visiting from Argentina, where

he had married a Scottish/Argentine wife (there was a large Scottish community in Buenos Aires) and had two daughters, Patricia and Lola. On the far right is Walter. Like many of the Woodbury men, he had gotten balding and portly. He was no longer the rakish young editor. Aunt Lucy could offer no financial help. She was now a widow, had lost her fine house on Park Avenue, Manchester, and supported herself and her several unmarried daughters by running an agency for domestic servants. So, Walter E. took an editorial job at the English version of the *Panama Star and Herald and Inter-Ocean* newspaper, covering the digging of the Panama Canal and building of the Panama Railway. That job proved fatal.

The project was plagued, literally, by yellow fever and malaria. Walter E. caught yellow fever and died in 1905. Ironically, a committee of physicians was working at the time on the disease vector being the mosquito and instituted fumigation of buildings. By 1906, swamps and ditches were being sprayed with insecticide. The death toll from yellow fever dropped to just one in Panama City in 1906. Before that, an estimated 22,000 workers had died of it during the construction of the Panama Canal and Railway. Walter E. was one of casualties. He was 40 years old.

CONSTANCE THE NURTURER

Constance, the third child and second daughter, was born February 26, 1867 while the family was still at Rusholme, Manchester. Like the rest of the family, she moved from pillar to post—seven times at least before Walter's death in 1885. There is no record of her having been sent to school, although the 1871 Census, when the family was at Penge, Surrey, does list a governess in the house and the children are listed as "scholars" but census takers listed virtually all children as scholars. In the 1881 Census, Constance and the younger children were still recorded as "scholars," presumably at a local day school. There are records of Avence and Fayance being in a boarding school in the 1891 Census, but there's no record of boarding school for Constance and the older children. Informal education was an integral part of Walter's

growing up. His grandfather, Walter Bentley, was listed in the Manchester Guide of the time as a schoolmaster; however, we have no record of Walter the father being enrolled in formal schooling. Perhaps the tradition of informal education was continued, especially when funds became scarce around the time of the bankruptcy.

We know little of the family's childhood other than one devastating sentence from Ellen Woodbury Ferguson's handwritten history:

> Marie did her best—poor little thing! She was clever with her needle, a good cook and tried hard, but, no one would associate with the children, or her—they had no play-fellows and as they grew older, no friends, always thrown in upon themselves! and the results were—very bad.[146]

Constance
(Courtesy the Collection of Luanne Woodbury)

We have no documentation of Constance, other than her presence in the 1871 and 1881 Census Reports, until 1887 when she had a son, Arthur, then a daughter, Edith, born in 1888. Both were registered with the surname "Woodbury." In 1890, she had a daughter, Constance Bentley, and this birth linked her to Arthur Charles Bentley, a commercial traveller for a photography company. Unfortunately, Constance seems to have had her Grandmother Ellen's luck with husbands (if he indeed was a husband; I cannot find a marriage certificate.) Arthur died in 1890 at the age of 24, leaving Constance, aged 23, with two toddlers and a babe in arms: Arthur, born January 8, 1887; Edith, born December 4, 1888 and Constance, born July 4, 1890.

The 1891 Census listed her a boomerang child, having moved back into what remains of the family home, with her mother who was now married to Edward Bent, recorded as an "African trader," and Mayence who was a "machinist." (I presume that meant a typewriter operator.) Constance was listed as a widow "living on own means." The younger girls, Fayance and Avence, were away at boarding school.

The house might have been crowded because the family had given up Manor House in Greenhithe and were living at 3 Victoria Villas in Shepherd's Bush.

Constance was serious about her children's education. She enrolled Arthur and Edith first at St. Matthew's School on Shepperton Road, on July 9, 1894 under the surname Bentley. They stayed very briefly and the girls were enrolled at Morland Street School on August 27, 1894. The children were withdrawn and readmitted as pupils #5595 and 5596 only to leave on September 2, 1895. Their guardian was Constance, a machinist (possibly a typist) living at 357 City Road, Islington.[147] I'm not sure if they were withdrawn in preparation for emigration to South Africa, or whether Constance could not pay the fees on a machinist's salary. Her status of "living on own means" had vanished.

Constance decided to take her chances outside of England the year that her stepfather Edward Stanley Bent, died. She and the three children boarded the *Gothic*, which sailed for Cape Town on April 15, 1896, possibly because her sister Mayence was already in South Africa. Two pages after her entry in the passenger manifest was "Wm. Mather, miner."[148] Constance and William had a whirlwind shipboard romance and were married six weeks later in Cape Town on May 31, 1896.

William adopted Constance's three children. Eight children of their own followed but some were born in South Africa and some were born in England. Elsie and Walter Woodbury Mather were born in 1898 and 1899 in South Africa, then Muriel Irene was born in Sevenoaks, Kent in 1900, and Winnifred was born in 1901 in South Africa. Then William Lace Mather was born in West Ham Essex in 1903 and Dorothy was born in Walthamstow, Essex in 1906.

Emigration in 1896 would have put Constance smack in war zone as the Boer War was heating up from skirmishes to a full out war in 1899. The South African War, as it is also known, was fought between the British

Constance dressed for travelling (Courtesy Collection of Jennifer Lock, her great granddaughter)

defending their colonies of Cape Town and the Africans or Boer colonies of Transvaal and Orange Free State, from 1899 to 1902. Perhaps this was the reason why Constance returned to England to have her children. Perhaps she suffered from or feared the same complications of childbirth that eventually killed her older sister, Florence.

It is difficult to trace someone in South Africa. The ground-breaking 1910 Census, which included "Bantu and mixed race" people, which a previous census had not, had the District Enumerators enter the collected data in such categories as "housing materials" and "agricultural" then destroy the original census questionnaires, so I might know what Constance's house was made of but not necessarily who lived in it!

We know Constance's house was a boarding house, from her great-granddaughter Jen Lock's research. She herself was born in Africa. The family prudently emigrated from Rhodesia (now Zimbabwe) during the Mau Mau uprising. All of the pictures in this section except the one of Constance as a child, which came from Luanne, are from Jen.

Constance and her brood, possibly around 1910
(Courtesy Collection of Jennifer Lock)

Here's Constance with 10 of her 11 children in South Africa. (Possibly child number 11 was taking the photo.) They look happy, well cared for, and well fed. The girl on the left is Constance, who had the Woodbury "travelling feet." She went to Montreal and lived

with Fayence, until Fayence's marriage imploded and she moved to Fremantle, Australia. Constance married Fayence's boarder, Charles Thomas Clarke, in Montreal in 1912 and made several trips with her son, Neville Clarke, to Hamilton, Bermuda, I presume to visit her Grandmother Marie. "Clarke" was the surname of Constance's stepgrandmother, Brigetina Clarke Bent, who also came from the West Indies, but I have not found a connection.

Constance had the genes for longevity that seem to be passed on from Marie. Walter's brothers and sisters didn't make old bones. All of the men and most of the women were dead before they were 60 but Marie's genes seem to have lengthened the lives of her children. Constance lived to be 96. (Her sister, Mayence, lived to be 98.) Constance died in Johannesburg, South Africa in 1963.

A much later picture with the brood grown up
(Courtesy Collection of Jennifer Lock)

Constance, in her garden in her 90s, the last picture taken of her (Courtesy Collection of Jennifer Lock)

INDOMINABLE MAYENCE

Mayence was one of those Bentley women who could have been an army general. Constance managed a successful boarding house and large family: Mayence created a commercial empire.

Mayence doesn't appear in the family documentation except in census rolls. In 1871 and 1881 she was a "scholar." In 1891, she was a machinist (probably a typist) living with Marie and Edward Bent, her sister Constance and Constance's three small children. Sometime between 1891 and 1893, she left England and headed for Africa, with her step-brother W. S. (William Stanley) Bent. Edward Stanley Bent, William's father, listed himself as an "African trader" in the 1891 census. This might be why the pair choose to go to Africa. Edward S. died in 1896 so perhaps he was too unwell to travel on such an arduous journey.

The picture of the two girls was sent to me by Luanne Woodbury and is of Mayence and Constance, dressed in elaborately Victorian matching outfits likely handmade by Marie. They seem close and Mayence's being in Africa was likely the reason Constance chose to go there unescorted, meeting future husband William Mather on the ship. Mayence is on the left; Constance on the right.

Mayance and Constance in matching dresses (Courtesy the Collection of Luanne Woodbury)

Mayence was not an unescorted traveller. She was travelling and living with W. S. Bent, although she could not marry him. In the eyes of the law, he was her brother as her mother and his father were married—even though Mayence and W. S. had no blood relationship. W. S. was Edward Stanley Bent's son from an earlier marriage to Marion Beever Farrel, which ended with her death in 1875. The Forbidden Marriage List was based on rulings from the Church of England in 1550 and was not amended until the 20th century. The

amendment that would have allowed Mayence to marry W. S. was made in 1949.

Mayence and W. S. presented themselves in South Africa as a couple, and on April 30, 1894, they had a daughter, Gladys Mayence Bent. Two years later they moved north, possibly to avoid social comment, possibly to find better opportunities.

Mayence and W. S. fetched up in Nairobi where W. S. worked for the fledgling Nairobi railway system. Nairobi was a frontier town then. In the book *Taking Land, Breaking Land*, the author, Glenda Riley, makes a case that Nairobi was the Wild East and the women there faced the same challenges as women in the American Wild West. Mayence was more than up to the challenge.

Riley writes:

> Unsurprisingly, because the growing capital city of Nairobi offered many openings for women, it had many women entrepreneurs. One of early Nairobi's most colourful and epic figures, May (Mayence) Bent, like her predecessors in California, utilized her domestic skills by housing and feeding people for pay.[149]

Mayence in full, fashionable Gibson girl mode
(Courtesy Collection of April Manino, her great-granddaughter)

W. S. had worked for the Nairobi Railways and had become the chief clerk of the Mombasa-Lake Victoria Railway Line. This lasted until W. S. was the Nairobi representative of the Railway Strike Committee (March 31, 1900). The railway didn't forget and didn't forgive: W. S. was given three months' notice in September 1901. The British Government began granting lands to settlers in 1902, so W. S.'s timing was right. He made a land grant application for 40 acres in "Kikuyu" on January 4, 1902, became a farmer and by July 1903, he was winning prizes for his vegetables in the Mombasa show. Mombasa was on the coast and a long-established city while Nairobi was a collection of "iron shacks."

Mayence also put in an application for a grant for land at Fort Smith (June 29, 1903), which makes me wonder if she and W. S. had split by this point or they just wanted two farms. She sold her farm products in *The Mombasa Times and Uganda Argus* later known as the *East African Standard*. Her advertisement for butter reeked confidence: "Fort Smith Butter. Mrs. Bent, Nairobi. It takes the cake. It would Keep For Ages but People don't Give it a Chance."

In 1902, when Gladys was eight, Mayence took a job with Tommy Wood who ran a general store in Victoria Street near the railway station. Mayence, like Florence, set up as a dressmaker and also as a milliner. Likely both girls were taught to sew by Marie, whom family historian Ellen grudgingly admitted was a clever seamstress. Perhaps the skill was something the mother could pass on to her daughters—something she could do that was of value for the family. Perhaps it was a kind of education that the bankrupt family could afford. In any case, sewing and tailoring stood Mayence in good stead.

Mayence was soon the go-to person for fashion in Nairobi. The store was truly a general store, selling dry goods, meat, clothing and, upstairs, it became "the Victoria Hotel." In the book *Red Strangers, the White Tribe of Kenya*, author C. S. Nichols tells of the reaction to the scene by a young chemist from Yorkshire:

> To the south the landscape was blemished by two huge corrugated-iron buildings: one was the railway shed, the other the

railway workshops. Leading from the station in a northerly direction was a wide track known as Station Street… About four hundred yards from the start of the street there were a number of corrugated-iron houses on its left. They were the residential quarters of the railway employees. To the right, running parallel with the main track were nine corrugated-iron buildings, flatteringly called stores or shops. The first one was double storey and some humourist called it a hotel. This was Victoria Street.[150]

Tommy Wood's store, bar and hotel in 1901: I wonder if Mayence is the formidable lady in the formidable hat between the ladder and the steps
(Courtesy Nairobi City/County Website)

At some point, Mayence and Tommy Wood had a disagreement. No one knows what it was about, but it was serious. Mayence walked out of the Victoria Hotel and she and Daniel Ernest Cooper, a fellow farmer with money to invest, started a rival hotel, just down the street. Their Stanley Hotel, named after the famed explorer Henry Morton Stanley ("Dr. Livingston, I presume?") was a dedicated space—it was meant to be a hotel, not just an upper floor with bed space curtained off. It was the first actual purpose-built hotel in Nairobi. The building

was a boarding house with 15 rooms, and by March 1905, it had a liquor license. Made of dressed stone and wood, not corrugated iron, it was a substantial structure.

When Mayence intended to expand the hotel and could not find sufficient mattresses, she made the fateful acquaintance of Abraham Lazarus Block. Block was a Lithuanian Jew; he was penniless—and resourcefully intelligent. He heard of Mayence's problem, saw the cut grass lying, drying along the railway right of way, and had an idea. He bought some strong cloth for ticking, asked the railway for the right to take the grass, hired a tailor and was set to make grass-stuffed mattresses.

There was only one problem: the tailor didn't have strong-enough needles, so Block fashioned some out of bicycle spokes. Mayence got her 23 mattresses and Block made enough money to put the down payment of a farm. I said "fateful" because Block continued to strive and thrive in Nairobi and, eventually, when in her late 70s, Mayence finally wanted to sell her hotel, Block bought The New Stanley Hotel.

The first purpose-built hotel in Nairobi: The Stanley
(Courtesy Wikipedia Public Domain)

Mayence's Stanley Hotel outperformed Wood's Victoria Hotel and made a profit. Then disaster struck. In 1906, the entire street of "iron shacks" burned down. One of my favourite stories about Mayence is that she had just equipped her hotel with enamel chamber pots and she was not going to let those pots be destroyed by the fire. There was

Mayence, in a street on fire, throwing the chamber pots out of the second-storey window!

Ever the entrepreneur, she reopened the hotel under canvas. Even with eight beds to a "room," travellers from South Africa flocked to the hotel. Soon, Mayence began rebuilding to create a 30-bed dedicated-space hotel.

By 1908, Mayence's "marriage" to W. S. seemed to have crumbled and he was now operating an employment agency. But things were not going well for him and in that year, he filed for bankruptcy.

Not only did he have to file for bankruptcy, he lost his wife. Mayence met Fred Tate. Fred worked for the Railway (a steady job), was 13 years Mayence's junior, and was a member of the "musical Tate family," the most famous of whom was his sister Dame Maggie Teyte (she deemed plain old "Tate" as, well, too plain) who was the only singer Debussey composed music for and even accompanied—a true diva. Fred's brother James was a theatrical impresario and married to "Naughty Lottie" Collins, the notorious skirt dancer of "Ta-ra-ra-Boom!-de-ay!" fame. (A skirt dancer was the British equivalent of a can-can dancer and Lottie swept up her skirt, backwards on the "boom!" Ladies did not wear underpants at this time so the audience saw a lot of Lottie.) Mayence's father was known for his conviviality in Batavia, and maybe family tradition was part of the attraction here. Fred came from a well-to-do family in Wolverhampton, where they were wine and spirit merchants and owned pubs. Fred also worked as a bartender and played the piano at the Railway Club.

At any rate, poor old W. S. was out of the picture. He remained in Nairobi, where he died of pneumonia in 1918 and was buried there.

Mayence and Fred eloped to Zanzibar (how romantic is that?) and got married. Nairobi's newspaper, *The Leader*, on 20 November 20, 1909 noted: 'The marriage

Fred Tate (Courtesy Europeans in Africa website)

of Miss Mayence Woodbury with Mr. Fred Tate was celebrated on the 9th inst. at the Catholic Cathedral at Zanzibar."[151] I find it interesting that Mayence calls herself "Miss Woodbury" rather than "Mrs. Bent," but it might have been difficult to produce divorce papers if the marriage to W. S. had never actually happened, nor as a divorced woman, would she have been able to marry in a Catholic church, let alone a cathedral. She and Fred rebuilt the Stanley Hotel to a 30-bed establishment, but it was not big enough. (Fred had a Bechstein piano and a Thurston billiard table.) Two lots became available closer to what has now become the centre of town on Delamere Avenue, now Tom Mboya St.

The Tates hired the firm of Robertson, Gow and Davidson and in 1912 began a building a 60-room hotel.[152] They sold the original hotel to Dan Noble, in 1913, but he wanted to keep the hotel's established reputation and custom and objected to the Tates calling their hotel "The Stanley Hotel." So, after a brief legal dispute, the Mayence and Fred called theirs "The New Stanley Hotel."

The New Stanley Hotel 1915—note the thorn tree growing out of the bar
(Courtesy New Stanley Hotel Website before revision)

In *White Hunters: The Golden Age of Africa Safaris*, author Brian Heme describes Mayence":

> ...the steely-eyed wife of a Nairobi railway man. Later Mrs. Tate became the owner of the now famous New Stanley hotel... She was known to her bar patrons as "Aunty" and one withering look from her was enough to break up a fistfight, according to Murray Smith, who knew her well.[153]

The new establishment prospered and became a landmark in Nairobi. The bar was a popular meeting place and was dominated by a huge Navisha thorn tree (and Mayence). It became custom to pin notes to the tree. Bar patrons would peruse the notes and deliver any they could, often adding missives of their own. It's a tradition that the hotel carries on to this day, with a message board located in the Thorn Tree café.[154] Many institutions of Nairobi got their start in the Stanley Hotel and the New Stanley Hotel. Mayence began the first lending library. The Nairobi Stock Exchange began in the Thorn Tree Bar in 1922. Tusker beer was first served in the Thorn Tree Bar.

Mayence and Fred ran the hotel happily for 11 years. Fred served with the Territorial forces in WWI. Then, disaster: Fred was stricken with a disease which left him paralyzed and blind. Mayence handed the hotel over to managers, Albert Ernest Waterman and his wife, and took Fred to England to see if there was any treatment.

There wasn't.

In 1932, the Tates returned to Nairobi. Fred seemed to be one of those rare people who have no self pity. Ensconced in a bed in the hotel, he was read to by Mayence and Gladys, went over the menus in detail, and generally took in stride what would have devastated a lesser man. He died in 1937.

Mayence never remarried.

Mayence, circa 1935
(Courtesy Collection of April Manino)

During the time that Fred and Mayence (and later Mayence on her own) ran the hotel, there were famous guests. Ernest Hemingway, recovering from an illness caught on safari, wrote one of his most famous stories, "The Short Happy Life of Francis McComber" in one of the guest suites. Nor was he alone. The hotel also hosted Elspeth Huxley (*Flame Trees of Thika*), Col. J. H. Patterson (*The Man-Eaters of Tsavo*), and Karen Blixen (*Out of Africa*). Other patrons were Dennis Finch-Hatton, Eward Grogan who walked from Cape Town to Cairo to prove his love for a woman, and Edward, Prince of Wales.[155]

A luggage sticker to show you had stayed at the famous New Stanley Hotel (Courtesy Wikipedia Public Domain)

Mayence in her 70s, still running the New Stanley Hotel
(Courtesy Collection of April Manino)

Mayence carried on running the New Stanley Hotel. The staff and the website called her "the indominable May Tate." Finally, in 1947, when she was 79, she sold the hotel to Abraham Lazarus Block, from whom she had bought those mattresses so many years ago. Block had become the proprietor of the rival Norfolk Hotel. He ran the New Stanley Hotel and rebuilt it extensively in the late 1950s. Mayence and Gladys were invited to and went to the re-opening, flying in all the way from England.

Later, Gregory Peck, Stewart Grainger, Ava Gardner, and Clark Gable used the hotel as a base for making the movie *Mogambo*, but that was in Block's time.[156]

Mayence left Kenya and moved back to England, where she lived for the rest of her life. In doing so, she missed hosting perhaps the most famous of all the New Stanley Hotel's guests. In 1952, Princess Elizabeth and Prince Phillip were guests at a luncheon at the hotel. They were given one of the suites in order to change clothes to go to their next stop of the day, a gift from the people of Kenya, Sagana Lodge. They needed more suitable attire for the Kenyan outdoors as Sagana Lodge was 80 miles away, near Mount Kenya.

As they were leaving, Margaret Stevens, an attendant, noticed that one of the royals had left a hat, and she was unable to catch the couple in time. Superstition is divided on left-behind hats: one camp views it as an omen while the other sees it as an indication that her person who left subconsciously wants to return. Elizabeth never returned: on Feb. 5, just a few days later, her father, the King, died while the Princess and her new husband were staying at Treetops Hotel, but she didn't find out until the following day at Sagana Lodge. She was now Queen Elizabeth II. And Mayence missed this moment of history.[157]

Princess, soon-to-be-Queen, Elizabeth outside the New Stanley Hotel (Courtesy of Wikipedia Public Domain)

Mayence's great-granddaughter, April Manino, remembers "two grans" in the family. Gladys was called "Little Gran" and Mayence was "Big Gran." Here is the family, with Gladys' husband, Henry Liversedge, and their children in 1946. Great-granddaughter April from whom we get these pictures is standing in front of Mayence.

April Manino (centre) with her "two grans," father and siblings
(Courtesy Collection of April Manino)

And she was not done yet. Mayence lived to be a remarkable 98 years old, dying in 1966. Here is one of the last photos of Mayence, on her 95th birthday.

Nor is the story over. In the course of writing this book, I contacted Mayence's great-great-grandson, Alex Hadwen. He liked the book's title, and said that he had been called "Paki" and "Gunga Din" at school in England because of his dark skin tone. We can't be too judgmental of the Victorians if we haven't learned all that much about character and ability being more important than skin pigment.

Mayence on her 95th birthday (Courtesy Collection of April Manino)

Incidentally, The New Stanley Hotel was purchased by the Sarova Hotel Group and is still very much in business. You can visit Nairobi and book an elegant, if pricey, room. You can even book the Tate Suite.

VALENCE THE REBEL

Marie Valence Woodbury (Courtesy Collection of Luanne Woodbury)

I know a lot about Mayence; I know little about Valence. I always think of Valence as "the rebel" because she didn't flee England. She married, lived in Fulham and raised a family.

Valence married James Cardew Truscott on July 19, 1887, when she was 21, two years after Walter's death. She and James lived in the St. James Norland district, which was artsy and upscale, and also was home to the William England family enclave, into which her sister Hermance married (at least for a short time).

Valence and James had a family of eight children with excruciatingly upscale Victorian names: Vivian Cardew (1889), Hilda Grace (1890), Dudley Francis (1893), Sybil Valence, and Stella Victoria (1895). Little Stella died in her birth year so they had a replacement: Stella born 1897. Then there was Irene (1896), James Leonard (1906), and Leonard Woodbury (1909).

Like Florene's husband David Steet, Valence's husband was neither photographer nor inventor nor artist, nor was he evenly remotely connected to the photographic community. His father was a clerk in the Army Pay Office, assistant pay master of the Royal Engineers and later in the 1901 Census, he was listed as a "retired civil servant" living in Ramsgate, a fashionable seaside town. Valence's husband had a variety of jobs: in the 1881 Census he was an apprentice draper, in 1887 his marriage banns indicate he was the manager of a cigarette company, in 1891's Census he was a printer's clerk, and in 1901 he was a blouse manufacturer. In the 1911 Census, he was a traveller or salesman. In 1918, he was a dispatch manager. He died on May 19, 1928, leaving Valence £25.

Both Dudley and Vivian served in WWI. They were decorated soldiers, Dudley as a veterinarian and Vivian in the machine gun corps.

Valence lived with her youngest son, Leonard Woodbury Truscott, until her death at 78 in 1949. Leonard married and had two children. He and his family moved out of London after Valence's death and he lived until 1982.

SCANDALOUS HERMANCE

Ironically, I don't have a picture of Hermance and she is one of the two "-ances" for whom I have no complete dates. I have the usual census stuff and some interesting records, but no image. I don't even have a death date. I only know that she may have been alive in 1925 or so because Luanne, who was born in 1920, remembers meeting her as a young child. And Hermance is my great-grandmother!

Hermance's behaviour was, by Victorian and even Edwardian standards, scandalous. Perhaps she was reacting to a society that did not accept her physical appearance by rejecting its social mores.

What do I know about Hermance? She was born in London on January 31, 1871. She was fourteen when her father died suddenly in Margate.

Document of permission for Walter England to marry Hermance
(Courtesy UK National Archives)

Walter's death left the family so impoverished that a collection had to be taken to pay for his funeral and headstone. Marie, a widow with six dependent children, was left £246. In 1888, three years after Walter's untimely death, Hermance married when she was actually 17, although the documentation reads that she was 18. She was married by

special permission to Walter John England, a widower with children. He needed to get the special permission because Hermance was a minor. The cursive writing at the bottom of the page says:

> …and he lastly made oath that the said minor hath no Father living or any Testamentary or other Guardian to her lawfully appointed or Guardian appointed by Her Majesty's High Court of Justice (Chancery Division) and that the said consent of Marie Woodbury the widow, the natural and lawful mother of the said minor hath been obtained to the said intended marriage.[157]

Three things interest me about this document. One is that on September 18, 1888, Hermance would not have been 18—almost, but not quite. The second is that the document was for a church wedding at St Thomas Parish, Shepherd's Bush, London. (None of the other sisters had a church wedding in England.) The third is that neither Marie nor Hermance signed it.

Walter John England was the family's neighbour, or at least they lived on the same short street, Walter at 62 Tunis Road and the Woodbury/Bent family at 33 Tunis Road, so Marie had had to give up Manor /Java House. Eleven years before, Walter had married Mary Jane Stephens. They had had three children before her death at the age of 36 in 1886: Florence, William Louis Edward, and James. At the time of the second marriage, they would have been eight, seven and six years old. Walter was 16 years older than Hermance.

Walter England was the son of William England, whose work Walter B. featured as two of the 28 plates in *Treasure Spots of the World*. William England was famous for his stereo-photographs, especially of the Swiss Alps and Tyrolean Alps and was a pioneer of photography in his own right, having invented a type of focal plane shutter. Before the shutter, the photographer exposed the plate by taking off and replacing the lens cap, so films necessarily were slow. The shutter allowed for faster film exposures and less "freeze time" for subjects.

William England had also taken the first commercial series of photographs of the US and been the first to use dry plate photography

for his Rhine Series of Stereo Photographs. He was the photographer of the best-selling stereo-photograph ever, *Blondin Crossing the Niagara Gorge*, which shows a teetering aerialist with a very long balance pole posed precariously above the rushing Niagara River in Ontario.[158] He was also the London Stereoscopic Company's official photographer of statuary in the Great Exhibition in the Crystal Palace, organized by Prince Albert.

The famous stereoview of Blondin crossing Niagara Gorge, by William England
(Courtesy Rijksmuesum)

The family England was a business unit, with an enclave in St. James Norland. Several family members lived within doors of each other and worked in various aspects of producing the popular stereoviews. William England's immensely popular views of the Alps, both in Switzerland and Italy, coupled with the Baeddeker's Guide and recently created Thomas Cook and Sons travel agency, spurred a boom in tourism among the better off members of the middle class.

Walter England was the family rebel: for a time as he wanted to be a traditional artist, and even managed to get a painting hung in a Royal Academy show. The painting was called *Ruth*, but I have been unable to trace it. By the time he married Hermance, Walter was back with the family firm as a lithographer and publisher.

The marriage licence (note both Hermance and Walter live on Tunis Road)
(Courtesy UK National Archives)

So, for good or ill, Walter married his young bride (who was actually a year older than her own mother was when she got married). A question that really bothers me is where did the children of the first marriage go? In the 1891 Census, the household was Walter, Hermance, and Oscar, their new baby. There is no record of the children from the previous marriage. Were they away at boarding school? They would still be very young—10, nine and eight. Were they being raised by relatives? And why?

Hermance and Walter had three children: Oscar Woodbury, Muriel Phyllis (my grandmother), and Gladys, but all was not well financially with the little family. According to PhotoLondon,[159] Walter John paid off the debts owing on The England Brothers' Studio at 25 Charles Street, Notting Hill, Kensington in 1890 for the substantial sum of £2,687 (Warrant of attorney April 24, 1895). Now this would be worth £243,000 in today's currency or $385,000, even more in Victorian context. The repayment broke Walter John financially.

Walter took on the debt, then when he didn't inherit anything from his father's estate, Hermance decamped. In 1897, she abandoned her three children, including Gladys, who would have been two. I have a theory. Until 1896, Hermance and Walter lived possibly in anticipation

of a legacy from William, Walter's famous photographer father, a legacy which apparently did not materialize when William died on August 13, 1896. The inheritance of £1,138 7s 5d went to William Mayland, another photographer, and Louis William England, Walter's brother, who was an architect. Having lived through a bankruptcy and straitened circumstances, did Hermance not want to face lean times again?

Walter's fortunes never recovered. He was left with three small children when Hermance fled, so he hired a housekeeper. She seemed to have been a housekeeper in the Batavian fashion, because in the 1901 Census, the housekeeper, Annie Best, was listed as "Annie, wife," although there was no formal marriage ceremony until 1909. They had two children, Vera Constance and Frank William. In the 1911 Census, Walter still listed himself as a printer but Annie, now officially his wife, was running a boarding house with six boarders, two small children. and no live-in servants. That indicated straitened circumstances. Walter died of TB in 1914.

There's another theory to explain Hermance's flight: she had met a man she fancied more than Walter. He was Henry Arliss Robinson, or Arliss-Robinson as the mood seemed to strike him or the Census-taker. He was a chemist working in an upscale chemist shop, Savoy and Moore in Belgravia. But more about him later.

In 1900, Walter and Hermance began divorce proceedings. This was highly unusual because Walter John must have been religious enough to have wanted a church wedding, and the Catholic Church does not look at all kindly on divorce. Hermance was the only one of her sisters married in church, although Mayence managed to be married in Zanzibar Cathedral possibly because she had not and could not marry W. S. Bent. The church aspect of this wedding had to have come from Walter. All the other daughters were married in a Registry Office. (Walter and Annie waited 12 years before marrying, perhaps because of the mess of ending this marriage.)

Divorce proceedings at the turn of the last century were very different. The 1857 *Matrimonial Causes Act* made divorce a possibility for the middle classes in that one no longer needed an Act of Parliament to dissolve a marriage, but the conditions were pretty stringent; more so, if

you were a woman divorcing a man. A man only had to prove adultery, but a woman had to prove incest, cruelty, bigamy, desertion… The act also decriminalized adultery. So, it may have simply been more efficient for Walter to sue Hermance for divorce than vice versa. Apparently, Walter did this at Hermance's request, so she could remarry, proving himself a better man than her second husband.

These frail, unassuming papers are so different from the officious, ornate, crested, and sealed papers that usually are English legal documents. Some of the pages even have handwritten additions in pencil. Divorce seemed to be a hush-hush, embarrassing proceeding for all concerned. And it would have been. Here's a husband accusing his young wife of deserting her children and home and cohabiting repeatedly with another man in a railway hotel. There is no defence of her actions from Hermance. I suspect that the situation with the man in the railway hotel, a suitably sleazy venue, was a set up to allow the terms of the *Divorce Act* to be met. There was no mention of the co-respondent Hezeltine (sometimes spelled Heseltine) in any other papers concerning Hermance, nor were there any damages awarded. Walter was granted custody of the three children.

Divorce papers were marked "Sealed until 2002"—that's 100 years after they were issued. (Courtesy UK National Archives)

The divorce was filed in December 1900 and the Decree Absolute was granted in 1901 and Hermance was free to marry. The actual divorce papers were sealed for 100 years, only becoming available to public scrutiny in 2002.

Name: Hermance Edith Woodbury
Registration Year: 1902
Registration Quarter: Jan-Feb-Mar
Registration district: Chorlton
Inferred County: Lancashire
Volume: 8c
Page: 1307
Records on Page: **Name**
Henry Arliss Robinson
Hermance Edith Woodbury

Henry Arliss-Robinson, the man Hermance deserted Walter and the children for, was born in Wilton, Lincolnshire in 1862, so he was two years older than Walter England, so 18 years older than Hermance. He trained as a chemist, and the 1881 Census found him working as an apprentice chemist on Steep Hill in Lincoln and living at home with his parents. By 1891, he had moved to the big city and was an apprentice chemist with the prestigious Savoy and Moore firm in Belgrave Square, London. In the 1898 *Pharmaceutical Journal and Transactions*, Henry he was in charge of tickets for the Junior Pharmacy Ball, to be held in the Portman Rooms, Baker Street, on February 13.[160] In the 1902 *Chemist and Druggist*, he was still the go-to man for tickets to the Junior Pharmacy Ball, now on March 1 and he was now the Honorable Secretary.[161]

I first thought that Henry had lost his job with Savoy and Moore because of the scandal of his relationship with Hermance, but if he were selling ball tickets in 1902, that was not the case. Perhaps Hermance's using her maiden name on the marriage certificate was an attempt to mitigate the situation. Perhaps it was a symbolic rejection of her time as Walter England's wife, to say nothing of her three children by him. Also, the wedding was registered at Chorlton, Lancashire, which is old Woodbury and Bentley family territory but unfamiliar to

Hermance who was born and bred in the environs of London and to Henry who came from Welton and Lincoln in Lincolnshire.

I wonder if Hermance stayed with a Manchester relative such as Aunt Lucy. Most of the others like Great Aunt Elizabeth Whitworth, had passed away. Aunt Ellen was working as a lady's companion, which is what gently reared women did when they had no money—that or being a governess and was in Conwy, Wales with her employer. Even Aunt Lucy was in a bit of financial trouble having given up the house on Park Lane and supporting herself and daughters by running an agency for domestic servants. Nor could Hermance go home to mama because Marie had left England for the West Indies. By the time of Hermance's second wedding, Walter Woodbury's immediate family was well and truly scattered to the four winds.

Arliss-Robinson ginger beer bottle (Collection of the Author)

The next time we find documentation on Henry (and by implication Hermance) is in 1906. He had bought the Philips Ginger Beer Company in Sutton, Surrey. He was also working in the Dispensary at Croydon Hospital. Henry was listed from 1906 to 1911 on the electoral registers of Epsom, Surrey. Hermance was not listed, because women did not have the vote. Ginger beer was extremely popular as a temperance beverage in the early years of the 1900s and there are societies today that collect the stoneware ginger beer bottles. I actuallly own this one, courtesy of e-Bay.

Arliss-Robinson Mineral Water bottle (Courtesy e-Bay screenshot)

Ginger beer was brewed from a yeast culture, so it would be something a chemist could get his head around. Henry also produced a mineral water, sold in blue bottles with the "Arliss-Robinson" name impressed on the glass.

Henry sold the ginger beer works in 1912, just after he emigrated to Perth and Fremantle, in

Western Australia. I'm sorry, Australians, but that is the back of beyond—and I'm a Canadian used to large open spaces. I used to wonder if perhaps Henry and Hermance went there because Hermance's sister, Fayence, had fled there with her little family (Herbert and Hilda) after her marriage imploded in Montreal in 1912. Actually, maybe it was the other way around: Fayence went to Perth because Hermance was there.

Henry and Hermance had taken on the licence of a hotel in Australia in 1911. The Perth *Truth* Newspaper, dated November 25, 1911, had this tantalizing bit of information

> HOTEL COTTESLOE.
>
> *The Hotel Cottesloe is under entirely management, H Arliss-Robinson now catering for the requirements of the thirsty traveller and the seeker of seaside benefits.*

The Cottesloe Hotel is still in operation as the Cottesloe Beach Hotel, by the way. But it figures even more in the story of Hermance: This is from the *Daily Mail*, Brisbane, Queensland, Thursday July 31, 1919, page 9.

> **WIFE'S CONDUCT—A Remarkable Letter..**
>
> Perth, Wednesday—Henry Arliss Robinson secured a divorce from his wife Hermance yesterday on the grounds of misconduct with Alfred Drake. The parties held the license of a hotel at Cottesloe in 1911 and Drake, a commercial traveller, boarded at the hotel. In 1912 they left the hotel and Robinson went farming, leaving his wife in Perth. Subsequently the wife took over a hotel in Armadale with Drake as a business partner Robinson learning from his wife that she preferred Drake and never wanted to see her husband again. Robinson horsewhipped Drake, and the pair disappeared, Drake going to the Eastern States and Mrs. Robinson to England, returning later

and settling in the Eastern States. Robinson wrote to his wife in 1914 and she answered from Sydney in the following terms:

"Received your letter. Why write to me like that? It does no good, and I don't think you can tell me anything about Drake that I don't know. You certainly are right in a lot you say and I will admit I am pretty bad—worse, possibly than you think me, if possible. You never say anything about divorce. Believe me, it would be far better for you, as well as for me, to be free. You need not be afraid I shall marry D. as, though I know he would want to, I would not do so, as I have had too much experience of marrying for love and find it is not a success, but as I am thinking of going to San Francisco next year on my own, I would like to feel free, so that if I met anyone with lots of money, I could marry him. You see, I am perfectly frank with you. Believe me, Arliss, I am sorry if you still have any feelings of affection left for me. So, try and forget me and marry some nice, quiet girl. If ever I am rich, I will return all the money I have cost you—Hermie." [162]

I find this letter revealing in several ways. First is the candour of Hermance's reply to what was undoubtedly an outraged and hostile letter from Henry. The second is her admission that marrying for love is a mug's game although it does indicate that, at some point, she did love my great grandfather. The implication is that the next time she will marry for money—money she will use to repay Henry for "all the money I have cost you," which indicates that money was a big issue for him. And it must have been for her, too.

Of course, this scandal was too tempting for the newspapers to resist, even in its edited state. In modern terms, the story went viral. The story, printed on the other side of Australia, had been picked up from this one *The Daily News* (Perth Western Australia) Monday, July 28, 1919.

> **A Wife's Frank Admissions—Her Lover is Horsewhipped**
>
> *Proceedings at the Divorce Court*
>
> Hermance Edith Arliss Robinson was perfectly frank with her husband. In a reply to a letter he wrote her after she had left him at Perth and gone to Sydney, Mrs. Robinson wrote: "Try and forget me and marry some nice, quiet girl who will not attract men; I know I do, as wherever I go there is always someone who wants me, and to my sorrow I can't help liked being liked."
>
> This passage occurred in a letter which was put in as evidence this morning at the Perth Divorce Court, presided over by Mr. Justice Burnside, when Henry Arliss Robinson petitioned for a dissolution of his marriage on the ground of his wife's adultery with Alfred Drake. Mr. W. H. Ackland appeared for Mr. Robinson.[163]

Henry Arliss-Robinson was not the most popular figure in Perth and nearby Fremantle. He had made few friends with his job as secretary of the Fremantle Hospital, having devised a new scheme for the collection of hospital bills. The press was enjoying the scandal. In fact, this article appeared in the *Fremantle Weekly Herald*, on March 25, 1920.

> **'Eartless Robinson—More Hospital Horrors**
>
> Arliss or 'Eartless-Robinson certainly applies that principle with remorseless stringency to the Fremantle Hospital. Any working man or working woman unfortunate enough to enter that institution is not left long in doubt of the part that the exaction of fees and not the alleviation of suffering is the prime motive for the existence of the hospital.[164]

Given Arliss-Robinson's unpopularity, with even more salacious glee than the *Daily News*, the *Truth* printed this story. The capitalized letters are theirs.

Fremantle Hospital Secretary's Duck Chooses Her Own Drake And Flies About Extensively

A long-pending divorce case was brought to a termination on Monday last by Judge Burnside. The proceedings were commenced as far back as 1913 and the failure to complete them was due to the fact that it had not been possible to serve the papers on the respondent until this year. The petitioner was Henry Arliss Robinson, at present secretary to the Fremantle Public Hospital. The respondent was Hermance Edith Arliss Robinson, who was charged with having committed adultery with Alfred Drake, a commercial traveller. Mr. W. H. Ackland appeared for the petitioner.

The parties were married at Manchester England on June 28, 1902 and came to W.A. [Western Australia] in January 1911. The petitioner took over the lease of the Hotel Cottesloe from a licensee named Drake whose brother Alfred was also living in the hotel. Alfred lived in the hotel for a few weeks longer. While they were in the hotel the respondent had access to the banking account and could draw money on her own signature. In January 1912, the respondent went for a trip to Albany but at that time the petitioner had no suspicion that there was anything amiss. In October 1912, the hotel lease expired and the petitioner went farming at Wongan Hills and the respondent went to live with her sister. In December, 1912, the petitioner returned to Perth and for the first time he heard reports concerning his wife and Drake. He also learned for the first time that she had taken over the Old Narrogin Inn at Armadale and had drawn £150 from the banking account.

The petitioner went to Armadale and told her of THE REPORTS HE HAD HEARD concerning herself and Drake, whom he understood was living in the hotel. She admitted that Drake was residing there but said he was her partner in the hotel. During the conversation she said, "I don't want to see you again. Drake is everything in the world to me. He is very good

to me and gives me everything I want. I don't want to ever see you any more." The petitioner looked around for Drake, and found him in the sitting room. He used strong language to him (Drake) and finally punched him. Drake left the premises, but when the petitioner paid another visit three or four days later, he found him present. Drake talked fight but the petitioner had come armed with a whip which he applied freely and then left when the respondent asked that there should not be a scene.

A little while later the petitioner met his wife in Fremantle. She was in a "beastly humor" when he spoke to her and would not listen to him. She said, "I suppose you want to know where Drake is. Well, you will not find him." Shortly afterwards the petitioner went to Albany to make inquiries concerning the trip the respondent had made in 1912. He went to the Middleton Beach Hotel, where the proprietor showed him a telegram from Drake, which said "reserve bridal chamber." Further inquiries showed that the respondent and co-respondent had occupied that particular room. Proceedings were commenced and the papers were served on Drake in the petitioner's presence. The following day the petitioner went to the R.M.S. Orvieto. He saw several pieces of luggage labelled with Drake's name and recognized three of the packages as belonging to the respondent. Inquiries made of the purser showed that no berths had been booked. At his request, the purser subsequently telegraphed that Drake had travelled alone. At first, the petitioner had intended to have Drake arrested as the respondent's trunks contained articles which belonged to him (the petitioner). The police in Adelaide were communicated with. The petitioner continued his inquiries and found that the respondent had left Albany by the S.S. Kapunda. The police in Adelaide notified him that the couple had met in Adelaide and left for Melbourne a few days later. The petitioner then lost trace of the respondent as the police department were no longer interested when the matter progressed into a likelihood of divorce only.

Having an idea that the respondent might have gone to Sydney, the petitioner addressed a letter to her at the G.P.O., Sydney, "on the off chance." In the letter he tried to point out how wrong she was, the CHARACTER OF DRAKE and how he had treated other women. At that time the petitioner was prepared to have a reconciliation. He also told her that he had heard she and Drake had been refused admission to a hotel at Midland Junction, and further that Drake had been exhibiting a photo of her in Bunbury. The plan succeeded for the respondent got the letter and duly replied in April 1914. In her replied she said inter alia "I will admit that I am pretty bad, Worse, if possible than you thought me, if that is possible. First, we did stay at Midland Junction. We were not turned out as we only intended to stay the one night. We were just working up a good business at Armadale when you came. So, you had your satisfaction. You never said in your letter about divorce. It would be far better for you and me. You need never be afraid that I will marry 'D." I don't want to. I have had too much experience of married life with you and I don't think is a success. Believe me I am sorry if you still have any feelings of affection for me. It is absolutely impossible for us to come together again. Try and forget me and marry some quiet little girl who will not attract men. I am sorry that wherever I go, I cannot help liking and being liked."

Nothing further took place until March or April of 1915 when the petitioner heard the respondent was in Perth. He tried to find her so that the citation could be served upon her, but found she had gone to England. In February of this year she returned. She called on the petitioner at his office in Fremantle and questioned him about the divorce. He declined to discuss anything with her and referred her to his lawyer. She admitted that she had been in England for three years and said she had travelled under the name of Mrs. Drake.

Edwin Austin the managing clerk for Durston and Ackland gave evidence on the service of the papers upon the respondent

> in the lawyers' office on February 24. To Mr. Ackland she admitted the misconduct alleged against her. A Decree Nisi, returnable in six months, was granted with costs, against the respondent, Drake.[165]

Oh, my! The press had had a field day!!!

Nearly a year later, this notice quietly appeared in *The Western Australian* newspaper in "The Law Courts" section on Monday, April 12, 1920: "The following is the list for the April Civil Sittings of the Supreme Court, which will be opened to-morrow Before Mr. Justice Northmore and a jury... Henry Arlis [sic] Robinson v. Hermance Edith Arliss Robinson and Alfred Drake (co respondent)." In the same newspaper on Thursday, April 15, 1920: "Divorce Decrees Absolute; The following decrees were passed as absolute at the Divorce Court today. Henry Arlis Robinson (petitioner) v. Hermance Edith Robinson (respondent) and Alfred Drake (co-respondent)." Twelve divorces were granted that day, seven being the wife suing the husband and five being the husband suing the wife and naming a co-respondent.[166]

Western Australia had an enlightened attitude to divorce, which accounted for the number of divorces granted in this sitting of the court. The Supreme Court in Western Australia held jurisdiction in matrimonial causes from 1863, when the *Divorce and Matrimonial Causes Act* was passed. The applicants could apply for judicial separation, restitution of conjugal rights, dissolution of the marriage or its annulment. Either husband or wife could petition for judicial separation on the grounds of cruelty, adultery or desertion for more than two years.

There were 1,148 divorces in Australia in 1920 according to the Australian Institute of Family Studies website. That's one marriage in every 500 in a population of 5,360,000.[167] In 1901, when Walter John divorced Hermance, there were 477 divorces in the entire UK, and the population was 32, 527, 831 according to the census of that year. Divorces in the UK were rare and expensive and considered shameful so that people separated and perhaps lived bigamously. Think Michael Henchard in *Mayor of Casterbridge*, which was published in 1886, although Hardy has Henchard drunkenly "divorce" his wife in

a drinks-tent at a fair, an action which causes heartache, remorse and finally fatal consequences by the end of the novel. And look at the mess of marriage, desertion, and divorce that forms *Jude the Obscure*! The shambles of the divorce of Soames and Irene in *The Forsyte Saga* form a more contemporary reference: the *Saga* was published between 1906 and 1922.

We have no later documentation of Hermance, only of Henry, who appeared in the Australian Electoral List for Western Australia off and on from 1912 to his death in 1941. At first he was a clerk, then he became the secretary and dispenser of the Fremantle Hospital at the salary of £5 a week. He continued in the position until he was unexpectedly fired in 1925. The following excerpt is from *Fremantle Hospital: A Social History* by Phyl Carrick and Chris Jeffrey:

> In 1925 Arliss Robisnson was confident in his position as secretary, yet may not have given the co-operation expected of an employee in charge of finances at the hospital. During a board meeting in August 1925, he was asked to retire and at the end of the meeting to resign.[168]

Henry Arliss (or 'Eartless) Robinson
(Courtesy of Jennifer Lock)

Actually, it comes out now that the National Library of Australia's wonderful digital newspaper archive, *Trove*, is online and available to the public, that Henry's transgression was relatively minor. According to the *Fremantle Weekly Herald*, of Friday, December 22: on Wednesday, December 13, 1924: Railway Prosecution—For having travelled from Subiaco to Fremantle without a railway ticket, John Arliss was fined £1 5s with 5 s costs. Inspector Walker prosecuted on behalf of the Railway Department and there was no appearance of the defendant.[169] This

was quoted in a furious article in which Chairman Bolton wanted to eject the *Herald* reporter from a meeting of the Hospital Board, which was going to discipline Henry Arliss Robinson so "John Arliss" and Henry Arliss Robinson were likely one in the same person. Even the irate reporter comments that if Henry had been "a working man" the ticket transgression would have received different handling. It seems that Henry really rubbed people the wrong way.

Here's Henry's justification of the actions that were the underlying cause of this hostility, in the *Sunday Times* of Perth, August 22, 1925:

> Nine years ago I took this position when the former secretary, Mr. Priestly, went to England on war service. [In 1914, Henry would have been 50, too old to serve in the armed forces.] Finances were low and I saw at once where the weak spot existed. Patients were receiving treatment for which they were expected to make some payment, but they had learned that they did not pay, no effort was made to enforce payment. Knowing of this laxity, other patients who were ready to pay naturally asked why they should do so whilst others were allowed to escape payment. To remedy this I introduced, with the sanction of the Board, a more effectual system of collecting hospital dues. This involved no hardship: anyone not able to pay appealed to the Board and got his account written off, if an inquiry justified that action. The success of this new system pleased the Board so much that when Mr. Priestly returned, he was offered and accepted position of dispenser and radiographer and my own services were retained in the office… In buying of stores, drugs, etc., my former experience—six years with Croydon Hospital and twelve years with Savory and Moore—gave considerable advantage to the institution which the Board recognized and my relations with all concerned were most friendly.[170]

Henry went on to indicate that changes in Board personnel were to blame and he had a letter from Mr. L. B. Bolton, chairman of the

board for the previous eight years, expressing surprise and regret at the conduct of the board.

Now, there are two nuggets worth digging out in Henry's justification. One nugget is "six years at the Croydon Hospital." Croydon is in Surrey so Henry supplemented his ginger beer income with working as a pharmacist at the local hospital. The other nugget is the scheme itself. No one, especially an independent Australian, would have appreciated having to put his or her inability to pay before a Hospital Board inquiry. Also, the consideration that Hermance's father had declared bankruptcy and in essence lost over a million dollars might have led husband and wife not to see eye to eye about the necessity of collecting every cent owing. (The creditors in Walter's bankruptcy were generous and the family did not lose their home at Manor/Java House.)

Of course, this may be a moot point as Henry and Hermance were no longer together. I suspect money was a real bone of contention for Henry and Hermance. Notice how in one transcription of the letter, she comments that "If ever I am rich I will return all the money I have cost you—Hermie."

Luanne Woodbury, the chief family historian, said that Hermance came back to settle her first husband, Walter's, estate, Walter having died in 1914, and Luanne remembered Australia in context. (It appears that Walter didn't make a will.) Since Luanne was born in 1921, she wouldn't recall much until 1925 or so, so perhaps Hermance returned to England to escape the notoriety of her very public divorce. Or, like other events in this family history, this could be a recreated memory.

Henry did remarry, meeting his new wife, Violet, aboard ship. Henry and Violet had the proverbial shipboard romance, spent their time in London together at the same address, and married when they returned to Australia in 1925. Perhaps he took a leaf out of Hermance's Book of Romance, or just took her advice and found a nice quiet girl to marry. Henry and Violet settled down, had two children, and Henry died in 1944.

I completely lost track of Hermance after the divorce scandal. I wish for her sake that her story ended well and, ironically, I am glad of the meanness of spirit that caused Henry to have her letter to him

read into court's evidence, because now I at least have heard my great-grandmother's candid voice, even if I do not have her image.

LEFT-BEHIND FAYENCE

Fayence was the second youngest of the Woodbury children, and perhaps the most travelled. Aside from a notation in the 1881 Census, we really first meet Fayence in awful circumstances: she was the older of the two young daughters who discovered Walter's body in the Margate bed and breakfast on Sept 1, 1885. She destroyed a sheet of "French expressions" found by Walter's deathbed, an action commented upon in the Inquest into Walter's death.

I am certain that the sudden death and the deathbed scenario were not meant to happen and that Walter would never have set up such a traumatic experience for his daughters. He was, to all accounts, a loving father from a loving family, he was used to measuring liquids accurately, his body chemistry was altered due to his diabetes (and drinking), and he was in an optimistic phase, working on his "tissue film" with a meeting he was very hopeful about scheduled for the following Wednesday. His death in Margate was a dreadful accident.

Details came out during the inquest: the girls, Fayence and Avence were first on the death scene and had actually tried to wake their father before they called the landlady and Fayence destroyed some writing she found on the bedside table. Now, according to family friend Edward Stanley Bent, Walter was in the habit of filling pages with doodles and illegible scrawls when he was drinking and thinking, but if, against all odds, this was a suicide note, what a burden it would be for an 11-year-old to shoulder.[171] We will never know what the contents of the paper was because Fayence reduced it to ashes.

In the 1891 Census, Fayence and Avence were away at boarding school. They would have been 16 and 14 (so they would have been 11 and nine at Walter's death). They were living at 2 Clyde Road, Didsbury, which is a suburb of Manchester, with a schoolmaster, Mr. F. Scott, his widowed sister, a visitor, a boarder and two other pupils. This could have been a boarding establishment for pupils of the Didsbury Training

Home at 16 Clyde Road. (The blunt Mancunian name was typical. Elsewhere in the city were the Manchester and Salford Asylum for Female Penitents at 99 Embden St., St, Mary's Home and Penitentiary at 77 Dickenson Road and the Bethesda Home for Crippled and Incurable Children at Cheetham Hill.)

Why had the girls been exiled to Manchester? Edward Stanley Bent, now Marie's husband, would most likely have had the choice of school and location, and Manchester was his home town. But they were a long way from the rest of the family, although that family was beginning its dispersal to the far corners of the earth. Mayence and Constance with her three toddlers were living with Edward and Marie, so perhaps the simple answer was that there wasn't enough room for everyone in the house at Victoria Villas, Shepherd's Bush. Manor House in South Norwood was long gone.

That the girls were together would have been strengthening. Fayence probably would not have had much of a rough ride because she was one of the two children the opinionated Ellen deemed "acceptable" with fair hair and blue eyes. Avence apparently favoured her Indonesian heritage. Both girls would have probably harassed about their father's very public death, no doubt: children could be cruel and Walter was well known in Manchester. Nevertheless, they must have received a decent education because later in life, Fayence made her living as a teacher in Perth. We can't know what use Avence would have made of her education.

Fast forward six years: the family had disbursed to the four winds. Marie's second husband Edward Stanley Bent had died in 1896 and that year she left England for the West Indies. Son Walter E. was working as the editor of the *Photographic Times* in New York. Florence had married David Steet and immigrated with her two children to Toronto, Ontario, Canada. Constance had been married (maybe) and widowed and was on her way to South Africa with her three young children, meeting her future husband, William Mather, on the ship. Mayence and her common-law husband and step-brother, W. S. Bent, have had a daughter, Gladys, and had just arrived in Kenya. Hermance was about to desert her husband and family in London and run off

with a chemist. Valence had married her unsuccessful husband, and had settled in Fulham with her brood of children with upscale names. And Avence was dead.

The birth registry where Fayence registered Avence Woodbury
(Courtesy National Archives UK)

I wish I knew more about this phase of Fayence's life. It must have been lonely, tumultuous, and frightening. More or less alone in London, Fayence gave birth to a baby girl whom she named Avence at the Queen Charlotte Hospital on Marylebone Rd. She registered little Avence as "Woodbury" and listed no husband on the hospital records. Little Avence was baptized on April 15, 1897, at St. Mark's, Marylebone. By December, she was dead at the age of eight months.

Detail of the registry (Courtesy National Archives UK)

Fayence had her daughter buried in a cemetery in Hackney.

I do not know the date of Fayence's sister, Avence's, death. The Victorians had a habit of naming children for the departed family members, almost like "replacements" so you find that when Valence lost one of her twins, Stella, in 1895, she named her next baby girl Stella in 1897. Could Fayence have named her baby for her sister who had died at sea? I am presuming that Marie left England shortly after the death of Edward Stanley Bent in 1896, and went to the West Indies, possibly to his family there. (His mother Brigitina Clarke was born in the West Indies, although the census-takers seem never to be quite sure where, so there might have been family or property there.) Avence was said to have died at sea emigrating with Marie, so—a shot in the dark here—could Fayence have been honouring her lost sister with the name of her daughter?

Fayence left England a year or so later, in 1899. By 1901, we find her in Montreal, wife of Thomas Herbert Charles Chesnut, a journalist. Now, I do not know much about Thomas, but I would hazard an opinion that he was rather a charming rat. Or a cad. Or a rat-cad. In the 1891 Canada Census, Thomas was living with his first wife,

Louise Caroline Ollard Chesnut, and their four living children (Aileen Meridith, Howard Douglas, Annie Brodie and Harcourt,). There had been two unnamed infants who died soon after birth. Thomas had deserted this family (now with seven children) in 1900, just months before his son, Morris, was born. He married Fayence, and Herbert Brodie Chesnut arrived in 1902.

By the 1911 Census, Herbert Brodie had a sister, Hilda Woodbury Chesnut, born in 1909. The household also included Constance Mather, who was Fayence's niece, Constance's daughter by Arthur Bentley, who was adopted by William Mather in South Africa. She must have had the family's travelling feet, because, although she married the boarder, Charles Thomas Clarke, she made (at first alone and later with her son Neville) several trips to Hamilton, Bermuda, presumably to visit her grandmother, Marie.

Things seem to be going well in 1909. T. Herbert Brodie, as he liked to call himself (that, or Allan Douglas Brodie) was an author as well as the news editor of the *Montreal Witness*. He had had some success earlier with *Nina, A Nautical Comic Operetta in Two Acts*, a work highly indebted to Gilbert and Sullivan. In 1909 he was featured in *The Canadian Bookman Magazine* Vol, 1, No. 7 July 1909.

The brief write-up reads:

> "Chicoutomi, a Romance of the Saguenay Country and Other Tales" by writer T. Herbert Chesnut is announced by William Briggs. Mr. Chesnut is better known under the pen name of Allen Douglas Brodie and is the news editor of the <u>Montreal Witness</u>. The book will contain a number of Mr. Chesnut's most popular stories.

T. Herbert Chesnut, aka Allan Douglas Brodie
(Courtesy *Canadian Bookman*)

The book is almost impossible to find, unlike the works of Chesnut's contemporaries, Robert W. Service and Lucy Maude Montgomery.

In 1912, Thomas Herbert Charles walked out on his second family. (Perhaps Fayence shouldn't have been utterly surprised.) Apparently he went to New York.

There is an editorial by Allan Douglas Brodie in the *New York Times* of May 10, 1916, "Textbooks Retain Old Antipathies, Disregard Long Peace," in which Brodie/Chesnut argued against US Isolationist policies, so he was likely working as a journalist at the time, probably in New York. We find him in the US 1920 Census. We can be reasonably sure that this is Chesnut because of the birthdate, birthplace, profession, country of origin and unusual spelling of the surname. Now, if it's 1920 there is a daughter, Dorothy B. (Brodie?) who was seven. She must have been conceived in 1912 or 1913. Thomas didn't waste any time.

Fayence didn't waste any time either. She packed up the two children and headed for the most remote city anyone could think of in the English-speaking world: Fremantle in Western Australia, perhaps because Hermance her sister was there. On May 20, 1912, Fayence disembarked the vessel *Steydlitz*, with Herbert and Hilda, at Fremantle. She had boarded the ship in Naples, so it had been a long journey from Montreal to Naples to Fremantle. It seems an odd route, but by 1912 the ship could have gone through the Suez Canal.

By the way, we find that Louise Olland Chesnut and her two daughters remained in Montreal, according in the 1921 Canadian Census. Louise was working as a clerk as was the younger daughter. Louise's salary was $763, which would be worth $11,600 in 2022 dollars. It was a good thing that the daughter who was working was bringing in $1,093 so together they were making $1,856. That's $27,700 or so today, which was means they're three women living in very lean circumstances. I don't know if Chesnut deserted his third wife and family. His track record says he probably did.

Fayence was briefly mentioned in the newspapers' gleeful accounts of Hermance's divorce. Hermance lived with Fayence while Henry Arliss-Robinson tried his hand at farming in October 1912, before, that is, she tried her hand at hotel-keeping with Alfred Drake. The 1916 Australian Electoral List noted Fayence on Albert St. in Balakatta,

a suburb of Perth, listed as the Householder. Later, by 1928, she had moved across the country to Victoria.

Fayence never married again. She lived alone and each electoral register listed her occupation as "home duties." Her two children did not seem to have had happy marriages. Herbert married a woman, Hazel Doreen, whom he sued for divorce on the grounds of desertion in 1939. Hilda, the daughter, married Geoffrey Fitzgeorge Maltby, and was featured as a Lovely Bride in *Table Talk* (Melbourne) in the December 27, 1934 issue.[172]

And then this in the Melbourne *Argus*, Tuesday May 3, 1955:

> MALTBY—In Queensland, result of accident, Hilda Woodbury beloved daughter of T. H. and Fayence Chesnut, mother of Lesley Jane Maltby (dec'd). Inserted by her loving mother, brother Herbert, sister-in-law Sylvia and Geoffrey Maltby.[173]

Hilda, who had gone back to using her maiden name, would have been 44 when she died. Fayence had buried Avence and Hilda, two of her three children, and her only grandchild, Lesley Jane, nicknamed "Piki" at the age of two and a half in 1941. In the death notice of the child, among the facts, was the sad little phrase, "Piki tired."

Fayence herself died in 1962. She lived alone.

Hilda, Featured in Beautiful Bride (Courtesy National Library of Australia)

AVENCE, THE FIRST TO DIE

Avence is least known of all the Woodbury children. She was the youngest, the least documented, and the first to die.

We have records of Avence in the 1881 Census, as one of the daughters mentioned in the Coroner's Inquest into Walter's death in 1885 and at boarding school with her sister in the 1891 Census. Then, according to Luanne, she left England with Marie on a voyage to Jamaica intending to emigrate to the West Indies, but she died at sea. I haven't been able to find documentation of this, but I have no reason to doubt Luanne's account.

I suspect that Avence died sometime in 1896 because Fayence named her baby Avence, possibly in memory of her beloved sister.

THREE HISTORIANS

Luanne Woodbury and Steven Wachlin with the old Walter Woodbury tombstone
(Courtesy Alan Elliott)

Here are three of the people who know most about Walter Bentley Woodbury. OK, only two are in the picture: Luanne Woodbury, granddaughter of Albert, Walter's younger brother and family historian, and Steven Wachlin, author of *Woodbury and Page: Photographers Java*, which is the seminal book on the Woodbury and Page company. The third historian was taking the picture. He was Alan Elliott, who had done so

much work on Walter's career in Australia. He co-authored *Walter Woodbury: A Victorian Study* and transcribed *The Woodbury Papers* that are mainly letters Walter wrote home while in Australia and Java, held by the Royal Photographic Society in England. In an incredibly generous gesture, Alan sent me his research notes on Woodbury when he entered an "aged care" facility in Melbourne in 2020.

Alan Elliott, the third historian, September 23, 1998 (Courtesy Alan Elliott)

The new Woodbury tombstone, placed by Luanne Woodbury (Courtesy Alan Elliott)

They were toasting on the occasion of the placement of Walter's new tombstone in Abney Park Cemetery, paid for by Luanne. The old stone is behind them, weathered into illegibility. This is the new stone, which the "Find a Grave" website comments was found for them and us "in a remote and rough part of the cemetery" by Iain McFarlaine. So, thank you Mr. McFarlaine.[174]

The tombstone, the inscription of which reads "Some Men Labour: Some Men Enter Into Their Labour" can form the coda of this part of the book. Despite his many inventions, Walter's grave is visited by few, mostly known only to members of his far flung family. I asked my nephew, James Spencer, who lives in Essex and works in the City of London, to take a bunch of flowers to the grave. After wandering around the rather overgrown Abney Park Cemetery, he couldn't find Walter's grave, so left the bunch of flowers on a memorial to the war dead (although he didn't specify which war).

Despite being replaced, this stone is not a fitting memorial to "the Edison of Photography."

In a sad footnote to these pictures, while I was in the late stages of writing this book, Alan Elliott died in October 2020 at the age of 99. Luanne, also 99, passed away in April 2021. I had so wanted to place a copy of this book into their hands, but it was not to be.

APPENDIX 1:
Ellen Woodbury Ferguson: An Embittered Woman Who Was, Perhaps, the Voice of her Times

Ellen Woodbury Ferguson, who wrote the family history in 1935 does not come off well in this book, but I suspect she was simply the voice of her age. To be fair, the history was hand-written and meant for family consumption, so I must allow Ellen her say.

This is the face behind the somewhat vitriolic family history, written 50 years after Walter's death, recounting many things that happened before the writer was born. Ellen is born in Batavia. Her mother, Sarah Jane Aldersey, came out and married her father, Henry James, there. They had been courting for years before Henry James joined Walter, but they did not have the wherewithal to marry. I find this interesting because I always assumed that the Woodbury family was comfortably off, given the amount of money that Walter Bentley spent on his passions like

Ellen in her later years, about the time she wrote the family history (Courtesy Collection of Luanne Woodbury)

the elephant skeleton, and the zoological garden, and that John Taylor Woodbury had enough free time to devote himself to causes like the Early Closing Movement. Perhaps after the deaths of both husbands, Walter's mother, Ellen, wanted the sons to prove themselves financially stable men even if Walter didn't deign to help with the family factory.

Henry proved himself when he was finally allowed to join Walter in Batavia, and became an asset to the atelier, especially as he had learned to colour portraits and was talented at photographing children. (Brother Albert was not an asset to the same degree.) Mother Ellen bought Walter's ticket to Australia and his place in the syndicate going there, but it was Walter who funded Henry James' passage to Java (probably Albert's too.) When his financial stability was established, circumstances allowed Henry James to send for Sarah with whom he had an "understanding." He and Sarah married and soon Ellen arrived.

Ellen came home to England as a babe in arms, probably because of the deleterious effects of the tropical climate on a population that did not have much in the way of medical or systemic weapons for combatting tropical disease. Her father, Henry James, died several years after his return from Java, of heart failure exacerbated by a disease he picked up in the tropics (malaria?) and Walter's business partner, James Page, had already died of sprue, despite fleeing to England for medical treatment. Walter himself felt the effects of the tropical climate and never enjoyed robust health. In fact, he spent the winter of 1870–71, just with Marie, in Italy, a move usually associated with TB and rest cures. Walter, of course, would not rest and took a series of landscape photographs and slides for his magic lantern company. Probably he needed the money.

Henry James returned from Batavia with £6,000, which is the equivalent of between half a million modern dollars and four million, depending on whether you are measuring simple inflation or using wages as a gauge. Like his brothers, Henry James could not hang onto his fortune. He invested his money in the cotton mill owned by his best friend and brother-in-law, Frederick Roscow, just as supplies from the US dried up because of the disruption of the Civil War and wearing cotton became unfashionable because it was a "slave produced" substance. Also, the Suez Canal would soon be making commerce with

India much more viable, although, until the advent of steamships, shipping could only go through the Canal in the direction of the prevailing winds, west to east.

The cotton mill went bankrupt. Henry James lost virtually everything, but found an angel, Mr. Lee, about whom I know nothing but his name and his generosity. He funded Henry James to the tune of £100 a year to minister to the poor of Besses-o'-th'-Barn, an impoverished suburb of Manchester. That's a far cry from living with millions of dollars because Mr. Lee's sum is the modern equivalent of £11,000 in 2020 pounds. A contemporary clerk in the patent office earned £170 per anum.

However, Henry's income was triple that of his parishioners. He was beloved in his parish and they were devastated when he died in 1873 at the age of 36. Sarah and Ellen were left penniless and dependent on the charity of others, although to give him his credit, Mr. Lee continued the stipend for seven more years. In the 1881 Census, Sarah and Ellen were living with Elizabeth Whitworth, our "Collector of Lost Woodburys." When she was 15, Ellen got the job as a teacher/governess to a family with eight children under eleven.

Ellen met and married John Ferguson, who was an apprentice in the Census of 1881. He was a senior shipping clerk in 1901 and a warehouse manager in the 1911 Census. Clearly, he was a man on his way up. Sarah Jane was a member of their household until her death in 1906.

John and Ellen had two children: Marianne born in 1893 and Donald born in 1894. Donald seemed to be a son any mother could be proud of, and the family did right by him. He was educated at the Stockport Grammar School and completed his education in Switzerland. He was a member of the Heaton Mersay Tennis Club and his name appeared in the Roll of Honour of the old scholars of Heaton Moor Congregational Sunday

Ellen's son, Donald, who died in the Gallipoli campaign 1915 (Courtesy Collection of Luanne Woodbury)

School. Then the world descended into the madness of World War I. Donald enlisted in the 176th Manchester Regiment, almost as soon as the conflict began in September 1914. Worst luck, Donald was sent to the Dardanelles for the Gallipoli campaign in July 1915. He contracted some kind of fever and was sent to Alexandria where he died on October 1, 1915. He was 22.[175]

You would never get over something like that.

But there was another child in the family, older sister Marianne. These small pictures of Donald and Marianne are from the collection of Luanne Woodbury. The writing is Luanne's.

Luanne's writing identifying Marianne in her nursing sister uniform (Courtesy Collection of Luanne Woodbury)

Marianne in the family garden in happier times (Courtesy Collecton of Luanne Wooddbury)

Marianne joined up too, in the most meaningful way a woman could, by becoming a nursing sister. Then, again, things went wrong. Luanne remembered a split in the family, in the mid- '30s, and Marianne never contacted anyone again. It was a few years after this schism that Ellen wrote her bitter family history. Marianne never married and died in London in 1964, leaving her effects to a solicitor and a medical practitioner:

> Probate, Ferguson, Marianne of 28 Park Crescent Mews West Harley Street, London W 1, died 24 May 1964 at Middlesex Hospital, London W1. Probate London Aug. 7 to Christopher Newman Frere-Smith, solicitor and John Edward Tindle, registered Medical Practitioner. Effects £ 5113.[176]

We have these pictures, taken between the wars, courtesy of Luanne. I asked her about the 2012 Olympics in London and she said that she had tickets to the rifle shooting, because she had done it during the war (she herself enlisted in World War II) and would understand what was going on—and the tickets were affordable. She went and, as a veteran and in a wheelchair, was treated like royalty, much to her pleasure.

Ellen at the same table, presumably on the same day
(Collection of Luanne Woodbury)

Suffice it to say that Ellen didn't seem to have many moments like that. She did not have a happy life. Hers was a life of losses: her family fortune, her father, her son, and finally her daughter. If her account of the Woodbury family is embittered, we can see where the bitterness comes from. She was not a happy woman.

APPENDIX 2:
Walter's Eccentric, Influential Grandfather

Walter Horton Bentley was an "Eccentric but Ingenious man" as described by a contemporary, and a seminal influence on young Walter Bentley Woodbury.

Grandfather Walter Horton Bentley was related to Thomas Bentley, the partner of Wedgewood whose taste influenced the classical designs for which Wedgewood is famous and whose business acumen allowed the pottery to become an economic powerhouse. Josiah Wedgewood himself was the master potter, the consummate technician, while Bentley was the "ideas man" in touch with the intelligentsia of his day such as Michael Boulton, Joseph Priestly, even Benjamin Franklin.[177]

In fact, until 1780 and the untimely death of Thomas Bentley, the firm was called "Wedgwood and Bentley." They were both part of the Midlands Enlightenment which, although not as famous as the French Enlightenment or Scottish Enlightenment, had the distinction of being a nexus between the world of hard-headed business acumen and the world of exciting, novel ideas. Those ideas occurred to men who had the financial ability to follow them, ideas like street lighting, decent housing for workers, engineered roads and canals, and the abolition of slavery.

We know from Parish Records that Walter Horton Bentley, Walter Bentley Woodbury's grandfather, was born on October 9, 1781 in Stafford and christened on Oct. 19 of the same year at St. Mary Stafford. He is listed in *Piggott's National Directory* in 1822 and 1828 as proprietor of a shoe warehouse at 7 St. Mary's Gate in Manchester. Before that, he seems to have had a lively time with the courts as legal bills exist for him as plaintiff suing various people in 1814, 1818, and later in 1831, although these, alas, are merely lawyers' fee statements and tell us nothing about the cases.

He married Elizabeth Reddish, and they had six surviving children and the boys seem to have received a good formal education. It's from the notes of the high master of Manchester Grammar School, Dr. Jerimiah F. Smith, that we have some fascinating snippets of information. One is that Bentley's godfather, William Horton, was the "man of some celebrity" and the other is Bentley's association with the unfortunate elephant Chuny or Chunee. (The teenaged Walter referred to here would be Walter Horton Bentley's son, Walter Bentley Woodbury's uncle.) Here are the notes in which the Headmaster opined that Bentley was an "eccentric but ingenious man."

> Enrolled on August 25, 1823
>
> Walter, son of Walter Bentley, Shoeseller, Manchester (aged 13 years). The eldest son of Walter H Bentley, who was a dealer in boots and shoes at a well frequented shop in St. Mary's Gate. The father a native of Stafford, received the name of Horton from his godfather, a man of some celebrity there and of whose portrait in lithography I possess a copy. This eccentric but ingenious man might occupy a niche in the temple of neglected biographies. One incident in his life, curiously enough, may serve for an example. When the well-known elephant, Chuny, went mad and was shot on the Exeter 'Change, Bentley purchased the remains of the noble beast and exhibited the skeleton before the public of his adopted town, together with the manipulated anatomies of a deer, some other creature, a frog and

> a mouse, for comparison's sake. But the idea, however original, proved not particularly locupletative; all the same, Bentley never learned the legitimate lesson it should have taught him: that "there's nothing like leather."
>
> I do not know what became of Walter Bentley or of the other two sons, James and Charles, who in after years, received part of their education at Manchester School.
>
> Reverend J. F. Smith[178]

William Horton, the "man of some celebrity" was considered to be the founder of the Stafford shoe manufacturing business. He began the business when he was 17 and, at its heyday, just before the Napoleonic Wars, employed 1,000 workers, which would have been a significant proportion of the population of Stafford and outlying districts, as the city of Stafford was recorded to have a population of 4,000 in 1801.

This was not a factory in Blake's "dark satanic mills" sense. The workers picked up cut leather pieces, took them home and brought them back as finished shoes, to be paid in Horton copper pennies. (The Royal Mint did not mint enough small change, as it much preferred to use silver, but commerce needed coins of lower value so created its own currency despite the practice not being entirely legal. I have two of them courtesy of e-Bay.) This bridge between a "manufactory" and cottage industry was very successful. Horton became mayor of Stafford in 1804 and was a good friend and frequent host of its MP, the playwright Richard Brinsley Sheridan, no less.

A Horton copper penny
(Collection of the Author)

Horton bought Chetwynd House and had his "manufactory" at the back. He and his descendants lived there until 1911 when the elegant Georgian mansion became Stafford's main Post Office and remained so until 2010 when it became a restaurant. So here was a man of commerce who hobnobbed with the intelligentsia of his day, perhaps a role model for his namesake, Walter Horton Bentley.[179]

OK, I had to look up the meaning of "locupletative," which is "having the tendency to enrich by increasing some desirable quality or attribute." The high master's arch little joke at Bentley's expense leads us to Bentley's association with the horrifying story of Chuny or Chunee, which is one that makes the modern reader shudder, but the Regency had a very different view of menageries and the keeping of exotic animals.

Chunee was a massive Indian elephant, resident of the Exeter Exchange Menagerie. Menageries were popular and, in some way, an indication of the power of their proprietors. There was, after all, a famous menagerie in the Tower of London.

> Not only was the presence of an elephant a curiosity, in some ways it was a proof of the power of the Empire. To ride an exotic beast from foreign climes was an important experience and sensation of British hegemony overseas. The capture and transportation of an animal like the elephant involved extensive colonial and mercantile networks—and the display of a live elephant on London's Strand rendered visible these power relations. To stroke, feed, and watch the elephant was to encounter in an embodied sense Empire.[180]

Even today, think of Longleat and Woburn Abbey's animal collections.

The Exeter 'Change Menagerie on the second floor of a shopping mall or exchange
(Courtesy Wikipedia Public Domain)

The Menagerie, where the only greenery the animals saw was painted on the walls
(Courtesy Wikipedia Public Domain)

The Exeter 'Change Menagerie was very popular, although it would be horrific to modern zoo-goers and animal welfare groups as the animals were housed in small cages on the second and third floors of a converted warehouse, with the only greenery in pots or painted on the walls. But it was an attraction. In *Sense and Sensibility*, John Dashwood used a visit with his son, Harry, to see the wild beasts as a reason not to make a timely visit to his step mother and sisters.[181] They would have seen Chunee who was a "beast of some celebrity," having acted on the stage and been trained to take coins from visitors. Lord Byron remembered: "The elephant took and gave me my money again, took off my hat, opened a door, trunked a whip, and behaved so well, that I wish he was my butler."[182]

Chunee had been in England since 1809 and in the Exeter 'Change Menagerie for 14 years. Originally, he had been purchased by Astley's Circus from the ship that imported him from India then rented to Covent Garden Theatre for a production of *Harlequin and Columbine* but a combination of his unruliness on stage and elephantine farts quickly ended his theatrical career.[183] He was coaxed up the stairs to a reinforced cage in the Exeter 'Change menagerie in 1812 and never left the building again. He grew to be huge, according to the Menagerie guide ten feet tall and weighing five tons,[184] but was kept in a small oak enclosure with a reinforced floor on the second level of the 'Change. The first floor of the 'Change was a shopping mall!

Unfortunately, Chunee ran amok. He had a septic tusk (imagine an elephant-sized toothache!) although the cause might have been exacerbated by his period of must (or musth), which is analogous to stags being in rut—a blinding sexual excitement. An "excited" elephant would be dangerous. On November 1, 1825, Chunee killed one of his keepers, Johann Tietjen, probably by accident. He had attacked a keeper, Albert Copps, for no apparent provocation about 10 years before, pinning him to the wall between his tusks and unnerving the man so much that he never ventured into Chunee's tiny enclosure again, so Chunee's record was already blemished.[185] No longer a star of the stage (Chunee had also appeared with Edmund Keane, matinee idol of his day) or the menagerie, Chunee was condemned to death by his owner although not by the Coroner's Inquest that fined him (the elephant!) a shilling. Chunee was shot to death—without an elephant gun.

On March 1, 1826, when the creature was too canny to eat poison-laced hay and buns, police and soldiers were called in. It took 152 rifle bullets and musket balls at point-blank range and the keeper with a makeshift harpoon to kill the screaming beast. In fact, the keeper intervened and killed Chunee just before a cannon that had been sent for arrived—the way two rogue elephants had been dispatched, one in Venice in 1820 and another later in Geneva in 1821. (Both unfortunate animals were owned by Mlle. Garnier who should have had another hobby.)[186]

The Killing of Chunee from a contemporary newspaper.
Note the keeper with the harpoon (Coutesy Wikidata)

Chunee's execution was luridly covered in the sensational press of the day, complete with description of the stricken elephant's cries.[187] The press also published recipes for elephant stew. Hundreds of people paid a shilling to see the stinking carcass butchered several days later. As I said, this was not the attitude of the modern world.

The meat from the carcass was sent to a knacker's yard to be converted into food for animals and possibly for unsuspecting humans. The hide was sold to Mr. Davis, a tanner at Charing Cross, for 50 pounds. The intestines were apparently thrown off Waterloo Bridge in the dark of night.[188] Chunee's owner, Edward Cross, now found himself not only out of pocket 950 pounds, as, alive, Chunee had been valued at 1,000 pounds, but also dealing with public reaction to the fate of Chunee—a fate that caused much outcry and even two sentimental poems by Charles Knight and Thomas Hood and a briefly popular play, *Chuneelah or the Death of the Elephant*.

According to High Master Smith, Walter Horton Bentley bought the skeleton, but he bought it in 1829, three years later, so he was not associated (I sincerely hope) with the ghastly death of Chunee. According to Jan Bondeson, Edward Cross was smarting from the negative reaction to the death of a London favourite—a death he himself decreed:

> In an attempt to salvage the claim that he (Edward Cross, owner of the Exeter Exchange Menagerie) had acted blamelessly in keeping the elephant so tightly caged, and perhaps with a view to recouping his finances, he had Chuny's skeleton put on display in the den in which the creature had lived. A press report from 1828 noted: 'the work has been admirably performed,— the articulations are perfect,—not a bone is absent,—and the huge remains of this most sagacious of quadrupeds cannot be viewed without exciting feelings of astonishment.[188]

The tactic did not work, and without its star attraction, the Exeter Exchange Menagerie went into decline and closed in 1829; the decrepit building was razed. The National Gallery was built where the 'Change stood and, ironically, the lions on Nelson's statue that overlook it may have been modelled after sketches of the unfortunate lions in the 'Change Menagerie. The remaining animals of the Menagerie were moved to suburban Waltham where, I hope, they existed in more humane conditions. Actually, they did for 20 years as the Surrey Zoo had 14 acres of land, that is, until the Zoo's popularity was eclipsed by the Crystal Palace in 1851 and the Zoo went bankrupt. The collection of animals was sold off for a pittance and the hapless bears were sold to a pomade maker to be converted into bear grease![189]

Advertising lithograph commissioned by Edward Cross for the exhibition of Chunee's skeleton (Courtesy Wikipedia Free Commons from Jan Bondeston's *Animal Freaks*)

Perhaps this time delay explains why Bentley did not purchase the hide as well, as would seem logical for a boot manufacturer, a fact also commented upon by High Master Smith.

According to Jan Bondeson in *The Feejee Mermaid*:

> Chunee's remains did not stay long at Charing Cross. In 1829, the mounted skeleton was sold to a certain Mr. Bentley, who is likely to have been an itinerant showman, since he once took it on tour to the provinces. Advertisement posters from

Manchester and Liverpool that were kept both reproduce an engraving of the skeleton which had probably once been made on Mr. Cross's orders, to be sold at the menagerie. An original of this engraving is in the Enthoven Collection; it shows not only the impressive proportions of the skeleton, but also that Mr. Cross had apparently equipped it with two new tusks. One of Chunee's original tusks had been injured in some way when the elephant was quite young, and the other was completely broken off during the final assault on the elephant house. Mr. Bentley seems to have been more of an enthusiast than a businessman, and the tour was a fiasco; he earned very little money and in 1830 the skeleton was lent to London University for a niggardly sum.[190]

Walter Horton Bentley of course, was NOT an itinerant showman. He was a solid Mancunian businessman with a fascination for natural history. He paid £300 for Chunee's skeleton. Three hundred pounds was the equivalent of £22,731 in a straight conversion, but it was the equivalent of £228,840 in labourers' wages or £1,255,500 if you consider the sum as a fraction of the GDP in 1829.[191] An average working man and his family in 1830 could live frugally for a year on £40 and comfortably for £50–60, so Bentley's expenditure for Chunee's skeleton was, by any measure, a huge outlay of money. A tradesman and his whole family could live happily for five or six years on what Bentley paid.

With his purchase, Bentley created a display of comparative anatomy, which he exhibited around the country. This was an attempt to educate the public, not to capitalize on the notoriety of the animal's death or an attempt to shift the blame. Although sources [192] said he willed the skeleton to the Royal College of Surgeons, he actually (being an astute Mancunian) sold them the skeleton, even though at a loss of one hundred pounds.

In May 1831, he contacted Mr. William Clift, the Conservator of the Hunterian Museum of the Royal College of Surgeons at

> Lincoln's Inn Fields. Mr. Clift recommended that the Trustees of the Hunterian Collection make the purchase, and 200 pounds were voted to Mr. Bentley on condition that he himself saw the skeleton mounted in the main hall.[193]

The curiosity was exhibited among others in the Hunterian Museum of the Royal College of Surgeons in Lincoln's Inn Fields. There is one further piece of information that shows me that Walter Horton Bentley was more than a showman. Edward Cross had had the skeleton outfitted with perfect tusks, perhaps in another attempt to deflect criticism. One of Chunee's tusks had been damaged when the elephant was young and the other during his horrific death. (Imagine the force that would take!) Bentley had kept the broken and damaged tusks and delivered them with the skeleton so that it was an accurate specimen, not Cross's anodyne creation. Again, Bondeson writes:

> William Clift, who was an expert zoologist, examined Chunee's skeleton thoroughly. He was particularly interested in the short, broken, original tusks, which Mr. Bentley delivered in a separate parcel. One of them showed signs of an advanced state of inflammation of the large matrix of the tusk, also engaging the jaw skeleton. This must have been exceedingly painful and is likely to have contributed to Chunee's paroxysms of fury.[194]

If Walter Bentley had been only interested in the show value of the skeleton, he would hardly have kept the broken tusks, but as a naturalist, he must have felt that they were more important than Cross's deceptive replacements. Chunee's skeleton remained on display in the Hunterian Museum collection until the building and its contents were destroyed by a direct hit by the Luftwaffe in 1941.

As unfortunate as this tale is, it shows us that Walter Horton Bentley was a part of the scientific community and had the cash to back up his interests. This money came from the shoemaking business that was run by his wife and daughter, so apparently the women in the family generated the income and the men spent much of it on their enthusiasms.

Unfortunately, this model that Walter Bentley Woodbury grew up with did not work for him as Marie was unable to run a business, being unable to speak English fluently when she arrived in the country, coming from a culture where women of her class were kept isolated from the hurly-burly of commerce, and being socially ostracized for her ethnicity.

The Hunterian Museum: Chunee's skeleton keeps company with The Irish Giant's
(Wikepedia Free Commons from the collection of Dr. Nuno Cavalho de Sousa, Lisbon)

How Walter Horton Bentley had the connections to buy Chunee's skeleton is even more interesting: he was introduced to it through his association with John James Audubon. Bentley was an avid amateur naturalist and was first and acquaintance then a friend of Audubon. Audubon sailed for Europe in 1826 and kept a diary of his three-year trip in *The European Journals*. Audubon's life had been almost entirely a series of disasters until he came to England to promote his project of a massive book/portfolio of naturalistic paintings of birds. He was what would be today called biracial, being born in Haiti, the son of a

plantation owner and a mixed race housekeeper, educated in France but moved by his father to the US to avoid conscription into the Napoleonic Wars.

In the US, he was supposed to manage Mill Grove farm in Pennsylvania but managed to bankrupt and lose it. The good part of the experience was that he met and married Lucy Bakewell there and remained totally in love with her all his life. They moved to Henderson, Kentucky, a relocation which was no more successful as he was eventually run out of that town for bankruptcy. Finally, he went to Louisiana where he found his muse: he created pictures of wildlife in lifelike poses, which often meant using a wire armature to pose freshly killed specimens. Desperate to find funding for his project of an album of his paintings, he sailed for England, armed with letters of introduction to various men of wealth with an interest in natural history. He was well received in Liverpool. His second stop was Manchester.

Audubon was not impressed with Manchester:

> Manchester, as I have seen it in my walks, seems a miserably laid out place, and the smokiest I ever was in. I think I ought not to use the words "laid out" at all. It is composed of an astonishing number of small, dirty, narrow, crooked lanes, where one cart can scarce pass another. It is full of noise and tumult; I thought last night not one person could have enjoyed repose. The postilion's horns, joined to the cry of the watchmen, kept my eyelids asunder till daylight again gave me leave to issue from the King's Arms. The population appears denser and worse off that in Liverpool. The vast number of youth of both sexes with sallow complexions, ragged apparel and downcast looks, made me feel they were not as happy as the slaves of Louisiana.[195]

That observation about slaves being happier than the working men and women of Manchester is not politically correct, and probably not correct at all, but the description of the town from an outsider's viewpoint might go a long way to explaining the early deaths of John Taylor

Woodbury, Walter Bentley's father, at the age of 36 and his stepfather, James Lea, also at the age of 36.

There were some good things about Manchester, one of them being Audubon's acquaintance and growing friendship with Walter Horton Bentley. Bentley was Audubon's target audience, being a man of both scientific bent and some wealth. For his part, Bentley would have seen Audubon as a talented, intelligent and exotic guest—and possibly someone who would overlook the socially damning fact that Bentley was or had been "in trade." (For the marriage of his daughters, Bentley lists himself in the banns as "gentleman.")

In *The European Journals*, Audubon noted that on October 21, 1826, which had been "a busy day":

> [O]n my return from Quarry Bank, I saw Mr. Bentley, Mr. Heywood and other friends, Mr. H. gave me a letter to Professor Jameson of Edinburgh. I called on Dr. Hulm; paid, in all, twenty visits, and dined with Mr. Bentley, and with his assistance packed up my birds safe and snug, though much; fatigued; it was late when we parted; he is a brother Mason and has been most kind to me.[196]

This is from page 141 of *The European Journals* creatively edited by Maria Audubon, his granddaughter. She added a footnote, identifying Bentley as "I believe Robert Bentley the publisher," but I would dispute her attribution. First, the wording sounds tentative. Nowhere else did she qualify the identification of one of Audubon's acquaintances with "I believe." On the same page, there's a comment by Audubon about how helpful Bentley, a "brother Mason" has been. Walter Horton Bentley was a Mason. He was initiated into Manchester's Lodge of Integrity on November 1, 1819.[197]

Oct. 15, 1826, Audubon was staying with Bentley. Bentley appeared to be an attentive host.

> I dined and spent the night at Mr. Bentley's; after retiring to my room, I was surprised at a knock; I opened the door and there

stood Mr. Bentley, who said he thought he heard me asking for something as he passed by. I told him I prayed aloud every night, as had been my habit from a child at my mother's knee in Nantes. He said nothing for a moment, then again wished me good-night and was gone.[198]

Audubon left Manchester for Edinburgh, where he was lionized, meeting luminaries like Lord Elgin and Sir Walter Scott and began arrangements for the publication of *Birds of North America* by the firm of Lizars. By May of the following year, 1827, he had returned to Manchester and spent the first evening at Bentley's. He had, however, agreed to stay with Mr. Sergeant, but did not know where Mr. Sergeant lived, so Bentley sent him on his way with Mr. Surr as a guide. That would be Thomas Surr, the husband of Bentley's eldest daughter, Mary.

Shortly after returning to Manchester and the Midlands, Audubon decided he had to make a foray into London. The plates from the Edinburgh publisher Lizars were not to Audubon's standards and he needed to find another publisher who could handle the huge project. On May 19, 1827, he noted in his journal "to my great joy, Mr. Bentley is going with me to London." They arrived in London and Audubon settled in to the hard work of being a celebrity, drumming up subscriptions and finding another publisher, which turned out to be Havell. The double elephant folio was to have 435 prints in it and each one was to be aquatinted by hand so publication was no small undertaking as the plates were 39¼ by 26 ½ inches (101 by 67.3 centimetres).

By January of the following year, 1828, Bentley was a " friend" and was activley helping Audubon with subscriptions for his Folio. "January 24. To my delight friend Bentley appeared this evening. I was glad I could give him a room while he is in London. He brought news of some fresh subscribers, and a letter from the Rev. D—— to ask to be excused from continuing the work. Query: how many amongst my now long list of subscribers will continue the work throughout?"[199] The price of the subscription was considerable, £182 14 s or $1,000 US dollars. To put the sum into perspective, £182 was three years good wages for a tradesman, more for a labourer.

Audubon and Bentley played the tourist in London, with far-reaching consequences.

> January 26. (1828) Of course, my early walk. After breakfast, Bentley being desirous to see Regent's Park, I accompanied him thither and we walked all round it; I think it is rather more than a mile in diameter. We saw a squadron of horse, and as I am fond of military manœuvres (Audubon's spelling) and as the horses were all handsome, with full tails, well mounted and managed, it was a fine sight, and we both admired it. We then went to Mr. Cross, and I had the honour of riding on a very fine and gentle elephant; I say "honour" because the immense animal was so well trained and so obedient as to be an example to many human beings who are neither.[200]

This entry confuses me. Chunee had been dead for nearly two years, and had never been let out of his small oak cell so did not and could not give rides. The Exeter Exchange Menagerie was still in downtown London. Also there was no indication that Edward Cross had bought a replacement, so who was this pachyderm? Was this some of Marie Audubon's creative editing? Maria's work was published in 1897. and by that time elephant rides at Regent's Park Zoo were common amusements. Like Audubon himself, she was known for enhancing the actual content of the Journals.

> A more intrusive editorial hand appeared after Audubon's death, when granddaughter Maria R. Audubon published a heavily censored form of his journals. According to naturalist Robert Finch, one of the challenges "of assessing Audubon's status as a writer is the fact that much of his published writing is not actually Audubon's own words, but those of his collaborators and editors."[201]

This journal entry, like the next, did however establish that there was a connection between Bentley and Cross, and Bentley would

purchase Cross's prize skeleton the next year. This smug looking gentleman is Edward Cross. The cub looks resigned to its fate.

In another entry in his journal, Autubon notes:

> February 1, 1828 Bentley and I paid a visit to the great anatomist Dr J Brookes, to see his collection of skeletons of diverse objects He received us with extreme kindness...he was called away on sudden and important business before we saw his museum, so we are to go on Monday. Mr. Cross, of the Exeter Exchange, had invited Bentley and me to dinner with his quadrupeds and bipeds, and at three o'clock we took a coach, for the rain was too heavy for Bentely and drove to the Menagerie. Mr. Cross by no means deserves his name for he is a pleasant man and we dined with his wife and himself and the keepers of the BEASTS (name given by men to quadrupeds.) None of the company were very polished, but all behaved with propriety and good humour and I liked it on many accounts.[202]

Edward Cross and a rather resigned-to-its-fate lion (?) cub (Courtesy Wiipedia Free Commons)

Again, I wonder where Chunee was in this entry. James Brookes was the anatomist who directed the shooters and carved up Chunee's remains. There was, metaphorically at least, an "elephant in the room" here. However, since it was early in 1828 and Chunee's skeleton only went on exhibit later that year, perhaps the skeleton was not on display yet. Being a bit cynical, I would suspect that it was to Cross's advantage to have Audubon, who was both a Romantic figure and a celebrity, associated with his Menagerie. He even gave Audubon a free pass so he could sketch the animals and be seen sketching the animals. Cross needed the publicity as the Menagerie was not doing well without its star attraction and moved out of downtown London to the suburbs in 1829.

And change was on the way:

> February 2 1828 Bentley and I went to the Gardens of the Zoological Society which are at the opposite end of Regent's Park from my lodgings. The Gardens are quite in a state of infancy; I have seen more curiosities in a swamp in America in one morning than is collected here since eighteen months; all, however, is well planned, clean and what specimens they have are fine and in good condition.[203]

Audubon was sensitive to the welfare of people and animals. He was distressed by the treadmill when introduced to the English prison system and frequently gave alms to begging children. In another entry, Audubon was distressed by the cruel treatment of coach horses.[204] This makes Audubon's silence on the death of Chunee all the more intriguing, unless he did not want to upset the scientific establishment of Dr. Brookes et al. or found the reaction to the animal's death sentimental rather than scientific. This, after all, was a man who frequently killed specimens in order to pose and paint them.

James Audubon, looking Romantic and woodsman-like Portait by John Syme (Courtesy Wikipedia Free Commons)

Sensibilities were changing. The Zoological Society of London had been founded, by Sir Stamford Raffles and Sir Humphrey Davy in 1826, the year of Chunee's execution, partly in response to the appalling conditions of animals in menageries. In 1830, the animals from the Tower of London Menagerie, mostly lions and tigers and bears (oh my!), were transferred from their stone cells to Regent's Park, on orders of the Duke of Wellington. Walter Horton Bentley must have been aware of the horror of Chunee's death (and life) for, in 1836, the Manchester Directory listed him as Secretary of the Zoological Society.[205]

The Manchester Zoological Gardens was founded that year, and although a zoo based on the Regent's Park model, it was actually a shareholding company. The two key points here are "zoological gardens" meaning the animals were in some contact with the natural world, and "shareholding company," meaning that this was at least in part, a business venture. The grounds were laid out by Richard Forrest

of Acton who also designed the defunct Surrey Zoo and the Bristol Zoo, which is still in operation. But the Manchester Zoo was in competition with Belle Vue Gardens, which offered exotic animals, horse racing and refreshments, just three miles down the road. Belle Vue did not offer as extensive a collection—it exhibited birds, mostly—but did have an admission price one third of what the Manchester Zoological Gardens charged.

Historian T. Brown calls Belle Vue "a showground with a substantial zoological element" rather than a zoological garden. The public made their choice and the Manchester Zoo went bankrupt in 1846.[206] Incidentally, in order to survive, Regent's Park Zoo had to reduce its entrance fee drastically so that it was accessible to the working public of London and when they were able to attend, the popularity of the zoo ensured its survival.

Turkey cock: the first and most famous plate in *Birds of North America*
(Courtesy Wikipedia Free Commons)

The Manchester Zoological Society then, was another enterprise that Walter Bentley seems to have taken on with more zeal for introducing the public to exotic animals than business acumen. I'm speculating

here, but in two instances, we've seen Walter Horton Bentley's financial judgment overruled by his enthusiasm for a scientific idea. We will see that same trait in his grandson, Walter Bentley Woodbury.

There was, however, a scientific enthusiasm which would have made money. A letter written to Bentley in 1835 exists in the archives of Princeton University in which Audubon commented about the book and asked how Bentley liked the second installment of plates. (The book was published in groups of five plates.) The publication of *Birds of North America* was begun in 1826 when the first plate, the turkey cock, was pulled and ended with the last plate, number 435, in 1838. In the letter, Audubon commented:

> My opinion is now made up, that not more than 50 or 60 Copies compleate [sic] will exist in Europe when I close the concern in about three years from this day, and that The Birds of America will then raise in value as much as they are now deprecated by certain Fools and envious persons.[207]

Audubon's prediction came true and Bentley's foresight and faith in Audubon was justified. Bentley's particular copy has long since vanished from the family's possession, but if we still had it, it would be one of Walter Horton Bentley's activities that actually more than recouped its expenses: a copy of *Birds of North America* sold at Sotheby's in 2019 for $6,642,400 US.[208]

Walter Horton Bentley died of apoplexy on October 5, 1848 at the age of 67. "Apoplexy" is the Victorian term for a cerebral hemorrhage or a stroke. His death would have been sudden and devastating to young Walter Bentley, who was 14 at the time. In Walter Horton Bentley we see the same far-reaching intelligence and inventiveness, the impulsiveness, affability and the (shall I say it?) lack of focus as we see in his grandson. This Walter, too, was willing to leave his family to get on with mundane things while he pursued his interests. He was a role model for Walter Bentley Woodbury but perhaps not in an altogether positive way.

APPENDIX 3:
Those Doughty Woodbury Women

Walter Horton Bentley educated his sons at the exclusively male Manchester Grammar School, but he also raised capable daughters. His third eldest, Elizabeth Bentley, was the most independent and held her own in a man's world. We find her in the 1841 census, living at the shoe warehouse, helping out with the business.

By the 1851 census, she was still living there with her elder sister, Ellen, who was now the widow of her second husband, James Lea, and had seven children—one, Emily, born posthumously. By 1861, Elizabeth had been married to James Whitworth, and by 1871 she was his widow. (Was it that Manchester air?) Elizabeth supported herself, her immediate family and extended family by becoming an entrepreneur—a grocer. In the Victorian sense of the term, this meant buying things by the gross, then breaking them into smaller lots and selling them at a street front store— a grocery store.

Elizabeth was supporting her own family of three children, sister Ellen's daughter also called

Elizabeth Bentley Whitworth, "Collector of Lost Woodburys" (Courtesy Collection of Janet Nelson)

Ellen and her niece, Anne Green, in 1871. In the 1881 census, Elizabeth was listed as "living on own means," which would mean on investments so we can assume she is a retired, successful businesswoman. In this census she is supporting her own children plus her nephew's widow and child, Sarah Aldersey Woodbury, and her daughter, yet another Ellen.[209]

Ellen, Walter's mum and Elizabeth's older sister, also was a businesswoman, but was not as independent although, perforce, she ran a business. She married John Taylor Woodbury in Manchester Cathedral in 1833, and she and John took over the shoe business probably from her mother because her father was absent for extended periods of time with his comparative anatomy project and his mentoring of Audubon.

It was John and Ellen who were living above the manufactory in St. Mary's Gate in the 1841 Census, with John listed as a mercer or dealer in fine cloth and Ellen as a shoe manufacturer, not as most women were, as a "housewife" or having "home duties." John must have been a forward-thinking man too because one of the only references I could find about him was his association with the Early Closing Movement (see Appendix 4).

Ellen was Walter Bentley Woodbury's beloved, somewhat indulgent mother. Walter wrote copious letters to her from Australia, although not many from Java. When her husband, James Taylor Woodbury, died at 36, she was left a widow with five children and a business to run. She remarried within 20 months, but with no greater luck: Ellen was widowed yet again when James Lea died in 1850 and left her with another child and a child on the way. It's no wonder she gave over Walter Bentley Woodbury to the tutelage of his grandfather. Yet, she too was a woman of business like her sister. When she wrote to Walter in Australia that she was marrying Edward Lloyd, a substantial Stafford businessman, Walter replied on February 26, 1856: "I think… that there is every prospect of happiness for you as you will now be relieved from the cares of business which I think you had sustained long enough."[210]

Walter had no desire to take on "the cares of business" and as a youth was not required to work in the shoe factory. He was allowed leisure and pocket money by Ellen. When his surrogate father, his grandfather

Walter Bentley, died suddenly, Walter began his apprenticeship with a civil engineering firm cum patent office, in 1848, and found a new fascination. Frederick Scott Archer's book on the collodion process of photography was published and Walter was hooked. He was a young man of strong enthusiasms like his father and grandfather before him, apparently aided and abetted by Ellen.

In 1852, Walter B. was in his fourth year (of five) as an apprentice in the office of a civil engineer as a draughtsman, which would have been complementary to his photographic bent, had not another enthusiasm intervened: The Australian Gold Rush.

> My old love, my idol (photography) was shattered and forgotten. Cradles, tents, picks, spades and revolvers put camera and collodion entirely on one side. I was off to Australia with all the requisites to make my fortune in a few months, and what is more, I truly believed I was going to do it.[211]

Walter had convinced his mother Ellen to pay for this adventure and she did, allowing him (as his father and grandfather before him) to follow his enthusiasm while the family business footed the costs. Perhaps this was the natural order of things in the Woodbury/Bentley enclave. It didn't seem to occur to Walter, as the eldest son, to stay home and help his twice widowed mother raise six younger children.

To sum up: The women of the Bentley/Woodbury clan were the reason that the men could have their enthusiasms and adventures. They ran middle-class families of some repute, and were financially stable enough to spend substantial sums on their men's passions. The women in the family seemed to have more business acumen than the men—and more physical staying power. Their industry provided the money which allowed their surviving menfolk to pursue whatever was their intellectual enthusiasm of the moment whether it be amateur scientific enterprises, social reform or technology. The women were indulgent of their men, perhaps to a fault, but if they weren't, we wouldn't have Walter's wonderful photographs.

Walter was a true child of his family: he followed his enthusiasm to Australia, funded by his mother. Like his grandfather, who tried to make the common man see the intricate beauty of nature, and perhaps his father, whom we know little about who tried to change the way people thought about working conditions, Walter left the comfortable world of the Manchester shoe factory run by Mummy to make his mark on the world. He did but not in the way he intended when he was 18, by digging up a fortune. Walter found gold in his camera.

APPENDIX 4:
The Early Closing Movement

The Early Closing Movement espoused by John Taylor Woodbury,[212] was aimed at assuring more humane hours for shop assistants and factory workers whose workday was not regulated and had expanded enormously due to the introduction of gas light and, consequently, safer streets. These radical thinkers actually asked for shops to close at 8 p.m. and workers to have Sundays off! With the extra time from early closing, the workers were expected to pursue adult education and healthful exercise. To me, this seems like a high-minded pipe dream in a world of crowded tenements, privation, and gin. But at least The Movement fought the good fight to improve the lot of the average man and woman.

The reforms championed by the Early Closing Movement did not get Parliamentary assent until 1912. The bill was opposed by luminaries like Winston Churchill and championed by men like H. G. Wells (who had spent two miserable years as a store clerk) and Sir Arthur Conan Doyle. But this was long after the untimely death of John Taylor Woodbury.

Gas lighting and the invention of a dedicated police force changed the nocturnal landscape of urban Britain. The dark was dangerous, peopled with footpads, thieves, grave robbers, young hellions, and other

scurrilous characters. In Paris, on average fifteen people a night were murdered. According to Roger Erlich in *At Day's Close: Night in Times Past*, the night was the opposite of the day, a time of overturned order.[213]

It was the Midlands Enlightenment that brought gas light to Manchester. Michael Boulton and James Watt dazzled the populace (literally) by putting gas light outside the Manchester police commissioners' office and inside of a factory in 1807.[214] Like so many inventions, the effect was not exactly what the inventors had intended; the gas light inside factories extended the work day. (Think of the cellphone and how it has lengthened the work day, dumbed-down vocabulary, and become a major cause of traffic accidents.) Not only was the urban landscape changing at night, the workplace was changing as well. Walter Horton's successful shoe business employed 1,000 people at its height just before the Napoleonic Wars, but many of those people worked at home, setting their own hours, breaktimes, and productivity goals. No more: the majority of workers now worked in factories and put in long, regimented hours. The average working day for a female textile worker was 12–13 hours. Often, factories were virtually windowless or the windows were boarded over to disassociate the workers from the sense of natural time as they put in long, long, shifts at noisy looms with little in the way of health and safety protection. No wonder the 1840s was a time of labour unrest.

It would be interesting to find out what working conditions were like inside the Bentley Shoe Factory…

APPENDIX 5:
My Family on the Canadian Prairies

My cousin, Pat Good, reminded me of our grandma's vocal racial prejudice, commenting that "she did not tolerate people of colour well." And she did not, usually in a loud voice because she was rather deaf in her later years. There were some very embarrassing moments—for us, not for Grandma.

So, I began to wonder whether Grandma knew of her ethnicity. She would have been at the least one-eighth Indonesian. Either she didn't, in which case the scenario was truly ironic or she did and, like so many of her family, had fled England where she was "not white enough." In this case, was her racial intolerance protective colouring so that nobody would think she herself was "not white enough"?

To recap, Grandma (aka Muriel Phyllis England) was the daughter of Walter Bentley Woodbury's daughter, Hermance, who married Walter John England, part of the England stereo-view photography empire headed by his father, "King of the Stereo-views" William England. The two families were professional acquaintances: Walter Bentley Woodbury included two of William England's photographs in his book, *Treasure Spots of the World*. Both fathers were members of the Solar Club of professional photographers.

Hermance was Walter's second wife. She was very young when she married, so much so that Walter had to obtain a special licence, although she was a year older than her mother, Marie, when she married. Walter was 14 years her senior and had children who would have been under 10 from the first marriage. Hermance didn't stick around very long, deserting Walter and her son, Oscar, daughter Muriel and daughter, Gladys who would have been a toddler at the time.

Walter hired a housekeeper, Annie Best, who was a housekeeper in the Indonesian fashion, apparently, and married Walter in 1909. Walter by this time was in dire financial straits. He had paid the debts left the England Brothers Studio and the early years of the 20th century found Walter and Annie taking in boarders. Annie did not have a live-in servant, yet the couple found the funds to sent the girls whom Hermance deserted to school, while the boy Oscar went to live with his Aunt Marie.

Grandma hated the Catholic day school she attended, especially the discipline that decreed things like you had to stay in the dining hall until you had finished what was on your plate. Grandma quickly discovered that, left alone in the refectory, she could get rid of the offending food by smearing a small amount on each of the deserted plates.

Grandma grew up in an artistic community in a cosmopolitan city. Then, in 1911, she signed up for a "wives for farmers" scheme and got a government-paid passage to Indian Head, Saskatchewan. Possibly she signed on because the opportunity arose shortly after Walter married housekeeper Annie. Or perhaps because with the family's precarious finances, she needed to make her own way. She was working in a laundry in the 1911 Census and that was arduous and unpleasant work, and a far cry from the middle-class world that both Hermance and Walter had grown up in. Possibly either the scandal of her mother's divorce, (which of necessity was on the grounds of adultery) or her own ethnicity put her out of the running in the marriage market of the small artistic community of London. So, she found herself on a steamer, the *Royal George*, nicknamed the "Rolling George" because of its nauseating instability, then on a long train ride to the middle of the Canadian Prairies. Family legend has it that she got off the train and

asked a local where the town was. Yes, she was standing in the middle of it.

Ann Morgan and Reggie, 1921. All the Morgan women were horsewomen. Collection of the Author

Grandma was met by Mrs. Ann Morgan, my paternal great-grandmother, and she lived in Ann's house until she married her son, Hector George Morgan. Ann had four sons and three formidable daughters and had been living on her own since being widowed in 1906.

The wedding took place within the year. In this wedding photo, Hector looks proud in his ill-tailored suit—Grandma not so thrilled.

Perhaps this next picture will explain Grandma's somewhat shell-shocked expression. She had lived in urban London, then she lived in Saskatchewan. She had lived on the edge of a community of artists; now everyone was a salt-of-the-earth farmer with

The Morgan Wedding Photo (Collection of the Author)

an elementary school education. People trained their own horses and grew their own food. Saskatchewan had just become a province. It had (and still has) dreadful weather—extremes of cold in the winter (minus 30°C) and heat in the summer (plus 40°C). It has mosquitos. And it is flat, flat, flat.

The Morgan family were considered pillars of the community. They were instrumental in establishing the Glen Lynn School. Each of the four sons, Hector, Albert, Hubert and Walter, had successfully claimed and farmed a "section" of land, which is one square mile. Each had built or would build his own house and barn and outbuildings (including an outhouse). One brother even built his wife a house with a ballroom because she loved to dance. The matriarch, Ann, had her own homestead and managed it very well, despite the fact she was widowed and had been for some years.

The House on the Prairie (not so little) with Hector, Muriel Phyllis, Gladys, and Vic (Collection of the Author)

This is a picture taken on the porch of Hector's farm at Strawberry Hills, Indian Head, Saskatchewan, in the summer of 1913. You can see how flat this section of the Prairies is—like living on a table top. The writing on the people is my mum's.

Again, Hector looks proud and pleased, Grandma (Phyllis) not so much. The cheerful baby is my Uncle Vic, who is also discretely hiding the baby bump that will be my mother, Eileen Florence. The young woman on the lower step is Gladys England. Hector and Muriel had gone to London and brought Gladys out to live with them. She married Albert, another of the four Morgan brothers. That marriage worked well and Gladys lived to be 102, dying in 1997. Marie had brought some genes for serious longevity into the family: daughter Constance lived to be 94, daughter Mayence to 98, granddaughter Muriel Phyllis to 96. My mum, who wrote the names on the picture, lived to be 100 years and thirteen days, I suspect because she wanted to get her hundredth birthday card from the Queen. She did.

Unfortunately, the marriage between Hector and Grandma Muriel was not as strong as that of Gladys and Albert. Perhaps Gladys coped more successfully with the isolation. Look at the flat prairie that the house rises from. It's an excellent house for the place and time and, frankly, Hector with his farming skills and square mile of some of the most fertile land on the Prairies, if not in the world, was a "catch" here but here was not London.

To give you an idea of the isolation, especially in winter, let me tell you a pair of stories that Mum told me from her childhood. The children went to school in Glen Lynn, which was three miles from the farmhouse. In fine weather, they walked but in winter, they took horses and a box sleigh. If the horses, once hitched up, refused to move out of the yard because of the depth of snow or because the sensed impending foul weather, the kids did not go to school that day. The horses' instincts ruled. (Mum's brothers were delighted but Mum was not. She loved school.)

On one occasion, the horses were over-ruled. When she was three, Eileen, my mother, as all toddlers will, was testing the limits of things, in this case a rocking chair. She managed to fling herself out of the chair and smack her face onto the glowing pot-bellied woodstove, severely burning the area around her eye. It was January, the dead of a Saskatchewan winter and bitterly cold and snowing. The farm was eight miles from Indian Head town and the nearest doctor. Hector

hitched up the horses and drove as fast as he could towards town, but after five miles in deep snow, the horses were spent. He pounded on the door of a neighbour and borrowed his team, while his own recuperated. In town, both doctors were occupied so Hector hijacked the town's retired doctor and they drove pell-mell back to the farm, changing horses again at the neighbour's farm. This took hours, but Mum's eyesight was saved.

After this, Grandma made Hector sell the farm and move into town so at least she had a street and neighbours. The move was not good for Hector; he killed himself four years later in 1921. Grandma went back to England, enrolled her three children in schools, then decided not to stay. She came back to Indian Head and married Sidney Coward, the runaway son of a wealthy brewing family in Boston, Lincolnshire. He was nearer her age and of the same social class and education. And he was dashing, serving in the Ambulance Brigade in WWI and heading the local soccer team. (Hector, salt of the Earth though he was, was the son of Gloucestershire agricultural labourers and was educated in Glenn Lynn's tiny school. As a farmer, he was in a protected occupation and did not fight in the war.) Sid was what was known as a "remittance man" who received an allowance from the family as long as he stayed out of England, having seriously quarrelled with his father, Montagu. His only brother, George, was also a remittance man in Australia, so I suspect Montagu was a bit of a martinet.

This is Sid looking dashing on his big horse, Roy. Muriel and Sid remained man and wife and had five children, three of whom survived, although one, William, died training pilots in WWII. At one point when I was about eleven, Sid (known in the family idiolect as Grandpa Bone as Muriel was Grandma Cookie) remarked to me, apropos of nothing, "Don't try to make your grandmother happy. It can't be done."

Sidney Coward on Roy
(Collection of the Author)

So, what made unhappy Grandma Muriel leave England, not once, but twice? A flight from Notting Hill to Indian Head was a decisive statement. There could have been several causes, personal and racial. Or maybe they blurred. In 1909, Walter, her father, married Annie Best, the housekeeper who is listed in the 1901 Census as "wife." He had two children by her. Money was tight. Muriel might have been horrified by her father marrying the housekeeper and her flight to the wilds of Saskatchewan was her protest. Or perhaps, working in a laundry, Grandma grabbed the opportunity offered by the Government of Canada to look for something, anything, better. Like the women going to Australia 50 years earlier, she would have had her passage paid or almost paid in an effort to populate the vast expanses of the Prairie.

Grandma's father, Walter, had divorced her mother, Hermance, in 1901. He divorced her at *her* request because, legally, it was much easier for the man to divorce the woman, and her desertion of her home and children was not seen to be a legally sufficient cause. The art/photography community would have been small and Hermance would have been notorious. To obtain her divorce, she would have had to be proven adulterous, so an assignation would have been set up in a railway hotel, documented, and the divorce granted. The man in question was not the person she married and was not heard of before or since in family history. However, divorce was scandalous. The papers were sealed for 100 years, until 2002. But what if the community was not only aware of Hermance's moral reputation but also aware of her "mixed blood"? Walter Woodbury made no secret of Marie, having her accompany him on speaking trips and on his trip to Italy. He appeared oblivious to her being biracial and probably expected everyone else to be too. But would the community have tolerated racial difference combined with scandalous behaviour?

And Hermance wasn't finished with scandal. Just at the time Grandma was widowed and returned to England, 1921, the Australian papers were full of gleeful coverage of Hermance's high-profile divorce from her second husband, complete with adultery, horsewhipping, desertion, a police pursuit, and letters of defiance read into the court's proceedings.

What caused Grandma to flee England, go back for her sister, and then flee England again when she was a rich widow? (Hector's insurance paid out as the polite fiction that he died cleaning a gun was accepted; however, maybe "rich" in Saskatchewan was not the same thing as being rich in London.) Did she discover that she was a "somebody" in Indian Head but a "nobody" in London? Her second return to Saskatchewan was eyes-wide-open. She chose to live in a backwater Prairie town rather than the capital of the British Empire. Is it because she didn't want to call Annie "Mum" or she couldn't shake the scandalous reputation of her mother or she just was not white enough for London?

Our Muriel here, married a pillar of the community, Hector Morgan. They lived on his triumphant farm. But it wasn't enough. Perhaps that feeling of "never enough" was what caused Hector's suicide or Sidney's sad comment 40 years later. My grandmother was an unhappy woman—a feeling that came in part from her heritage.

APPENDIX 6:
The Wedding in Singapore

When I was researching the Woodbury family, I came across relatives in England, Australia, South Africa, South America, Mexico, Samoa, New Zealand, and Thailand. I also came across more instances where the members of our extended family were deemed "not white enough." Much of the information here comes from distant cousin, Richard Bartholemew, who lives in Chiang Mai, Thailand. Richard sent me this formal picture of the wedding of Sarah Lucy, his grandmother, to J. F. Hodgkins, his grandfather.

This is a photo of a society wedding in Singapore in 1910. The ladies are dressed in the height of Edwardian fashion. The paterfamilias, Frederick Brooksbank, is on the far left. The materfamilias, Caroline Olmeijer Brooksbank, is third from the right. Frederick worked with Thomas Lingard, the Rajah Laut, and married his adopted (?) daughter, Caroline.

Brooksbank-Hodgins Wedding, Singapore Old Kirk, 1910
(Courtesy of Collection of Richard Bartholemew)

Lingard was the sea captain after whom Joseph Conrad modeled "Lord Jim" of his eponymous novel, although the fictional character has about as much similarity to the actual person as Marie's brother Carl Olmeijer had to "Almayer" of *Almayer's Folly* and *The Outcast of the Islands*. Lingard had married Johanna Olmeijer, a formidable lady, in 1864. As an Olmeijer, Johanna would have been Eurasian. In one adventure, their trading barque was attacked by Malay pirates, and while the men sailed it for their lives, Johanna (wo)manned the gun, and the pirates were defeated. It's likely that Joanna wasn't Caroline's biological mother, as the Rajah Laut was "one for the ladies."

Caroline could well have been Lingard's daughter, "adopted" either to give a paper trail to deflect snooping socialites or to provide an explanation for her obviously Indonesian heritage. The ruse did not work. The society pages covered the wedding with breathless sycophancy, but there was not one mention of the mother of the bride:

> An exceedingly pretty wedding celebrated at Scotch Kirk on Saturday afternoon. Then Mr. J F Hodgins, assistant with

John Little and Coe, was united in matrimony to Sarah Lucy Brooksbank, the daughter of Mr. Brooksbank of Tanjong Pagar, was gaily embellished for the occasion and a crowded congregation composed of friends and well wishers of the happy couple attended the ceremony. Practically all assistants of Messers. John Little and Co. were present, Robert Little being one of the congregation, while Tanjong Pagar men up in force including the Secretary Mr. W. G. Xiven (illegible)in honour of the bride. Aitkin played the voluntary as the bride marched up the aisle on the arm of her father, and Rev. S. Walker, pastor of the church, officiated at the marriage ceremony. The bride, attended by Miss Daisy and Miss Lena Brooksbank, her sisters, were the bridesmaids while Patrick acted as best man for his cousin. Miss Olive Brooksbank was the flower girl and looked very pretty as she carried a handsome [illegible]. After the marriage ceremony and the register had been signed, the radiant bride and her husband went to the carriage waiting, the organist playing the Wedding March. The reception was afterward held at the residence of the bride's intents, Loy Hill, and the esteem in which the newly married couple is held by the immense gathering of relatives and friends about the house. The cake, an example of the confectioner's art, made by Mrs. Mogen, and consisting of five tiers, was cut and the usual toasts of health, happiness and purity to the newly-married couple were heartily pledged. The bride afterward left amid showers of confetti and rice for Seleca where the honeymoon will be. It must be mentioned that the house and grounds at Loy Hill were elaborate for the draped banners and evergreen having been arranged in profusion. The presents in the evening were numerous and Brooksbank gave a dance which attracted many. A pleasant and auspicious day ended when the toast of the host and had honoured.[215]

The bride, the bridesmaids, the flower girl, even the lady who made the cake and the decorations at the reception, were commented on—but not Caroline, mother of the bride, invisible in this account

probably because of her unacceptable ethnicity. The attitude of the British in Singapore was much less tolerant than the Dutch in Batavia. In Batavia, a Eurasian woman, educated and dressed as a European and obviously placed in a position of respect by her family, would not likely have been snubbed this way.

Another cousin, from Melbourne this time, Ghita, commented concerning Jim Lingard, the Rajah Laut's son:

> I'm not sure if I ever mentioned it to you but I had contact with a distant cousin Djonasayah from Indonesia a few years ago, a great grandson of Siti (Fatimah). According to him, Siti and Jim Lingard had four other children who were not as light skinned as Edward, Nellie, Albert and Walter and who were not sent to Singapore to be educated but remained in Bera. Djonasayah advised that his grandmother was the daughter of one of these offspring left behind. In fact, his grandmother's full name was apparently Akang Binti Jim Lingard.

The interesting part I find is that this branch of the family dealt with the racism of Singapore by not exposing the children who looked Javanese to the kind of behaviour that Caroline and her daughters faced.

There were six children born to the wedding couple in the photo. When Caroline's dubious ethnicity was discovered by daughter Marjorie's fiancée, Marjorie was dumped rather publicly. The family's reaction was to pull up stakes and immigrate to Britain, which was rather the reverse of what Walter's family was doing. This was between WWI and WWII and was one of the times that racism ironically worked in the family's favour, as this family was not in Singapore to be interned by the Japanese in WWII. Aunts Lena and Olive who remained were.

Cousin Richard sent me this picture of the family on a P and O liner, leaving Singapore for good (Courtesy Collection of Penny Desai)

APPENDIX 7:
Walter Bentley Woodbury Timeline

1834, July 19 Walter born to Ellen Bentley and John Taylor Woodbury.

1842 Death of John Taylor Woodbury, age 36, leaving Ellen with five living children: Walter, Henry-James, Lucy, Albert, Ellen. Walter is eight.

1844 Ellen marries James Lea.

1848 Death of grandfather, Walter Bentley, Walter apprenticed to patent/surveyor's office at age 14.

1850 Death of James Lea, age 36, leaving two children, Frederick and Emily, with Emily born posthumously.

1852 Walter breaks his apprenticeship, embarks the *Serampore* for Australia, arrives in October after a 96 day voyage.

1853 Walter gets blisters working for a carter, works as a cook, buys a camera with 66 per cent of his money, gets a job as a surveyor with William Tennant Dawson, begins to take pictures.

1854 Walter works as a draughtsman with the Melbourne Water Commission in the building of the Yarra Reservoir, takes photos of the city, wins Exhibition Medal for *Nine Views of Melbourne*.

1855 Walter partners with Spencer, opens a studio in Kyneton, which fails. Walter opens his own studio in north Manchester, takes a job with photographer Perez Mann Batchelder. Ellen, Walter's mother, marries husband number three, Edward Lloyd of Stafford.

1856 Walter and new partner Davies go to the Ovens Goldfields, as rival photographer shows up, business does not thrive. Walter decides to leave Australia.

1857 Walter and new partner, James Page, take the *Young America* to Batavia, rent rooms, establish a photographic studio, take photos of Buitenzorg Botanic Gardens.

1858 Walter and partner Page go on "photographic ramble" through Java to obtain pictures as collateral for much-needed supplies.

1859 Henry James comes to Java to join the business. Walter returns to England to buy supplies, meets Rowbottom, sells pictures to Negretti and Zambra, stays with Rowbottom and sees transparency.

1860 Walter, Page, and Henry James go on another photographic ramble.

1861 Woodbury and Page firm move into purpose-built studio. Page goes to England to buy supplies. Walter's mum, Ellen Bentley Woodbury Lea Lloyd dies.

1862 Albert Woodbury joins Woodbury and Page, is disruptive and leaves for Australia, returning in 1866. Walter sees Marie Olmeijer falls madly in love.

1863 Walter marries Marie on January 22, over the protest of his brothers, who act as witnesses. Walter moves to England to patent photomechanical process. Sarah Aldersey sails to Batavia and marries Henry James on August 5.

1864 Walter begins patent on Woodburytype British Patent 2338 September 23 chromogelatine process. First daughter, Florence, born.

1865 Walter involved with dispute with Swan, operates photographic studio in Manchester, Walter Edward born. Birth of Ellen, daughter of Henry James and Sarah Aldersey, in Batavia. Page returns to England for medical treatment for sprue, dies age 32.

1866 Walter granted further patent for chromo-gelatine process (BP 105, January 12) also BP 1315 for ornamenting and BP 1918 for photomechanical printing, the Woodburytype process. Walter forms Photo-Relievo Company. Walter severely injures his eyes experimenting with carbon arc lighting for developing. Henry James, Sarah, and Ellen return to England, leaving the studio in Albert's care. Page's daughter, Anne, brought to Page's sister Hanna Boese.

1867 Walter granted BP 947 for photomechanical printing; Photo-Relievo Company dissolved. Walter sells French patent rights to Woodburytype to Goupil. Walter invents photo-filigraine process. Daughter Constance is born.

1868 Walter granted patent in US; daughter Mayence is born.

1869 Suez Canal opens. Walter photographed in group shot of Solar Club. Daughter Marie Valence is born.

1870 Walter and family live in Craven Cottage. Two more patents issued BP 346 and 2171, for photomechanical printing. Goupil and Cie default on patent payments. Walter walks away with 20 per cent of agreed monies.

1871 Walter travels to the US where he meets Edward Wilson of Philadelphia and L. J. Marcy, inventor of the sciopticon. Walter improves light source and writes a manual. Granted BP 3654.

1872 Walter awarded the Grand Medal of the Moscow Exposition. Daughter Hermance Edith is born.

1873 Sciopticon clones produced by rivals because of loophole in patent wording, outnumber real sciopticons. Walter goes to Germany and files two patents there. Henry James dies working as a minister in Besses-o'th'Barn, Pilkington Manchester, July 13.

1874 Walter elected to the Council of the Photographic Society.

1875 *Treasure Spots of the World* is published. Walter and Marie spend the winter in Italy, taking sciopticon slides, and are nearly blown up. Walter begins working with colour printing. Daughter Fayence is born.

1876 Walter is working on colour printing (stenchromatic process). Daughter Avence is born.

1877 Walter invents the balloon camera for aerial surveillance: BP 1647. Army rejects it. Woodbury remarkets the camera portion as "The Woodbury Tourist Camera."

1878 Walter works on colour photography, files patent BP2912, chromogeletine process.

1879 Walter invents stannotype process. He is sued for bankruptcy; Sciopticon Company liquidated.

1880 Walter forms Treadway and Company for stannotypes.

1881 Walter files patent BP 2527 for the stannotype process.

1882 Walter suffers macular degeneration, which he attributes to 1866 eye injury.

1883 Walter is awarded Progress Medal of the (Royal) Photographic Society and Exhibition Medal for stannotype process. Walter is forced to sell his shares in Treadway and Company. Walter files patent BP 4735. Walter writes about rapidly deteriorating sight, blaming experiments with arc lighting in 1866.

1884 Walter is diagnosed with diabetes; files patent 2981.

1885 Walter's failing health spurs collection for the family. Walter files patent for paper backed film, dies of laudanum overdose in Margate, September 5 at age 51. Photographic community holds a collection for a headstone. Walter leaves £246.

APPENDIX 8:
A Simplified Family Tree

Walter Horton Bentley 1781-1848—Elizabeth Reddish 1779–1843
 Mary 1806 (m. Thomas Surr, no children)
 Ellen 1810–1863 (Walter's beloved mum)
 Elizabeth 1816–1881 (m. Whitworth.) Collector of Lost Woodburys, whose daughter Lizzy compiles *The Whitworth Album*
 six other children

Ellen's Husband 1 **James Taylor Woodbury** 1806–1842
 Walter Bentley Woodbury 1834–1885
 Henry James 1836–1873
 Albert 1840–1900
 Lucy 1841–1906
 Ellen 1837–1909
 Husband 2 **James Lea** 1814–1848
 Frederick 1845–1865 (?) (Lost at Sea)
 Emily 1848–1908

Walter Bentley Woodbury m **Marie Olmeijer** 1848–1931 (dies in Bermuda)
 Florence 1864–1901 (Ontario)
 Walter Edward 1865–1905 (Panama)

Constance 1867–1963 (South Africa)
Ellen Mayence 1868–1966 (England after Kenya)
Marie Valence 1869–1949 (England)
Hermance Edith 1871–? (Somewhere in Australia)
Fayence 1875–1962 (Australia)
Avence 1876–1896 (?) (Dies at Sea)

Henry James—Sarah Jane Aldersey 1832–1919
Ellen 1865–1941 (the family historian)

Albert—Katherine Louisa Knott 1856–1946
Albert Leonard 1880–1961—Olive Weaver Hunt 1890–1947
Luanne (the *real* family historian) 1921–2021

APPENDIX 9:
*Walter Bentley Woodbury:
Partial List of Patents*

British Patent 2338 September 23, 1864: chromogelatine process. (The Woodburytype)

British Patent 105 January 12, 1866: (with G. Davies). An improved method of and apparatus for finishing impressions (in coloured gelatine or other soluble material) obtained from metallic or other plates produced by the aid of photography.

British Patent 505 February 17, 1866: production of ornamental surfaces for jewellery and other purposes.

British Patent 1315 May 8, 1866: ornamenting. Producing designs upon wood and other materials by the aid of photography.

British Patent 1918 July 24, 1866: photomechanical printing (Woodburytype Process). An improved method and apparatus for printing from metal intaglios (obtained by the aid of photography) in gelatinous or other semi-transparent ink.

British Patent 947 March 30, 1867: photomechanical printing (with R. H. Ashton).

US Patent 77, 280 Means of Producing Designs on paper Granted April 28 1868, expired 1885.

British Patent 346 February 7, 1870: an improved method of producing surfaces by the aid of photography.

British Patent 2171 August 4, 1870: an improved method of producing surfaces by the aid of photography.

British Patent 3654 December 4, 1872: an improved method of producing surfaces by the aid of photography

British Patent 1954 May 30, 1873: an improved method of producing surfaces by the aid of photography

British Patent 1699 Lime-light apparatus for magic lanterns

British Patent 1647 April 27, 1877 Photographic Equipment. Balloon camera for military observation

British Patent 2912 July 22, 1878 chromogelatine process.

British Patent 3760 September 19, 1879 photomechanical printing. Improvements in means for and methods of producing designs upon metallic surfaces. (The Stannotype)

British Patent 2527 June 10, 1881: as above.

British Patent 4735 October 5, 1883: as above.

British Patent 2981 February 8, 1884: as above.

British Patent 10911 musical railway signal

British Patent 5164 1884 hygrometer: a star-shaped device for the detecting of dampness in cloth.

British Patent 14963 sound recording device

British Patent 9575 August 11, 1885: sensitized film (with F.Vergara).. This patent was filed less than a month before Walter's death.

APPENDIX 10:
The Woodbury Glacier

At least somebody appreciated Walter's Balloon camera!

The Woodbury Glacier is located within the British Antarctic Territories at 64°47' S and 62°20'W. (1) The glacier was given the name by the United Kingdom Antarctic Placenames Committee (APC) in 1960. The citation, as given in the Australian Antarctic website, reads:

> Glacier just west of Montgolfier Glacier, flowing into Piccard Cove, Wilhemina Bay, on the west coast of Graham Land. Mapped by the FIDS [Falkland Islands Dependencies Survey]

from air photos taken by Hunting Aerosurveys Ltd. In 1956–57. Named by the UK-APC in 1960 for Walter Bentley Woodbury (1834–1885), English pioneer of photomechanical printing in 1865 and of serial film cameras for use in balloons and kites in 1877; in association with the names of pioneers of photogrammetry and air survey grouped in this area. (APC, 1960, p.8; BA chart 3566, 25. viii, 1961.)

AFTERWORD

In the course of writing this book, my perspective on the events in it changed. At first, I was incensed by the effects of Victorian racism. As I dug into and connected and analyzed and just thought about the story, I came to realize that racism was too simplistic an answer for what happened to Walter and his family.

Part of the cause of the tragedy of this family lay in Walter himself. He was a generous, impulsive, naïve man who happened to be a genius. He didn't see the deep waters he had chosen to commit Marie and his children to, and they all paid the price. Had Walter been a better business man, and had he been able to hang on to some of the wealth his inventions generated—or would have generated, in the case of "tissue film"—his family might have been more insulated from the vicissitudes of public opinion. Rich people are usually described by the kinder word "eccentric."

I also see a tragedy of the repudiation of the rich heritage of Indonesia. I discovered this aspect of our family history by accident after being given a genealogy program as a Christmas present and discovering that our family had erased our Indonesian heritage. My maternal grandmother, Hermance's daughter Muriel, never mentioned Marie; in fact, she barely mentioned her family at all. It was as if she had left them behind. Perhaps she never forgave Hermance for abandoning her and her two siblings. Perhaps she never forgave her for being Eurasian.

I think of the losses. To be "Eurasian," Marie was not allowed to be Indonesian. She had to dress as a European, speak a European language, go to a European school. I don't imagine she had a choice. In the view of a working colonial like her father, her status would be higher this way; her chance of making a good marriage would be too. So, "for her own good," Marie could not dress, speak, or be educated as an Indonesian. Even though the immediate goal of the plan was successful (an advantageous marriage), would her life have been happy if she were neither European nor Asian? I'm sure some people managed it. I'm equally sure others did not. I do not know which group Marie would have fallen into.

The other loss is the loss of the Woodbury children's heritage and sense of belonging. I can find no evidence that they were ever taught about Indonesia or even communicated with relatives there. When they fled England, not one of them went to Java. The Woodbury children seemed to have no affinity for or connection to their mother's homeland. Instead, they fled to the corners of the English-speaking world—Canada, the US, Australia, South Africa, Kenya…

I applaud my niece, Cheryl Spencer Cardinal, for making sure her children know the whole story of this family. I wrote this book so others would know the story too.

This is the story as far as I have traced it as of November, 2022. Frequently new material, sources and connections turn up. Stay tuned for further developments.

Muriel Morris

LIST OF ILLUSTRATIONS

1. Frontispiece and Page 10. Walter Bentley Woodbury with Camera c 1857. Wikipedia Public Domain Royal Photographic Society (Bath)
2. Page 16. Deep Sinking Bakery Hill, Ballarat, 1853. National Museum of Australia http://nla.gov.aus.cat.YN2064785
3. Page 18. Melbourne's Canvas Town, National Museum of Australia
4. Page 20. Cross-written Letter by Walter Woodbury to Ellen Woodbury, National Library of Australia
5. Page 23. Surveyors' Camp, Buninyong 1853, Royal Photographic Society (Victoria Australia) Newsletter, Collection of Alan Elliott.
6. Page 26 Panorama of Melbourne, Royal Photographic Society, (Victoria) Collection of Alan Elliott.
7. Page 27. 1854 Exhibition Medal, Royal Photographic Society (Victoria) Collection of Alan Elliott.
8. Page 28. Lola Montez 1851, Wikipedia US Public domain, Southworth and Hawes, Collection of the Metropolitan Museum of Art, NY.
9. Page 30. Woodbury's Portrait Rooms, Wikipedia Free Commons.

10. Page 35. "Young America" Clipper Ship painting by Antonio Jacobsen (1850–1921) Image courtesy of Reh's Gallery Inc. NY, *Walter Woodbury A Victorian Study*. Print 34
11. Page 36. "Miner in Top Hat," the *Nellie Babcock Album*, National Library of Australia http://nla.gov.aus.cat.YN4811874
12. Page 36. "View of Ford Street," the *Nellie Babcock Album*, National Library of Australia. http://nla.gov.au/nla.obj-151247409
13. Page 38. Early Photograph of Woodbury Atelier Rijksmuseum NG 2100-21-9
14. Page 39. Back Garden of Woodbury Atelier, Rijkstudio NG-2011-29-39-1
15. Page 40. Woodbury's Photographic Staff and Porters, KITLV 30816 University of Leiden website
16. Page 41. Acclaimed Painter Raden Saleh, Rijksmuseum NG-1988-30-8-2
17. Page 41. Raden Saleh's House, Rijksmuseum NG 2011-331-31
18. Page 42. Landscape with Tigers Listening to Travelling Group, Raden Saleh, Wikiart Commons
19. Page 44. Later Photograph of Woodbury Atelier with Dutch Royal Crest over the Door. KITLV 3476 University of Leiden website
20. Page 45. Portrait of Henry James Woodbury, *Whitworth Album*, Courtesy of Janet Nelson, Ontario
21. Page 46. Buitenzorg Garden, Collection of the Author also KITLV 3128
22. Page 48. Holmes Stereo Viewer Wikipedia public domain Photo released into public domain by photographer David Pape
23. Page 51. Ruins at Borobudur, Collection of the Author also KITLV 4137
24. Page 51. The Stupa--Ruins at Borobudur, KITLV 408095
25. Page 54. "Two Observers of the Ruins," *Vues de Java* KITLV 82598
26. Page 54. "Statue of Ganesha," *Vues de Java*, KITLV 10057

27. Page 56. Albert and Henry James Woodbury Playing Chess, Collection of Luanne Woodbury, London also KITLV 31928
28. Page 62. Young Girl in a Sarong—Mena?. Rijkstudio NG 1988 30-D-20-2
29. Page 63. Seated Housekeeper, KITLV 30797
30. Page 65. Photograph of Woodbury and Page, screenshot of e-Bay website by the author
31. Page 66. Detail of Ruins at Borobudur, Collection of the Author also KITLV 163316
32. Page 67. Carte de Visite of European woman in European dress KITLV
33. Page 67. Carte de Visite of Eurasian (totok) woman in European dress KITLV
34. Page 68. Aristocratic Young Woman, Collection of the Author also KITLV 4564
35. Page 69. Woodbury Atelier with Figures on Porch, Rijksmuseum NG-2011-31-9
36. Page 70. Detail of Woodbury Atelier with Figures on the Porch Rijksmuseum, NG-2011-31-9
37. Page 71. Closer Detail of Woodbury Atelier with Figures on the Porch, Rijksmuseum NG-2011-31-9
38. Page 72. "Behind Van Leeuwen's House," Rijksmuseum RP-F01220-Y
39. Page 73. Detail of "Behind Van Leeuwen's House," Rijksmuseum RP-F01220-Y
40. Page 74. Front of Van Leeuwen's House, Rijksmuseum Collection NG-2011-30-24
41. Page 75. Detail of Front of Van Leeuwen's House, Rijksmuseum NG-2011-30-24.
42. Page 75. Private House of Mr. Schenk, Rijksmuseum NG-2011-29-37-12
43. Page 77. Albert Leonard Woodbury and his Amah, Collection of Luanne Woodbury, London also KITLV 31926
44. Page 79. Private House in Surabaya, KITLV 183724

45. Page 81. Inter-racial Couple Posing Proudly with their Child, Woodbury and Page, Rijkstudio RP-F-2007-14-32
46. Page 82. Sarah Jane, Ellen and Henry James Woodbury Returning to England, Collection of Luanne Woodbury, London
47. Page 96. "The Mountain Dew Girl" Photograph by Henry Peach Robinson, David A. Hanson Collection of the History of Photomechanical Reproduction.
48. Page 98. PL'Establissment Photographique de MM. Goupil et Cie a Asmieres," wood engraving by H. Dutheul, Published *L'Illustration,* no. 1572, 12 April, 1873
49. Page 99. "The Crawlers," *Street Life in London,* John Thomson 1877 Wikipedia Free Commons National Library of Scotland http://www.nls.uk/digitallibrary/thomson/sixth81.htm
50. Page 101. The Solar Club Group Portrait, from the research notes of Alan Elliott
51. Page 102. Sciopticon or Magic Lantern, Victoria Museum, Melbourne, Australia
52. Page 102. "Opium User" Glass Sciopticon slide by Woodbury KITLV Java OR.27.862
53. Page 104. *Treasure Spots of the World* Cover, Rijksmuseum RP-F-2001-7-1475
54. Page 105. "Colossal Figure" from *Treasure Spots of the World* Rijksmuseum RP-F-2001-7-1475-13
55. Page 109. Diagram of Woodbury's Balloon Camera, Royal Photographic Society (Victoria Australia) Newsletter Feb 2003
56. Page 112. Walter B Woodbury, carte de visite face and verso, Collection of the Author
57. Page 113. Cover of the *Manual for the Stannotype Process,* Collection of Alan Elliott, Australia
58. Page 114. Progress Medal of the Photographic Society, Royal Photographic Society (Victoria Australia) Newsletter January 2001
59. Page 114. The Woodbury Photometer, screen shot e-Bay
60. Page 122. Carte de Visite of Marie Olmeijer, Collection of the Author

61. Page 124. Ellen Walter's sister, *Whitworth Album*, Collection of Janet Nelson
62. Page 125. Lucy, Walter's sister, *Whitworth Album*, Collection of Janet Nelson
63. Page 129. Profile of Marie, *Whitworth Album*, Collection of Janet Nelson
64. Page 131. Walter B Woodbury, *Whitworth Album*, Collection of Janet Nelson
65. Page 134. Craven Cottage, Collection of Luanne Woodbury
66. Page 142. Racial types, Wikipedia Commons H. Stricland Constable illustrator.
67. Page 144. "The Beloved," Tate Gallery, London Wikipedia Commons https://commons.wikimedia.org/wiki/File:Dante_Gabriel_Rossetti_-_The_Bride_-_WGA20108.jpg
68. Page 145. Florence in Walter's Manchester Studio, *Whitworth Album*, Collection of Janet Nelson.
69. Page 151. Possibly Marie and Florence Luminous Lint Webpage www.luminous.lint.com/phv_app.php?/f/_photographer_woodbury_page_portraits_from_southeast_asia_01/ listed as in the private collection of Jan Weijers
70. Page 152. Possibly Florence, ripped "tissue film" Science and Society website Victoria and Albert Museum.
71. Page 153 Notice of Bankruptcy Hearing, Times, Feb 9 Page 4 issue 29025 Column C
72. Page 158. Pear's Soap Advertisement "The White Man's Burden" Wikimedia public domain Free Commons File:1890sc Pears Soap Ad.jpg
73. Page 158. Pear's Soap Advertisement "Washing the Blackamoor White" Blackwiki https://blackwiki.org/index.php?curid=260381
74. Page 162. Florence, KITLV 41688
75. Page 164. Grace Steet Shambrook's Tombstone, Find a Grave website https://www.findagrave.com/memorial/138822836
76. Page 165. Walter Edward Woodbury as a child, *Whitworth Album*. Collection of Janet Nelson

77. Page 167. Cover of *The Photographic Times* Photoseed website Courtesy David Spencer
78. Page 167. Cover/letter/Walter E triptych Photoseed website Courtesy David Spencer
79. Page 168. Walter E Woodbury Photoseed website, Courtesy of David Spencer
80. Page 168. Photograph taken through a beetle's eye from Photographic Times. Photoseed Website Highlights. photoseed.com/blog/category/history of photography/3/ Courtesy of David Spencer
81. Page 169. A Photographic Feat (Walter Woodbury subject) Photoseed Highlights photoseed.com/blog/category/history of photography/3/ Courtesy David Spencer
82. Page 170. Man menaced by a ghost from *Photographic Amusements* Photoseed Website Courtesy David Spencer
83. Page 173. Facsimile of Walter E's introduction Picturesque Bits of New York Photoseed Website. https://photoseed.com/collection/group/picturesque-bits-of-new-york-and-other-studies/ Courtesy Photoseed Website, David Spencer
84. Page 173. Winter on Fifth Avenue from *Picturesque Bits of New York* Photoseed Website, Courtesy David Spencer
85. Page 174. Triptych of A Goodspeed, Radiograph of a hand and J Carbutt. Scoville and Adams website.
86. Page 175. Lucy Woodbury Roscow with daughters, son Albert Woodbury Roscow and nephew Walter E Woodbury Collection of Luanne Woodbury
87. Page 177. Constance Woodbury, Collection of Luanne Woodbury
88. Page 178. Constance Woodbury. Collection of Jennifer Lock, (great granddaughter)
89. Page 179. Constance in South Africa with 10 of her 11 children Collection of Jennifer Lock
90. Page 180. Constance and her Older Children, Collection of Jennifer Lock

91. Page 180. Constance in her 90's in her Garden, Collection of Jennifer Lock
92. Page 181. Mayence and Constance as Children, Collection of Luanne Woodbury
93. Page 182. Mayence in the 1890's, Collection of April Manino, (great granddaughter)
94. Page 184. Tommy Woods' store: Nairobi City/County Website https://nairobi.go.ke/history/
95. Page 185. Stanley Hotel Wikipedia public domain https://commons.wikimedia..org/w/index .php.curid=38481354
96. Page 186. Fred Tate, https://www.europeansineastafrica.co.uk/_site/custom/database/?a=viewIndividual&pid=2&person=1884
97. Page 187. The New Stanley Hotel 1915s New Stanley Hotel website before revision
98. Page 188. Mayence in mid life Collection of April Manino
99. Page 189. New Stanley Hotel Luggage Sticker Wikipedia Free Commons
100. Page 189. Mayence in her 70's. Collection of April Manino
101. Page 190. Princess Elizabeth at the New Stanley Hotel 1952 Wikipedia PD/US
102. Page 191. "Big Gran and Little Gran" Collection of April Manino
103. Page 191. Mayence on her 95th Birthday Collection of April Manino
104. Page 192. Marie Valence Woodbury Collection of Luanne Woodbury
105. Page 193. Walter England's Application to Marry a Minor, Hermance Woodbury, National Archives, Britain, Ancestry.com
106. Page 195. Stereo-view by William England of Acrobat Blondin Crossing the Niagara River Rijksmuseum RM00001 Collection273615
107. Page 196. Marriage Certificate, Walter England and Hermance Woodbury, National Archives, UK "England & Wales Marriages, 1837-2005," database, findmypast (http://www.findmypast.com:

2012); citing 1888, quarter 3, vol. 1A, p. 550, Fulham, London, England, General Register Office, Southport, England.

108. Page 198. Divorce Papers Walter England and Hermance Woodbury, National Archives, UK K 72/708/1533
109. Page 200. Arliss-Robinson Ginger Beer Bottle, Collection of the Author
110. Page 200. Arliss-Robinson Mineral Water Bottle, e-Bay screenshot
111. Page 208. Henry Arliss-Robinson, Collection of Jennifer Lock, England
112. Page 213. Hospital Register of the Birth of Fayance's Daughter Avence "England & Wales Births, 1837-2006," database, findmypast (http://www.findmypast.com: 2012); citing Birth Registration, Marylebone, London, England, citing General Register Office, Southport, England.
113. Page 214. Detail of the Register (as above)
114. Page 215. T. H. Chesnut, *Canadian Bookman*, Vol. 1, No 7, July 1901, p.98
115. Page 217. Hilda, Daughter of Fayence, as a Beautiful Bride. National Library of Australia, nlanews.page000017701868.nlanews
116. Page 219. Luanne Woodbury and Stephen Wachlin at Abney Park Cemetery Beside the New Headstone, Picture Taken by Alan Elliott. Collection of Alan Elliott
117. Page 220. Historian Alan Elliott with Walter's old tombstone. Collection of Alan Elliott.
118. Page 220. The New Woodbury Tombstone, Collection of Alan Elliott
119. Page 221. Ellen Woodbury Ferguson in Later Life, Collection of Luanne Woodbury
120. Page 223. Donald Ferguson, Collection of Luanne Woodbury
121. Page 224. Marianne Ferguson, Collection of Luanne Woodbury
122. Page 224. Marianne and in the Garden in Happier Time, Collection of Luanne Woodbury

123. Page 225. Ellen in the Garden in Happier Times, Collection of Luanne Woodbury
124. Page 229. Walter Horton Penny, Collection of the Author
125. Page 231. The Exeter 'Change Menagerie, Wikipedia Free Commons By Internet Archive Book Images - https://www.flickr.com/photos/internetarchivebookimages/14782117254/ Source book page: https://archive.org/stream/oldnewlondonnarr03thor/oldnewlondonnarr03thor#page/n126/mode/1up, No restrictions, https://commons.wikimedia.org/w/index.php?curid=43644950
126. Page 231. Interior of Polito's (Soon to be the Exeter 'Change) Menagerie 1812 from Ackerman's Repository, British Museum Wikipedia https://upload.wikimedia.org/wikipedia/commons/1/1e/Exeter_Change_1820.jpg?20100331183731
127. Page 233. Newspaper Lithograph of the Killing of Chunee, Wikidata Public Domain
128. Page 234. Handout Advertising the Exhibition of Chunee's Skeleton, Wikipedia Commons from Jan Bondeston's *Animal Freaks*
129. Page 237. The Interior of the Hunterian Museum Wikipedia Commons from De.Nuno Cavallio de Sousa Private Collection, Lisbon
130. Page 242. Edward Cross, owner of the Exeter Change Wikipedia Free Commons [File:Edward Cross by Agasse.jpg|Edward Cross by Agasse]
131. Page 243. John James Audubon 1826, Portrait by John Syme (1795-1861) Wikipedia Free Commons
132. Page 244. Turkey Cock Plate 1 of *Birds of North America* Wikipedia Free Commons
133. Page 247. Elizabeth Bentley Whitworth, *Whitworth Album* Collection of Janet Nelson
134. Page 255. Ann Morgan with Reggie, Collection of the Author.
135. Page 255. Wedding Photo Muriel Phyllis England and Hector Morgan, Collection of the Author

136. Page 256. Hector Morgan with Muriel Phyllis, son Victor and sister-in-law Gladys England on the Steps of the Farmhouse, Strawberry Hills, Indian Head, Saskatchewan, Collection of the Author

137. Page 258. Sid Coward on Roy, Collection of the Author

138. Page 262. Brooksbank Wedding Photo at the Scotch Kirk, Singapore 1910 Collection of Richard Bartholemew

139. Page 264. Hodgins Family Leaving Singapore Aboard a P&O Liner Collection of Penny Desai

140. Page 277. Aerial View of the Woodbury Glacier, Antarctica, Google Earth

NOTES

THE EARLY YEARS:

1. Jan Bondeston, *The Feejee Mermaid and Other Essays in Natural and Unnatural History*, (Cornell University Press, 2014) p. 90.
2. T. Brown, "Manchester Zoological Gardens," *Zoo Grapevine*, Summer 2011.
3. John James Audubon, *European Journals*, ed. Maria Audubon Charles, Charles Scribner and Sons, New York, 1897, p 141.
4. Wikipedia.org/wiki/Early Closing Association.
5. GS Film Number: 004508433 Digital Folder Number: 004508433 Image Number: 00005 Citing this Record "England, Manchester, Parish Registers, 1603-1910," database with images, FamilySearch (https://familysearch.org/ark:/61903/1:1:QK14-BM89: 23 July 2019), Walter Horton Bentley, 16 Oct 1848, Burial; citing St Luke, Chorlton upon Medlock.
6. *The Amateur Photographer*, Dec 26 1884, p. 18.
7. Ibid.
8. Ibid.

AUSTRALIA FOOTNOTES:

9. (National Museum of Australia http://www.nma.gov.au/online_features/defining moments/featured/gold-rushes)

10. Robert Hughes, *The Fatal Shore,* (Random House, New York 198) p. 561.
11. Ibid. p. 564-565.
12. Ibid. p.563.
13. Walter B Woodbury, ed. Alan Elliott. *The Woodbury Papers Letters and Documents held by the Royal Photographic Society*, (privately printed Melbourne 1997) Letter 8, 6 October, 1853.

A ROUGH START

14. Alan Elliott et al., *Walter Woodbury: A Victorian Study,* Royal Photographic Society, Melbourne Chapter, Melbourne Australia 2008 p.9.
15. Woodbury, *Letters and Documents.* Letter 1, Nov. 21, 1852.
16. Ibid. Letter 8, Oct 6, 1853.
17. Ibid. Letter 1, Nov 21, 1852.
18. Ibid. Letter 6, June 20 1853.
19. Raymond Evans. *Fighting Words: Writing about Racism,* (Queensland University Press, 1999) p. 19.
20. Walter Woodbury, "Reminiscences of an Amateur Photographer. *The Amateur Photographer,* Dec 26, 1884, pp 185.

A BIG BREAK

21. Woodbury, *The Woodbury Papers Letters and Documents*, Letter 3 Jan 30, 1852.
22. Ibid. Letter 6 June 20, 1852.
23. Ibid. Letter 2 Dec 30, 1852.
24. Ibid Letter 7, August 10, 1853.
25. Ibid. Letter 4, April 24 1853.
26. *The Amateur Photographer,* Dec. 26 1884, p. 186.
27. *Letters and Documents*, Letter 11 Dec 30 1854.
28. *The Amateur Photographer,* Dec. 26, p. 186.
29. Ibid.
30. *Letters and Documents*, Letter 12 August 1855.

31. Montez, Lola, *Australian Dictionary of Biography*, Vol 5 MUP 1974.
32. *Letters and Documents*, Letter 13, Feb 26, 1856.
33. Ibid. Letter 14, August 23 1856.

A BIG DECISION

34. Ibid. Letter 14, August 23, 1856.
35. Ibid.
36. Ibid.

JAVA: FOOTNOTES
WALTER STRIKES GOLD OF ANOTHER KIND

37. Arthur Rowbottom, *Travels in Search of New Trade Prospects*, (Jarrold and Sons, London 1893) p. 116.
38. sydneylivingmuseums.com.au/stories/chinese-goldfields
39. National Library of Australia, *Nellie Babcock Album* nla.gov.au/nlaobj-15124632/view
40. Walter Woodbury, ed. Alan Elliott, *The Woodbury Papers: Letters and Documents held by the Royal Photographic Society*, (privately printed Melbourne 1997), Letter 15 May 4, 1857.
41. Ibid., Letter 16, September 2, 1857.
42. Marianne Hulsbosch, *Pointy Shoes and Pith Helmets*, (KITLV, Leyden, 2004) pp. 106 -107.
43. Wikipedia: "Indos in Colonial History" https://en.wikipedia.org/wiki/Indos_in_colonial_history
44. Alfred Russel Wallace, *The Malay Archipelago*, (Harper 1869) Chapter 7.
45. Gael Newton, *Garden of the East: photography in Indonesia 1850s-1940s*, (National Gallery of Australia. 2014).
46. Walter Woodbury, ed. Alan Elliott, *Letters and Documents held by the Royal Photographic Society*, Letter 16, September, 1857.
47. https://www.measuringworth.com/ukc

LIVING THE LIFE

48. *Woodbury Papers, Letters and Documents*, Letter 15, September 2, 1857.
49. *Woodbury Papers, Letters and Documents*, Letter 19. September 1, 1858.
50. Arthur Rowbottom, *Travels in Search of New Trade Products*, p.116.
51. *British Journal of Photography*, (15 April 1861) :156.
52. Rowbottom, *Travels in Search of New Trade Products*, p. 116.
53. Walter Bentley Woodbury. "Photography in Java: Account of a short photographic ramble through the interior of the east end of the island," *The Photographic News*, February 2, 14 and Mar 15, 1861.
54. Ibid.
55. Ibid.
56. Rowbottom, *Travels in Search of New Trade Products*, p.117.
57. Ellen Woodbury Ferguson, Letter to Albert Leonard Woodbury, Jan 4 1936. Collection of Luanne Woodbury.

WALTER WOULD HAVE SURPRISED HIS MOTHER

58. Woodbury, *Letters and Documents,* Letter 10 Sept. 1, 1854 Melbourne.
59. Woodbury, *Letters and Documents,* Letter 14, August 23 1856 Woolshed Creek.
60. Alan Elliott, "Walter and Those Dancing Girls," *RPS (Victoria) Newsletter* Oct, 1999.
61. *The Melbourne Age,* January 1857.
62. James Jupp, ed. *The Australian Peoples: an Encyclopedia of the Nation, Its People and Their Origins,* (Cambridge University Press 2001) p. 31.
63. Miriam Hulsbosch, *Pointy Shoes and Pith Helmets: The Social World of Batavia: European and Eurasian in Dutch Asia,* p. 109.
64. Roger Wiseman, "Assimilation Out: European, Indo European and Indonesians seen through Sugar from the 1880's to the

1950's." *Panel Paper from AASA Conference,* (U of Melbourne, July 2000) p. 8.
65. *Wikipedia* article "Indos in Colonial History" (no pagination) https://en.wikipedia.org/wiki/Indos_in_colonial_history
66. Jean Gelman Taylor, *The Social World of Batavia: European and Eurasian in Dutch Asia,* (University of Wisconsin Press, 2006) p. 126.
67. Ann Stoler, *Carnal Knowledge and Imperial Power*, (University of California, Berkley 2002) p. 46.
68. Woodbury, *Letters and Documents*, Letter 16 2 Sept. 1857 Batavia.
69. Woodbury, *Letters and Documents*, Letter 18 June 15 1858 Passaurean.
70. Jean Gelman Taylor, *The Social World of Batavia,* p. xxii.
71. Hulsbosch, *Pointy Shoes and Pith Helmets*, p. 109.
72. Joseph Conrad, *A Personal Record*, p, 74 Personal Record 1916 p. 186.
73. Z. Najer, Joseph Conrad, a Chronicle, Cambridge University Press.1983 p. 99 quoted in *Dictionary of Real People and Places in Fiction*, M C Rintoul, Rutledge, London and NY, 1993.
74. Hulsbosch, *Pointy Shoes and Pith Helmets*, p. 109.
75. J G Taylor, *The Social World of Batavia*, p. 132.
76. J G Taylor, Ibid.
77. Ellen Woodbury Ferguson, Handwritten Family History, 1935, in the possession of the heirs of Luanne Woodbury.
78. Wiseman, "Assimilation Out: European, Indo European and Indonesians seen through Sugar from the 1880's to the 1950's." *Panel Paper from AASA Conference,* p. 6.
79. Ellen Woodbury Ferguson, Letter to Albert Leonard Woodbury (her cousin) 22 Oct. 1935 quoted in Steven Wachlin, *Woodbury and Page, Photographers Java*, (KITLV Press 1994) p. 33.
80. Wachlin, Ibid. p. 33.

WHAT HAPPENS IN ENGLAND: FOOTNOTES WALTER'S CAREER SKYROCKETS AND CRASHES

81. Rowbottom, *Travels in Search of New Trade Prospects*, p. 117.
82. Barret Oliver, *A History of the Woodburytype,* (Carl Mautz Publisher 2007) p. 11.
83. Oliver, Ibid. p. 30.
84. Alan Elliott article on Woodbury *in Encyclopedias. Biz* website http://www.encyclopedias.biz/encyclopedia-of-19th-century-photography/27653-woodbury-walter-bentley-1834-1885
85. Alice Kuegler. The Responsiveness of Inventing: Evidence from a Patent Fee Reform" 2016 http://eh.net/eha/wp-content/uploads/2016/08/Kuegler.pdf
86. Peter Jackson, *Encyclopedia of 19th Century Photography*, John Hannavy ed. (Routledge, London 2007) p. 1512.
87. Henry Baden-Pritchard, *Photographic Studios of Europe*, (Piper and Carter, London 1882) p. 49.
88. Trevor Beattie, "Walter Woodbury and his Sciopticon," *The new magic lantern journal: volume 10 number 3* (Autumn 2007), pp.39-42. Reproduced by courtesy of the Magic Lantern Society, www.magiclantern.org.uk, accessed 3 March 2020.
89. Beattie, Ibid.
90. Walter Bentley Woodbury., *Treasure Spots of the World,* (Lock and Tyler, London 1875) Preface.
91. Walter Bentley Woodbury "The Imaginary Brigand", *British Journal of Photography,* 3 February 1882 p. 64.
92. Andrew Aitkinson, "Continuous Tone Alternatives to Half Tone Through Historical Reflection," I S &T and Pics 2003 Conference paper. p. 287.
93. Henry Baden-Pritchard, *Photographic Studios of Europe*. p. 47.
94. Quoted in "Woodbury's Remarkable Aerial Camera," *Royal Photographic Society (Victoria, Australia) Newsletter* Feb. 2003.
95. *The London Gazette*, March 28, 1879, p. 2517.

96. The Debtors Act 1869 http://www.legislation.gov.uk/ukpga/Vict/32-33/62/enacted
97. *British Journal of Photography* 1884, p. 166.
98. John Hannavy, *Encyclopedia of Nineteenth Century Photography*, p. 1511.
99. Henry Baden-Pritchard, *Photographic Studios of Europe*, p. 47.
100. Walter Bentley Woodbury, *The Yearbook of Photography and Photographic News Almanac for 1885*, p. 87.
101. Walter Bentley Woodbury, Letter to Edmund Wilson, quoted in *Walter Woodbury: A Victorian Study*, p. 106.
102. *The Amateur Photographer,* March 20th 1885, p. 384. The same appeal was also published in *The British Journal of Photography*, March 13 1885, p. 167, *The Photographic News,* March 13, 1885, p. 165, and *The Philadelphia Photographer,* May 1885, p. 144.
103. Edward Wilson, *The Philadelphia Photographer*, 1885 p 369-370.
104. John Malcolm lists sources: *The Amateur Photographer* 1885, p 364-365. Keebles Margate and Ramsgate *Gazette,* Sept 12, 1885.
105. Ibid.
106. Ibid.
107. Edmund Wilson, *The Philadelphia Photographer,* October 1885 pp. 340-341.
108. Edmund Wilson, *The Philadelphia Photographer*, November 1885 p. 369- 370.
109. Probate: Administration of the Personal Estate of Walter Bentley Woodbury late of Java House Norwood Junction in the County of surrey who died 4 September 1885 at Margate in the county of Kent was granted at the Principal Registry to Marie Woodbury of Java House widow, the relict. Effects under 240 pounds.
110. Edmund Wilson, "A Worthy Life Ended: Walter Bentley Woodbury," The *Philadelphia Photographer,* November 1885, quoted in *Walter Woodbury: A Victorian Study,* p. 106.
111. *Amateur Photographer* 1888 p. 147 quoted in John Malcolm, Dissertation: The Life of Walter Bentley Woodbury. A dissertation submitted in partial fulfillment of the requirements for the

Degree of Master of Arts in the Department of Communication Arts and Design, Faculty of Art and Design, Manchester Polytechnic, November, 1979.

MARIE'S VICTORIAN LIFE

112. Ellen Woodbury Ferguson. Handwritten Family History. Collection of Luanne Woodbury.
113. Rozina Visram. *Asians in Britain: 400 Years of History* (Pluto Press, Kindle Edition) Location 1535.
114. Florence Hartley. *The Ladies Book of Etiquette and Manual of Politeness.* http://wwwgutenberg.org/files/35123/35123-h/35123- htm
115. Charles Dickens. *Bleak House.* http://wwwgutenberg.org/files/1023/1023-h/1023h-htm
116. Ellen Woodbury Ferguson. Handwritten Family History. Collection of Luanne Woodbury.
117. Deborah Cohen. *Family Secrets: Living with Shame from the Victorians to the Present Day.* (Penguin, UK. 2013) p xiii.
118. Legacies of British Slave Ownership website, http://www.ucl.ac.uk/lbs/
119. Deborah Cohen, *Family Secrets: Living with Shame from the Victorians to the Present Day.* pp. 42-43.
120. Wikipedia. The Morant Bay Rebellion https://en.wikipedia.org/wiki/Morant_Bay_rebellion
121. John Stuart Mill, Letter to William Sims Pratten, June 9, 1868.
122. Thomas Carlyle. *The Carlyle Encyclopedia*, ed. Mark Cumming, Farleigh Dickinson University Press, Teaneck 2004 p. 427.
123. Richard Huzzey, *BBC History Magazine*, Christmas 2015.
124. John Stuart Mill, *Autobiography* Chapter 7 (no pagination).
125. Transcription of note in Walter's handwriting, RPS library, Research Notes, Alan Elliott.
126. Charles Kingsley. In a letter to his wife quoted *in The Victorian Web: Racism and Anti Irish Prejudice*, by Anthony S Whol Vassar

College http://www.victorianweb.org/history/race/Racism.html
127. Thomas Henry Huxley. *Emancipation--Black And White 1865*, Collected Essays III https://mathcs.clarku.edu/huxley/CE3/B&W.html
128. Jeff Campagna. "The Cannibal Club, Racism and Rabble Rousing in Victorian England" *Smithsonian Magazine*, July 18, 2014 https://www.smithsonianmag.com/history/cannibal-club-racism-and-rabble-rousing-victorian-england-180952088/
129. A. N. Wilson. *The Victorians*. (Arrow Publishing, London 2003) p. 255.
130. Stella Halliwell. "Women from Nowhere: The Pre-Raphaelite Order." http://stellahalliwell.co.uk/pre-raphaelites/women-from-nowhere-the-pre-raphaelite-other/
131. Patrick Brantlinger. *Taming Cannibals: Race and the Victorians*, (Cornell University Press. 2002) p. 130.
132. Ellen Woodbury Ferguson, Handwritten Family History, Collection of Luanne Woodbury.
133. Michael Golchinsky. "Otherness and Identity in the Victorian Era," University of Georgia English Faculty Paper, 2002.
134. Gwen Sebus. "Woodbury in Leiden." uk/the magic lantern pdfs 4010552apdf
135. *The Times*, Feb 09, 1877 Issue 29095 Column C.
136. Jean Gelman Taylor, *The Social World of Batavia*, p 157.

THE FAMILY DIASPORA

137. Ontario Registry of Deaths 1899-1900 Ancestry.com
138. Grace Shambrook's grave *Find a Grave Website* https://www.findagrave.com/memorial/138822836
139. David Spencer, "The Photographic Times 1871-191: a definitive American Photographic Journal" *Photoseed Website* c. 2012.
140. *American Annual of Photography*: Volume 19, Jan 1, 1896.

141. *The Artist, Photographer and Decorator: An Illustrated Monthly Journal of Applied Art*, January 1895 www.victorianperiodicals.com/series/single_sample.asp?id_96833
142. The Photographer, April 30, 1896 quoted in *Photoseed* article https://photoseed.com/highlights/the-photographic-times-1871-1915-definitive-american-photographic-journal/
143. Walter E. Woodbury, Introduction to the *Curious Bits of New York and Other Countries* http://photoseedcom/single/walter-e-woodbury-concerning-the-content
144. Radiography. Photoseed http://photoseed.com/blog/history-of-photography3.
145. Walter E Woodbury on radiography https://photoseed.com/blog/category/historyofphotography/3/
146. Ellen Woodbury Ferguson, *Family History* 1935, Collection of Luanne Woodbury.
147. School Records. Constance Bentley. Ancestry.com National Archives UK.
148. Passenger Manifest Ancestry.com.
149. Glenda Riley, *Taking Land, Breaking Land*, (University of New Mexico Press 2003) p. 166.
150. C. S. Nicholls, *Red Strangers, The White Tribe of Kenya, (Timewell Press, London 2005)* p. 39.
151. *The Nairobi Leader*, 20 Nov 1909 Quoted in Christine Nicholl's blog oldafricamagazine.com/mayanece-bent-and-the-new-stanley-hotel
152. Ibid.
153. Brian Herne. *White Hunters: The Golden Age of African Safaris* (Holt, London, 1999) p. 15.
154. Formerly in the Sarova Stanley Hotel's history page; now Wikipedia heeps://en.wikipedia.org/wiki/Stanley_Hotel_Nairobi
155. Ibid.
156. Ibid.
157. Transcript of Document of Special Permission to Marry: Walter England and Hermance Woodbury, *National Archives UK*.

158. Ian Jeffery, *An American Journey: The Photographs of William England,* (Prestel Publishing, Munich/London/New York, 1999) p. 14.
159. PhotoLondon. https://www.photolondon.org.uk/#/details?id=2538
160. *The Pharmaceutical Journal and Transactions* 1898, Vol. 58, p. 160 Google Books.
161. *Chemist and Druggist: Newsweekly for Pharmacists,* Vol. 40 Google Books.
162. Trove Website. *Daily Mail* Brisbane, Queensland, Thurs, July 31, 1919, p. 9 https://trove.nla.gov.au/newspaper/page/23390355
163. Trove Website. *The Daily News,* Perth, Western Australia, Mon. July 28, 1919 https://trove.nla.gov.au/newspaper/article/79578803
164. Trove Website. *The Fremantle Herald*, Fremantle, Western Australia, Fri. Mar. 25 1920 https://trove.nla.gov.au/newspaper/article/256731546
165. Trove Website. *The Truth* August 10, 1919 https://nla.gov.au/newspaper/article/200397285
166. Trove Website. *The Western Australian*, Thursday, April 15, 1920. https://trove.nla.gov.au/newspaper/
167. Australian Government website https://aifs.gov.au/facts-and-figures/divorce-australia
168. Phyl Carrick and Chris Jeffery, *Fremantle Hospital: a social history,* (Fremantle Hospital, 1989) p. 178.
169. Trove Website. *The Sunday Times*, Perth, Western Australia, Aug 22 1925 https://trove.nla.gov.au/newspaper/
170. Trove Website. Fremantle Herald, December 13, 1924. https://trove.nla.gov.au/newspaper/
171. Coroner's Inquest into the Death of Walter Bentley Woodbury, Margate, Sept. 12, 1885 (see footnote 102).
172. Trove Website. "Beautiful Brides," *Table Talk*, Melbourne, Dec 27, 1934.
173. Trove Website. *Melbourne Argus*, Tues May 3 1955.

174. Woodbury Grave https://www.findagrave/memorial/25432389/walter-bentley-woodbury

APPENDICES

175. Donald Ferguson collection of Luanne Woodbury.
176. Marianne Ferguson will Ancestry.com.
177. Neil McKendrick, " Josiah Wedgwood and Thomas Bentley: An Inventor-Enterpreneur Partnership in the Industrial Revolution," *Transactions of the Royal Historical Society*, Vol 14, (Cambridge University Press on behalf of the Royal Historical Society, 1964) p. 7.
178. Rev. J. F.Smith (ed.), *The Manchester School Register*, Vol. 3, Part 2, May 1807-Sept 1837, The Cheetham Society: Manchester, 1874, p. 178.
179. The Evode History Project http://www.evodehidtoryproject.org.uk
180. Christopher Plumb, *Exotic Animals in 18th Century Britain: A Thesis Submitted to the University of Manchester, Centre for Museology* 2010 p. 212.
181. Jane Austen, *Sense and Sensibility*, Bernhard Tauchnitz, Leipzig, 1864, Google Free ebooks, p. 197.
182. Jan Bondeson, *The Cat Orchestra and the Elephant Butler,* (Tempus Press; Gloucestershire 2006) p.69.
183. Ibid p.73.
184. Ibid. pp. 73-77.
185. Ibid/ p. 78.
186. Ibid. P. 83.
187. Jan Bondeson, *The Feejee Mermaid and Other Essays in Natural and Unnatural History.* (Cornell University Press, 2014) p. 87.
188. Ibid. p. 94.
189. Jan Bondeson, *The Feejee Mermaid,* p. 95.
190. Ibid. p.90.
191. Measuring Worth https://www.measuringworth.com/calculators/ppoweruk/

192. Bill Jay, "Walter Bentley Woodbury 1834-1885 and the history of his Woodburytype process" www.billjayonphotography.com/writings2.html
193. Bondeson, *The Feejee Mermaid* p. 91.
194. Ibid. p. 91.
195. John James Audubon, *The European Journals,* edited by Maria Audubon (Charles Scribner's Sons New York 1897) p.117.
196. Ibid p. 191.
197. Ancestry.com.
198. Audubon *The European Journals,* pp. 139-140.
199. Ibid. Jan. 23, 1828, p. 279.
200. Ibid. Jan. 26, 1828, p. 279.
201. Danny Heitman, "Audubon the Writer", *Humanities,* Vol. 82, No. 6 Nov/Dec. 2011.
202. Audubon. *The European Journals,* Feb. 1, 1828, p. 280.
203. Ibid. p. 281.
204. Ibid p. 133.
205. T. Brown, "The Manchester Zoo Gardens 6," *Zoo Grapevine,* Summer 2011.
206. Ibid.
207. Princeton letter March 17, 1835. Cited in Richard Rhodes. *John James Audubon: The Making of an American,* (First Vintage Press, 2004).
208. Sotheby's https://www.sothebys.com/en/buy/auction/2019/the-birds-of-america-from-original-drawings-by-john-james-audubon.
209. Census 1811 Whitworth Household. Ancestry.com.
210. Walter Bentley Woodbury, *Letters,* Letter 13, February 26, 1856.
211. Walter Bentley Woodbury, "Reminiscences of an Amateur Photographer," *The Amateur Photographer Magazine,* Dec. 1884, p. 185-186.
212. No author cited, "Early Closing Movement," *The Student: a magazine of theology, literature and science, Vol. 1,* (James Gilbert, 49 Paternoster Row, London, 1844) pp. 338-340.

213. Roger Erlich, *At Day's Close,* (W.W. Norton, New York, 2000) p. 219.
214. Bruce Watson, Light--A radiant History form Creation to the Quantum Age, (Bloomsbury, 2016) p. 150.
215. Straits Times, Collection of Richard Bartholemew.

BIBLIOGRAPHY

1. Aitkinson, Andrew. "Continuous Tone Alternatives to Half Tone Through Historical Reflection" IS&T and PICS 2003 Conference paper.
2. Altic, Richard. *Shows of London*. Harvard 1978.
3. Audubon, James. *The European Journals.* ed. Maria Audubon, New York: Charles Scribner's Sons, 1897.
4. *Australian Dictionary of Biography*, Volume 5, (MUP), 1974.
5. Beattie, Trevor, "Walter Bentley Woodbury and his Sciopticon" in *The new magic lantern journal: volume 10 number 3* (Autumn 2007), pp. 39–42. Reproduced by courtesy of the Magic Lantern Society, www.magiclantern.org.uk, accessed March 3, 2020.
6. Bondeson, Jan. *The Cat Orchestra and the Elephant Butler*. Gloucestershire: Tempus Press, 2006.
7. Bondeson, Jan. *The Feejee Mermaid and Other Essays in Natural and Unnatural History*. New York: Cornell University Press 1999.
8. Boudewijn, Petra. 'You Must Have Inherited This Trait from Your Eurasian Mother': The Representation of Mixed-race Characters in Dutch Colonial Literature. Published online 24 Feb. 2016 https://doi.org/10.1080/03096564.2016.1139777
9. Bowman, Karen. *Corsets and Codpieces*. UK: Pen and Sword History, 2015.
10. Brantlinger, Patrick. *Taming Cannibals: Race and the Victorians*. New York: Cornell University Press, 2002.

11. Brown, T. "The Manchester Zoo Gardens." *Zoo Grapevine*, Summer 2011.
12. Campagne, Jeff. "Racism and Rabble Rousing in Victorian England." *Smithsonian Magazine* online, July 18, 2014.
13. Tomlinson, Asha, et al. "'Whiter Skin in 14 Days': Tracking the illegal sale of skin whitening creams in Canada." *CBC Marketplace· CBC News* · Posted: Feb 7, 2020 4:00 AM ET.
14. Cohen, Deborah. *Family Secrets: Living with Shame from the Victorians to the Present Day*. UK: Penguin, 2013.
15. Dickens, Charles. *Bleak House*. Project Gutenberg http://www-gutenberg.org/files/1023/1023-h/1023h-htm
16. Elliott, Alan ed. *The Woodbury Papers: Letters and Documents Held by the Royal Photographic Society*. Pub. Alan Elliott, Victoria Australia 1997.
17. Elliott, Alan et al. *Walter Woodbury: A Victorian Study* Melbourne: Royal Photographic Society, Victorian Chapter Melbourne, Australia 2008.
18. Elliott, Alan, ed. *Walter Woodbury Research Notes from the Royal Photographic Society (Victoria) 1996–2012,* copyright Alan Elliott, 2013.
19. Ellis-Reese, William. *The Elephant at the Exeter Exchange A Tale of Cruelty and Confinement in Victorian London*. Kindle Copyright 2017.
20. Erlich, Robert. *At Day's Close*. New York: W. W. Norton Co., 2005.
21. Evans, Raymond. *Fighting Words: Writing about Racism*, Australia: Queensland University Press, 1999.
22. Evans, Richard. "The Victorians: Empire and Race." London: Museum of London Lectures, April 11, 2011.
23. Evode History Project http://www.evodehistoryproject.org.uk
24. Fasseur, Cornelius, *The Politics of Colonial Exploitation: Java the Dutch and the Cultivation System*, tr. R. Elson, Southeast Asia Program, Cornell University 1992.
25. Ferguson, Ellen Woodbury *Handwritten Family History*, 1935 in the possession of the heirs of Luanne Woodbury.

26. Francis, Andrew. *Culture and Commerce in Conrad's Asian Fiction*, UK: Cambridge University Press, 2015.
27. Francis. Andrew. "You always leave us—for your own ends—Marriage and Concubinage in Conrad's Asian Fiction." *The Conradian*, Vol. 35. No 2. Autumn 2010.
28. Galchinsky, Michael. *Otherness and Identity in the Victorian Novel*. Georgia State University English Faculty Publications, 2002.
29. Garrick Phyl, and Jeffrey Chris. *Fremantle Hospital: A Social History to 1987*. Australia: UWA Press 1987.
30. Gouda, Frances. *Dutch Culture Overseas: Colonial Practice in the Netherlands Indies 1900-1942*. Singapore: Equinox Publishing, 2008.
31. Haks, Leo and Wachlin, Steven. *Indonesia in 500 Early Postcards*, Singapore: Didier Millet Press, 2005.
32. Haliwell Stella. *An Undergraduate Symposium Paper: Women from Nowhere: The Pre- Raphaelite Order*. https://stellahalliwell.co.uk/pre-raphaelites/women-from-nowhere-the-pre-raphaelite-other.
33. Hannavy, John *The Encyclopedia of Nineteenth Century Photograph*. London: Routledge 2007.
34. Hartley, Florence. *The Ladies' Book of Etiquette and Manual of Politeness*. Project Gutenberg. https://www.gutenberg.org/ebooks/35123.
35. Heitman, Danny. "Audubon the Writer," *Humanities*, Vol. 32 no., 6 Dec 2011 *Humanities • Back Issues •* November/December 2011.
36. Herne, Brian. *White Hunters: The Golden Age of African Safaris*. London: Holt, 1999.
37. Hughes, Robert. *The Fatal Shore*. New York: Random House, 1986.
38. Hulsbosch, Marianne. *Pointy Shoes and Pith Helmets, The Social World of Batavia: European and Eurasian in Dutch Asia*. Madison, Wisconsin: University of Wisconsin Press, 2006.
39. Huxley, Elspeth and Perham, Margery. *Race and Politics in Kenya*. London: Faber and Faber 1944.

40. Huzzey, Richard. "Jamaica's Morant Bay Rebellion: brutality and outrage in the British Empire." *BBC History Magazine*, Christmas 2015 Issue.
41. Jay, Bill. *Walter Bentley Woodbury 1834–1885 and the History of his Woodburytype Process.* www.billjayonphotography.com/writings2.html.
42. Jefferey, Ian. *An American Journey, The Photography of William England.* Munich: Prestel Publishing, 1999.
43. Jupp, James. *The Australian Peoples: an Encyclopedia of the Nation, Its People and Their Origins.* UK: Cambridge University Press, 2001.
44. KITLV (Royal Netherlands Institute of Southeast Asia and Caribbean Archive of Photographs), University of Leiden, Netherlands.
45. Kuegler, Alice. "The Responsiveness of Inventing: Evidence from a Patent Fee Reform," 2016. https://sites.bu.edu/tpri/files/2018/07/Kuegler.pdf.
46. Levy-Reed, Jane, ed. *Towards Independence: A Century of Indonesia Photographed.* San Francisco: The Friends of Photography, 1991.
47. Malcolm, John. *Dissertation: The Life of Walter Bentley Woodbury.* A dissertation submitted in partial fulfillment of the requirements for the Degree of Master of Arts in the Department of Communication Arts and Design, Faculty of Art and Design, Manchester Polytechnic, November, 1979.
48. Merilees, Scott. *Batavia in 19th Century Photographs.* Singapore: Didier Millet, 2001.
49. Newton, Gael. *Garden of the East.* Australia: National Gallery of Australia, 2014.
50. Nichols, Christine S. *Red Strangers: The White Tribe of Kenya,* London: Timewell Press, 2005.
51. Noricia, Megan A. *X Marks the Spot: Women Writers Map the Empire for British Children, 1790–1895. Athens, Ohio:* Ohio University Press, 2010.
52. Oehlers, F. A. C. *That's How It Goes: The Autobiography of a Singapore Eurasian,* Singapore: Select Publishing, Singapore 2008.

53. Oliver, Barret. *A History of the Woodburytype*. Nevada City, California: Carl Mautz Publisher, 2007.
54. Plumb, Christopher. *Exotic Animals in Eighteenth-Century Britain A thesis submitted to The University of Manchester for the degree of PhD in Museology in the Faculty of Humanities*. Centre for Museology Centre for the History of Science, Technology and Medicine. Manchester: 2010.
55. Pritchard, Henry Baden. *Photography Studios of Europe*. London: Piper and Carter: 1882.
56. *Processes: The Woodburytype,* Getty Conservation Institute, Los Angeles, 2014.
57. Riley, Glenda. *Taking Land, Breaking Land: Women Colonizing the American West and Kenya*. Albuquerque, New Mexico: University of New Mexico Press, 2003.
58. Rintoul, M. C. *Dictionary of Real People and Places in Fiction*, London: Routledge, 1993.
59. Rowbottom, Arthur. *Travels in Search of Trade Products*. London: Jarrold and Sons, 1893.
60. Sebus, Gwen. "Woodbury in Leiden." http://www.magiclantern.org.uk/the-magic-lantern/pdfs/4010052a.pdf.
61. Sherry, Norman. *Conrad's Eastern World*. UK: Cambridge University Press, 1977.
62. Sivasundaram, Sujit, "Trading Knowledge: The East India Company's Elephants in India and Britain." *The Historical Journal* Cambridge University Press 48:1 2005.
63. Smith, Rev. J. F. (ed.), *The Manchester School Register*, Vol. 3, Part 2, May 1807–Sept 1837, The Cheetham Society: Manchester, 1874.
64. Spencer, David. "The Photographic Times 1871–1915: a definitive American photographic journal." https://photoseed.com/highlights/the-photographic-times-1871-1915-definitive-american-photographic-journal/.
65. Stevenson, Robert Louis. *A Child's Garden of Verses*, New York: Charles Scribner's Sons, 1895.

66. Stoler, Ann Laura. *Carnal Knowledge and Imperial Power: Race and the Intimate in Colonial Rule* Berkley: University of California Press, 2002.
67. Susanto, Eko Bhudi et al. *Portrait of Dutch East Indies Everyday Live in Woodbury and Page's Photographic Works,* AESCIART: International Conference on Aesthetics and the Science of Art, Institut Technoloji Bandung, 28 Sept. 2020.
68. Taylor, Jean Gelman. *The Social World of Batavia: European and Eurasian in Dutch Asia.* Madison, Wisconsin: University of Wisconsin Press, 2006.
69. *The Student: a magazine of theology, literature and science,* Vol. 1 London: James Gilbert publisher, 1844.
70. Trzebinski, Errol. *The Kenya Pioneers, The Frontiersmen of an Adopted Land.* London: Mandarin Paperback, 1985.
71. Visram, Rozina. *Asians in Britain: 400 Years of History.* (Kindle Location 7775). Pluto Press. Kindle Edition.
72. Wachlin, Steven. *Woodbury and Page, Photographers Java,* Leiden:KITLV Press, 1994.
73. Watson, Bruce. *Light, A Radiant History from Creation to Quantum Age,* London: Bloomsbury, 2016.
74. Welsh, Frank. *Australia: A New History of the Great Southern Land.* New York: Overlook Press, 2004.
75. Wilson, A. N. *The Victorians.* London: Arrow Publishing, 2003.
76. Wiseman, Roger. *Assimilation Out: European, Indo European and Indonesians seen through Sugar from the 1889's to the 1950's.* Panel Pater from ASAA Conference, University of Melbourne, July 2000.
77. Woodbury, Walter Bentley. "The Imaginary Brigand," *British Journal of Photography,* 3 February 1882.
78. Woodbury, Walter Bentley, ed. *Treasure Spots of the World,* London: Lock and Tyler, 1875.
79. Woodbury, Walter E. and Frank Fraprie. *Photographic Amusements.* New York: Scoville and Adams, 1896.

INDEX

A

Albert: 41, 44, 55-57, 76-77, 114, 123, 126, 130, 156, 219, 222, 265, 266, 271
Albert Leonard: 57, 77, 83, 126, 130, 272
Aldersey, Sarah Jane: 44, 55, 57, 76-78, 83-84, 123, 126, 221, 223, 248, 267, 272
Amah or Ayah: 77, 126, 130
Arliss-Robinson, Henry: 171-172, 174, 176, 198, 199
Atelier: 38, 39, 44, 45, 66, 69, 70, 72, 85, 125, 156, 222
Atelier in Batavia: 33-34, 38-39, 57, 60-63, 75, 108, 192
Audubon: 6, 7, 67, 91, 99, 130, 132, 237-245
Australian gold rush: 5, 14, 248
Avence the Baby: 213-214, 217
Avence the Daughter: 90, 117, 145, 156, 158, 176, 177, 211-214, 218, 286, 272

B

Babcock Album: 31, 35
Balloon Camera: 108-109, 268, 274, 277
Bankruptcy: 110-112, 115, 149, 152, 177, 197, 269
Batchelder, Perez M: 26, 28, 266

Bartholemew, Richard: 261-262, 320
Beechworth/Ovens Australia: 26, 27, 30, 50, 231
Beloved, The: 125
Bent, Brigitina: 135, 155
Bent, Edward Stanley: 103, 133-134, 153, 157, 183-185, 186
Bent, Gladys: 182-183, 189-191
Bent, W.S.: 154, 181-183, 186-189, 197, 212
Bentley, Ellen: 6, 8, 11, 18, 20, 25, 29, 39, 42, 44, 45, 47, 59, 62, 77, 82, 91, 124, 132, 177, 222, 247, 248, 249, 265, 266, 271
Bentley, Walter Horton: 6-9, 227-245, 271
Best, Annie: 197, 254, 259
Blindness: 115, 116, 269
Bondeson, Jan: 233, 234, 236
Borobudur Ruins: 42, 50, 70, 73, 77
Brooksbank, Carolynne Olmeijer: 261, 263
Brooksbank, Frederick: 261, 263
Buitenzorg Garden: 45-46, 266

C

Cannibal Club: 163
Carbutt, James: 101, 174
Chesnut, Thomas C: 214-216
Chesnut, Hilda Woodbury: 201, 215-217
Chunee: 6, 7, 91, 228, 231-234, 240-243
Conrad, Joseph: 64-66, 262
Constance: 90, 145, 158, 176-181, 197, 212, 257, 267, 272
Coroner's Inquest: 118-119, 151, 152, 218
Coward, Sidney: 258
Craven Cottage: 134-145, 146, 258
Cross, Edward: 233-236, 241-242

D

Dawson, A T: 22-25, 265

Death in Margate: 117, 118, 193, 211, 268
Diabetes: 116, 118, 211, 269
Divorce in England: 197, 198, 207, 208, 254, 258
Divorce in Australia: 201-207, 210, 258
Dutch East India Company or VOC: 39-40, 60-62

E

Early Closing Movement: 7, 8, 91, 132, 222, 248, 251
Elliott, Alan: 11, 18, 22-23, 53, 58, 71, 94, 141, 219-220
England, Gladys: 196, 254, 257
England, Muriel Phyllis: 196, 251-260
England Walter J,: 101, 194-195, 199, 207, 253
England, William: 103-105, 192-195, 165, 197, 251
Exeter Change Menagerie: 6, 230, 234, 240
Exhibition Medal Australia: 26-27, 30, 42, 266
Exhibition Medal Royal Photographic Society: 112, 114

F

Fayence: 120, 145, 180, 201, 211-218, 268, 272
Ferguson, Ellen Woodbury: 22, 34, 44, 45, 57, 76, 77, 81-84, 92, 107, 122, 124-126, 128, 133, 146, 151, 163-164, 177, 183, 212, 221-225, 267, 272
Florence: 90, 123, 134, 145-6, 151-152, 162-165, 179, 183, 212, 267, 271
Fraprie, Frank: 170
Fremantle: 200, 203-206, 208, 216
Funeral: 5, 29, 121, 152, 193

G

Glacier: 1, 109, 277
Goupil et Cie: 98, 99, 267
Grandma (aka Muriel England Morgan Coward): 253-260

H

Headstone: 122, 152, 193, 219-220, 268
Henry-James: 8, 17, 24-25, 44-45, 50-57, 64, 66, 69, 72, 76, 77, 82-84, 91, 123, 125-126, 156, 221-223, 251, 253, 265-268, 272
Hermance: 14, 90, 101, 106, 145, 192-208, 210, 212, 216, 253-254, 259, 268, 272, 279
Horton, William: 228-230
Hulsbosch, Miriam: 39, 64, 68, 320

I

Indian Head, Saskatchewan: 254-260
Imaginary Brigand: 106-107

J

John Taylor Woodbury: 6, 7, 222, 238, 248, 251, 265

K

Kipling: 156
Knott, Katherine Louisa: 77, 272

L

Laudanum: 116, 118-120, 268
Lea, James: 8, 124, 239, 247-248, 265, 271
Lee, Mr (the Angel): 56-57, 92, 221
Little Henry and His Bearer: 147, 148
Lingard, Tom: 262, 263
Lingard, Jim : 264
Lock, Jennifer: 179-181, 320

London: 6, 26, 29, 45, 47, 90, 99-100, 104, 110-111, 122, 126, 130-132, 136, 138, 142, 146, 153, 162, 192-194, 200, 210-211, 220, 225, 230, 235-236, 240-244, 251, 254, 255, 257, 260
Lord of the Flies: 147
Luanne: 122, 130, 152, 158, 179, 181, 193, 210, 218-220, 224, 225, 272, 319
Lucy: 25, 56, 92, 123, 126, 133, 156, 175, 176, 200, 265, 272

M

Magic Lantern (also see Sciopticon): 97, 101-105, 110, 125, 149-150, 222, 270
Manchester: 6, 11, 20, 36, 38-39, 55, 64, 71, 76, 81, 86, 90, 96-98, 115, 117, 122, 126-127, 130-133, 144, 146, 151, 153, 162, 164, 176-177, 200, 204, 211-212, 224, 228-230, 238-242, 247-248, 250
Manchester Zoological Gardens: 6, 91, 243-245
Mather Constance: 148, 212, 214
Mather, William: 178, 181, 212, 214
Marie: 5, 44, 54, 64, 67-73, 76-82, 84-87, 89-91, 105, 107, 111, 117-136, 138, 139, 144-147, 152-159, 161-164, 177, 180-183, 193, 200, 212, 214-216, 218, 222, 237, 241, 255, 257, 259, 262, 266-268, 271, 279
Manino, April: 191, 320
Mayence: 90, 134, 145, 155, 177, 178, 180, 181, 181-191, 197, 212, 257, 267, 272
Melbourne: 14-22, 25, 26-28, 34, 36, 59, 205, 316, 264, 266
Melbourne Exhibition: 26
Melbourne Panorama: 25-26
Monogenists vs. Polygenists: 142
Montez, Lola: 25, 27-28
Morant Bay Rebellion: 139-140
Morgan, Hector: 253-2258, 260
Mum (aka Eileen Florence Morgan): 256-258, 260
Mum (aka Ellen Bentley Woodbury): 10, 15, 19-20, 27, 47, 58, 62-62, 82, 91, 107, 124, 132, 156, 248, 250, 266

N

Nairobi: 134, 182-192
Naughty Lottie Collins: 186
Negretti and Zambra: 48, 266
Nelson, Janet: 49, 133, 145, 320
New Stanley Hotel: 185-188, 190-191
Nyai or Naia: 61, 63, 84

O

Oliver, Barret: 93
Olmeijer, Carl: 64-66, 76, 262
Olmeijer, Caroline: 261-264
Olmeijer, Johanna: 262
Olmeijer Marie Sophia: 5, 44, 64, 67-73, 76-82m, 84-87, 89-91, 106-107, 111, 117-136, 138, 144-147, 150-159, 161-164, 177, 180-182, 193-192, 200, 212, 214, 216, 218, 222, 237, 241, 254, 259, 262, 266-268, 271

P

Page, Annie: 62, 83-85
Page, James: 33-39, 40-41, 44, 47-58, 62, 65, 66, 60 61, 80, 83, 85, 222, 266, 267
Panama: 178
Patent: 9, 44, 81, 89, 92, 96-98, 101-103, 113-116, 119, 121, 123, 125, 130, 152, 222, 265, 269, 271-275
Photographic Amusements: 170
Photographic Times, The: 146-174, 212
Photofiligraine: 100
Photometer: 110
Pritchard, H.B.: 100, 108, 114
Progress Medal: 68, 113-114

R

Radiographic photo: 174
Rajah Laut: 262
Roscow, Frederick: 56, 222
Roscow, Lucy Woodbury: 25, 56, 92, 123, 126, 133, 156, 175, 176, 200, 265, 272
Rowbottom, Arthur: 33-35, 38, 47-48, 55, 62, 71, 83-85, 91-93, 124, 128, 135, 151, 155, 266
Royal Photographic Society: 34, 73, 90, 100, 107, 114, 166, 220, 266

S

Saleh, Raden: 41, 86
Scandal in Australia: 191, 199, 202-203, 210, 255, 259-260
Scenograph: 109
Sciopticon: 97, 101-105, 110, 125, 149-150-222, 270
Secret Garden, The: 148
Singapore: 38, 40, 47, 50, 76, 84, 123, 132-133, 150, 261-264
Slaves and Slavery: 5, 40, 56, 132-140, 145, 148, 222, 227, 238
Solar Club: 91, 100, 253, 267
South Africa: 13, 71, 149, 155, 178-180, 182, 186, 212, 215, 261, 272, 280
Spencer, Cheryl Cardinal: 280
Spencer, David: 320
Spencer, James: 220
Spencer, Mike: title page verso
Spencer the partner: 27, 34 adn, 266
Stanley Hotel: 185-187
Stieglitz: 168, 172, 174
Stannotype: 112-114, 117, 268
Stenchromatic Printing: 108, 267
Stevenson, RL: 149
Swan, Sir Joseph: 95-96, 98, 121, 152, 267

T

Tate, Fred: 155, 186-192
Tate, Mayence Woodbury: 186-192
Taylor, Jean Gelman: 63, 78-80
Teyte, Dame Maggie: 186
Totoks: 59-60, 66, 76, 85, 157

V

Van Leeuwen's House: 71-75
Valence: 90, 145, 162, 192, 213, 214, 262, 272
Vergara, Felix: 116, 118, 162
Visram, Rosina: 125-126
VOC: 39-40, 60-62
Vues de Java: 48, 54, 55

W

Wachlin, Steven: 83, 219
Walter E.: 164-176, 212, 267, 272
Whitworth Album: 49, 81, 111, 123, 145, 165, 320
Whitworth, Elizabeth Bentley: 57, 84, 92, 111, 124, 145, 200, 223, 247, 271
Wilson, Edmund: 101, 117, 120-121, 166, 268
Wood, Tommy: 183-184
Woodbury, Albert: 41, 44, 55-57, 76-77, 114, 123, 126, 130, 156, 219, 222, 265, 266, 271
Woodbury, Albert Leonard: 57, 77, 83, 126, 130, 272
Woodbury Avence the First : 90, 117, 145, 156, 158, 176, 177, 211-214, 218, 286, 272
Woodbury, Avence the Second: 213, 217
Woodbury, Constance: 90, 145, 158, 176-181, 197, 212, 257, 267, 272
Woodbury, Ellen: 6, 8, 11, 18, 20, 25, 29, 39, 42, 44, 46-47, 58, 62, 77, 82, 91, 124, 132, 247-249, 265-266, 272

Woodbury, Ellen Bentley, aka Mum: 10, 15, 19-20, 27, 47, 58, 62-62, 82, 91, 107, 124, 132, 156, 248, 250, 266

Woodbury, Ellen (the sister): 91, 124, 156, 200, 247

Woodbury, Fayence: 120, 145, 180, 201, 211-218, 268, 272

Woodbury, Florence: 90, 123, 134, 145-146, 151-152, 162-165, 179, 183, 212, 267, 271

Woodbury, Henry James: 8, 17, 24-25, 44-45, 50-57, 64 ,66, 69, 72, 76-77, 82-84, 91, 123, 125-126, 156, 221-223, 251, 253, 265-268, 272

Woodbury, Hermance: 14, 90, 101, 106, 145, 192-208, 210, 212, 216, 253-254, 259, 268, 272, 279

Woodbury, John Taylor and the Early Closing Movement: 6, 7, 222, 238, 248, 251, 265

Woodbury, Leonard: 192

Woodbury, Luanne: 122, 130, 152, 158, 179, 181, 193, 210, 218-220, 224, 225, 272, 319

Woodbury, Marie: 5, 44, 54, 64, 67-73, 76-82, 84-87, 89-91, 105, 107, 111, 117-136, 138, 139, 144-147, 152-159, 161-164, 177, 180-183, 193, 200, 212, 214-216, 218, 222, 237, 241, 255, 257, 259, 262, 266-268, 271, 279

Woodbury, Mayence: 90, 134, 145, 155, 177, 178, 180, 181-191, 197, 212, 257, 267, 272

Woodbury, Valence: 90, 145, 162, 192, 213, 214, 262, 272

Woodbury, Walter Bentley: In Australia: 13-28
 In England: 89-160
 In Italy: 106-107
 In Java: 33-88
 Death: 117-122
 Family tree: 271
 Timeline: 265-270
 List of patents: 273-275

Woodbury, Walter E: 164-176, 212, 267, 272

Woodburytype: 44, 48, 50, 54, 81, 92-95, 97-104, 112-113, 123, 130, 149, 266, 273

ACKNOWLEDGEMENTS

One of the most satisfying things about writing this book was that I discovered I was part of a community that I didn't know existed. I could not have written this book without their generous help. Some are relatives whom I discovered in my search for my ancestors. Some are genealogists. Some are historians. Some are erudite friends I have imposed upon. All have been supportive, generous and kind.

Luanne Woodbury in London sent me family pictures and documents that have formed the backbone of this work. She herself was a formidable family historian and was kind enough to encourage me especially in the beginning stages of the work. Alan Elliott in Australia was my "go-to guy" for all questions about Walter in Australia and about the technical side of Walter's photography. (Alan was a retired research chemist and understood these things far better than I do—I have double degrees in English.) His transcription of Walter's letters in the RPS Collection then in Bath, is a key source for my writing. And, wonderfully, Alan was able to tell me the name of my great-grandmother. Sadly, Alan died in late October of 2020 and Luanne in April of 2021, both at the age of 99, before I could put this book in their hands. I thank their relatives, Tess Lee-Ack and Chrissie Tomkin, who kindly let me know of the passing of my mentors and continued to encourage the work.

Janet Nelson in Caledon, Ontario, owns the fabulous *Whitworth Album* we "decoded" together, learning who most of the sitters, are. She has generously allowed me to use the photos in this work.

Other members of my extended family have been instrumental in the writing of this book. I cannot thank all my cousins of some degree enough: Richard Bartholemew in Thailand, Matt Steady, Jenn Lock and April Manino in England and Cousins Val England and Gita in Melbourne.

I would like to thank the kindness of historians and authors whom I pestered: Gael Newton, Gerlind May, Marianne Hulsbosch and C. S. Nicholls. Several did not answer me, but these ladies did! And I would like to thank the generosity of institutions like KITLV, The Rijksmuseum and Rijkstudio, which allowed me to download many, many images for the furthering of knowledge, an appropriate citation, and a copy of the book. I also thank David Spencer who allowed me to use the material about Walter Edward Woodbury form Photoseed.

And, last but not least, I would like to thank my honest proofreader/critics, Jerry Stemnock in Chicago, Carolynne Wright in Anacortes, Washington, and my sister Mary Spencer, who has stoically listened to me go on and on and on about my researches and plied me with pertinent questions.

ABOUT THE AUTHOR

For more than 43 years, Muriel Morris taught English, English literature, journalism, and creative writing, among other subjects. She has double degrees in English and previously published *Shakespeare Goes to the Dogs* (later re-issued as *Shakespeare Made Easy: an Illustrated Approach*), a dozen Shakespeare plays acted out by cartoon dachshunds. "Merry Dachshunds of Windsor" was a part of the 2000 *Shakespeare: Man of the Millennium* exhibition put on by Britain's National Shakespeare Institute in Stratford-upon-Avon, the Bard's birthplace.

Like her great-great grandfather and other Woodbury relatives, Morris has "travelling feet," having visited the UK, Europe, South America, North Africa, India, and China, where she rode a Bactrian camel in Inner Mongolia. She's also ridden a dromedary on the Sahara, an elephant in the teak forests of India and gone down the Amazon in a large canoe. Morris lives in Chilliwack, British Columbia, in the company of two dachshunds, Portia and Smashing Pumpkin, referred to as "The Dachshund Princesses."

Milton Keynes UK
Ingram Content Group UK Ltd.
UKHW050655090823
426571UK00011B/77